CRAFTING
BEAUTYIN
MODERN
JAPAN

CRAFTING BEAUTY IN MODERN JAPAN

Celebrating Fifty Years of the
Japan Traditional Art Crafts Exhibition

わざの美
伝統工芸の50年

EDITED BY NICOLE ROUSMANIERE

THE BRITISH MUSEUM PRESS

This book is published to accompany the exhibition at the British Museum from 19 July to 21 October 2007.

Organized with The National Museum of Modern Art, Tokyo. In association with The National Museum of Modern Art, Kyoto, Japan Art Crafts Association and The Japan Foundation.

Supported by Agency for Cultural Affairs, Japan

Transportation supported by All Nippon Airways

Project support from The Asahi Shimbun

JAPANFOUNDATION

First published in 2007 by The British Museum Press
A division of The British Museum Company Ltd
38 Russell Square, London WC1B 3QQ
www.britishmuseum.co.uk

ISBN-13 978-0-7141-2448-3
ISBN-10 0-7141-2448-6

A catalogue record for this book is available from the British Library

Designed and typeset in Palatino by Redloh Designs Ltd
Printed and bound in Spain

Frontispiece: Detail of cat. no. 84.
Right: Detail of cat. no. 42.

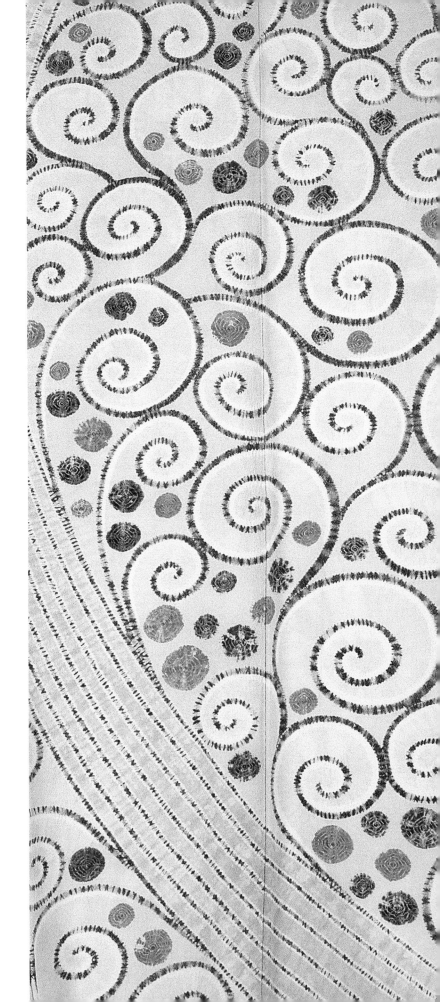

CONTENTS

FOREWORDS

The National Museums of Modern Art,
 Tokyo and Kyoto

Japan Art Crafts Association

The Japan Foundation

The British Museum

PREFACE

By Kaneko Kenji (Chief Curator, Crafts Gallery,
 The National Museum of Modern Art, Tokyo)

ESSAYS

CONTINUITY AND CHANGE – UNDERSTANDING
JAPANESE ART CRAFTS IN CONTEXT
By Nicole Rousmaniere 12

THE JAPAN TRADITIONAL ART CRAFTS
 EXHIBITION – ITS HISTORY AND SPIRIT
By Uchiyama Takeo (Director Emeritus,
 The National Museum of Modern Art, Kyoto) 26

THE CATALOGUE

 Ceramics 37
 Textiles 67
 Lacquer 95
 Metal 113
 Wood and Bamboo 125
 Other Crafts 137
 Dolls 138
 Cut metal foil 144
 Glass 146
 Craft Heritage 149

 Craft Techniques 158
 Artist Biographies 168
 Description of Works 196
 Bibliography 204
 Acknowledgements 208

Foreword

Crafts have developed as a precious cultural resource in Japan, nurtured by our particular geography and climate – the beautiful natural environment as it changes with the seasons. They are also the product of the particular local character of the various regions of our country. Many famous craftspeople and artists of the past have worked hard to bring this tradition to the high level of achievement that it enjoys today.

Building on this history, in 1955 Japan created the system of designating the skills of various performers and craftspeople as Intangible Cultural Properties, part of the Law for the Protection of Cultural Properties. This was designed to protect traditional crafts and to encourage their spread and development.

Japan Art Crafts Association, which comprises the holders of Intangible Cultural Properties (the so-called 'Living National Treasures') and other craft artists, has worked hard to encourage the making of works which use the splendid skills derived from tradition and to present them to a wide public, also to foster the successors who will maintain these skills. They have done this in cooperation with Agency for Cultural Affairs, Japan (Bunkachō) and various regional public bodies and media organizations and by means of the annual Japan Traditional Art Crafts Exhibition, which this year will be held for the 54th time.

We are delighted that the British Museum values this long history and tradition and is holding the present exhibition. This is a wonderful event for the craft world in Japan.

The National Museums of Modern Art in Tokyo and Kyoto are the museums in Japan responsible for the collection, preservation, display, research and educational activities relating to Japanese crafts. We are very glad to give our full cooperation to the British Museum to realize this exhibition project.

In this exhibition are displayed the very best of the works made by the Living National Treasures and others craftspeople who represent Japan, drawn primarily from the collections of the National Museums of Modern Art in Tokyo and Kyoto and Agency for Cultural Affairs.

We hope that the exhibition will be seen by many art-lovers not only from the UK but also from among the many visitors who come to the British Museum from all around the world, and that it will contribute to a deeper engagement with the crafts and traditional culture of Japan.

Tsujimura Tetsuo
Director, The National Museum of Modern Art, Tokyo

Iwaki Ken'ichi
Director, The National Museum of Modern Art, Kyoto

Foreword

As one who is dedicated to the preservation of traditional Japanese art crafts, I am delighted that the British Museum is presenting *Crafting Beauty in Modern Japan: Celebrating Fifty Years of the Japan Traditional Art Crafts Exhibition* and that many people in the UK will be able to enjoy them.

I think that broadly speaking there are two kinds of traditional art craft in Japan. The first demonstrates as much skill as possible in the work, an ambition common to crafts all around the world. In Japan, crafts use motifs such as birds and flowers and other patterns that are particular to our culture.

The second kind also uses the utmost skill, but tries to ensure that this is not visible on the surface of the work. I think this second kind of craft may be unique to Japan and it particularly relates to the culture of tea.

Imagine a typical tea room. It is a small building with a thatched roof, and the floor area is only about ten metres square. The light from outside is dimmed by paper *shōji*, and it is humid inside because of the thatched roof. An antique scroll is displayed and there is a single wild flower in a vase. At first glance this may seem like a farmer's humble cottage, but in fact large amounts of money have been lavished on it. Considerable technical skill has been expended on the building, but that skill is hidden in an aesthetic of simplicity, artlessness and natural effects. The teabowl itself may be imbued with tremendous spiritual feeling, and yet it is irregular in shape and looks like a rough piece of everyday pottery. Porcelain-making originated in China. However, the bowls used at tea gatherings in Japan are very different from those used in China, which are regular and pure in shape and have a hard finish. Most teabowls in Japan are individually crafted, not mass-produced. Many were given a name by their maker and their individual histories are known. This makes them completely different from normal works of art. Famous teabowls in China are simply classified by their date of production and the name of the kiln.

It is said in Japan that famous teabowls were valued as highly as large tracts of property. Tea masters discovered in them the highest form of beauty and deep bonds of friendship between host and guest were formed at a tea gathering. It is perhaps surprising that the two groups who most appreciated this kind of pleasure were warriors who spent their lives on the battlefield and wealthy townspeople. This happened four hundred years ago, corresponding in England to the reign of Queen Elizabeth I. Amazingly, this sense of taste is continued by many ordinary people in Japan today, even though most aspects of their lives have become modernized and Westernized. Behind the ritual practices of tea lies Buddhist philosophy as expressed in phrases such as 'the world is empty and transient, only in the Buddha does truth reside'; also ancient Chinese notions of rejecting the world, like the famous sages who met in a bamboo grove. In the West, maybe this is similar to the spiritual atmosphere of a monastery, where monks live a simple life, work hard and begin and end each day in prayer.

Yasujima Hisashi
President, Japan Art Crafts Association

Foreword

As one of the co-organizers, The Japan Foundation is delighted to present the exhibition *Crafting Beauty in Modern Japan* at the British Museum.

The Japan Foundation was founded in 1972 with the purpose of deepening other nations' understanding of Japan and promoting better mutual understanding among countries. We have carried out programmes in a variety of fields, engaging in international dialogue through arts and cultural exchanges, promoting Japanese language education overseas, and supporting Japanese studies and intellectual exchange. In order to enhance the understanding of Japanese arts, the Foundation collaborates with overseas museums on a wide range of exhibitions from traditional to contemporary arts. As part of the UK–Japan festival 'Japan 2001', for example, we were pleased to stage the flagship exhibitions *Shinto: Sacred Art of Ancient Japan* at the British Museum and *Facts of Life: Contemporary Japan* at the Hayward Gallery.

Crafting Beauty in Modern Japan consists of 112 works of traditional art crafts made by outstanding Japanese artists during the period from 1955 to the present. During the 1950s in Japan a system was established by the government for the protection of 'Intangible Cultural Properties'. It includes distinguished traditional craft skills, and masters of these traditional skills are designated 'Living National Treasures'. This system was born from the concern following World War II that the traditional culture of Japan would disappear unless appropriate measures were taken. Owing to this unique system Japan enjoys a diverse range of arts and crafts that are created using a large variety of styles and techniques, to wide acclaim, from traditional craft skills to the latest high technology.

The exhibition brings together some of the finest craft works which have been created during the last fifty years in the media of ceramics, textiles, lacquer, metal, wood, bamboo, dolls, cut metal foil and glass – all fields that have developed over a long period of history. We hope the exhibition will give pleasure to many people.

We would like to express our warm appreciation to the British Museum; Japan Art Crafts Association; Agency for Cultural Affairs; The National Museum of Modern Art, Tokyo; The National Museum of Modern Art, Kyoto; the artists whose works are displayed; the various owners who kindly agreed to loan their works; and all others who have contributed to the realization of this exhibition.

Ogoura Kazuo
President, The Japan Foundation

Foreword

The British Museum has collected modern Japanese crafts since its founding in 1753. Displayed in our Enlightenment Gallery are three modest and very beautiful – and at that time new – Utsutsugawa ware ceramic bowls, acquired in Japan in the 1690s by Engelbert Kaempfer. The bowls later found their way into Sir Hans Sloane's collection, along with Kaempfer's precious manuscripts for *The History of Japan*. From the 1870s until his death in 1897, the greatest of British Museum curators Augustus Wollaston Franks was indefatigable in his collecting of many types of Japanese ceramics, both historical and contemporary. In recent decades, perhaps in recognition of the richness of these holdings and the dynamism of the Museum's Japanese Section in using them, some of Japan's Living National Treasure ceramic artists have graciously donated major works to our collections. These handsome pieces, by several individuals also represented in *Crafting Beauty*, now take pride of place in the centre of new displays about modern Japan in the Museum's Japanese Galleries. The new displays, *Japan from Prehistory to the Present*, situate these masterpieces of contemporary ceramic art – perhaps uniquely among world museums – within a rich continuum of the production of beautiful objects that stretches back thousands of years to prehistoric Jōmon times.

Crafting Beauty has been developed from an exhibition entitled *Waza no bi* ('The Beauty of Skill') which successfully toured Japan in 2003–4, celebrating fifty years of the Japan Traditional Art Crafts Exhibition. We are indebted to our friends at Asahi Shimbun, co-organizers of that exhibition, for the introductions and assistance that have permitted the Japanese Section and guest curator Dr Nicole Rousmaniere to develop *Crafting Beauty* in close cooperation with many individuals and organizations in Japan. We are particularly grateful to Kaneko Kenji and his colleagues Moroyama Masanori and Kida Takuya at the Crafts Gallery of the National Museum of Modern Art, Tokyo for their unstinting support to create the present exhibition. Japan Art Crafts Association (Nihon Kōgeikai), representing the craft artists, has given full assistance through the person of *yūzen* textile artist Moriguchi Kunihiko. Additional and most valued support has been given by the National Museum of Modern Art, Kyoto, The Japan Foundation and Agency for Cultural Affairs. Professor Uchiyama Takeo has graciously contributed one of the essays. In London, colleagues at the Victoria & Albert Museum have given valuable advice including the gift of the exhibition title, the inspired idea of craft expert Dr Rupert Faulkner. Our close ties with the Sainsbury Institute for the Study of Japanese Arts and Cultures have brought to the project the welcome assistance of Dr Rousmaniere, Uchida Hiromi and Morohashi Kazuko. The Embassy of Japan in London has done much to facilitate the project.

We think of Japan as a country and a culture that has always contrived to integrate beauty, apparently effortlessly, into everyday life. And yet to sustain this culture of constant beauty does of course require the considerable labours and skill of many talented artists. During the past half century the traditional crafts of Japan have been encouraged to develop new and modern forms of beauty with the support of the government's unique system of 'Living National Treasures'. We hope that this exhibition, presented to the international audience that visits the British Museum, will provide the opportunity to enjoy the achievements of the Japan Traditional Art Crafts Exhibition and to consider its activities in that international context.

Neil MacGregor
Director, The British Museum

The Development of 'Traditional Art Crafts' in Japan

Kaneko Kenji

The exhibition *Crafting Beauty in Modern Japan* presents a selection of the best of what are known as 'traditional art crafts' (*dentō kōgei*) from within the wider context of post-war Japanese crafts. I would like to take the opportunity here to reflect on the background and special character of traditional art crafts in Japan.

One person seminal in the development of Japanese traditional art crafts in their present form was Koyama Fujio (1900–75), a scholar of East Asian ceramics and a government official who played an important role in the formulation of the Law for the Protection of Cultural Properties and in the founding of the Japan Art Crafts Association. In an essay written for an exhibition of ceramic works by Ishiguro Munemaro (1893–1968, cat. no. 4) held in Toyama city in 1936, Koyama wrote the following: 'Your works are different from crafts displayed in the Teiten exhibition which follow modernism in a cursory way, and they have taken a different course from so-called Folk Crafts (Mingei). Yet they do not follow the traditional taste of tea masters either. You have chosen an idiosyncratic and difficult path.'

This passage clearly shows that Koyama was one of the first to recognize the beginnings of craft production by individual artists in the modern sense, or to put it another way, the production of craft as artistic expression. Craft production by individual artists grew out of industrial crafts of the Meiji era (1868–1912), using the same materials and techniques but mobilizing these solely for the purpose of individual expression. However, the boundaries between art craft and craft industry are not always clear, and at the time little attempt was made to distinguish qualitatively between industrial and artistic expression. Judgements, in general, went no further than deciding which pieces were good and which not well executed. No one hesitated to refer to both industrial and individual works as 'art crafts' (*bijutsu kōgei*). At the Paris Exposition Universelle of 1900, for example, the former were called 'superior grade crafts' (*yūtō kōgei*). The reality, however, was that industrial crafts were indistinguishable from what we would now call manufactured wares and soon they would no longer be called 'art crafts'. This term is now used exclusively for craftworks that reflect individual artistic expression.

The Tokyo Peace Memorial Exposition of 1922 took place just as these craft divisions were starting to be realized and, tellingly, crafts were given recognition on a par with industry, painting and sculpture. The status of craft on a par with art was confirmed with the establishment of an official art crafts (*bijutsu kōgei*) section at the Teiten exhibition of 1927. There is general consensus that the beginnings of individual artistic craft production occurred around 1920–1, when Tomimoto Kenkichi (1886–1963, cat. no. 1) started to exhibit his work and when Kusube Yaichi (1897–1984) and the Sekidosha Society, which he helped to found, began exhibitions of their works.

Four distinct tendencies can be observed in how modern craft artists established their individual identities in the period to the later 1930s:

1. Those who strove to transform themselves from artisan to artist based on Western styles and philosophies (*c.* mid-1910s–late 1920s)
2. Those who sought to revive classical Japanese styles of the past – from the Momoyama period (1573–1600) in the case of ceramics, and from the Nara (AD 710–94) and Heian (AD 794–1185) periods in the case of lacquer (1930s)
3. Those who revived the classical Chinese and Korean ceramic styles (1930s)
4. Those who worked in the 'Folk Crafts' (Mingei) style, inspired by the simple vigour of wares used by ordinary people, and with a certain spiritual philosophy (late 1920s)

For example, Ishiguro Munemaro, who is included in the third category, established his kiln and residence at Yase in Kyoto in 1935, after a period of study of Chinese Jian and Cizhou wares. In 1937 he exhibited at the Paris Exposition and in 1942 at the First Japan Export Crafts Federation Craft Exhibition, where he was awarded a prize. In 1940 he achieved a revival of the various forms of Jian ware glaze technique.

In 1941 Arakawa Toyozō (1894–1985, cat. no. 7), who falls into the second category, held his first solo exhibition of ceramics and painting, having experimented with the revival of Shino, Black Seto and Yellow Seto wares. Katō Hajime (1900–68, cat. no. 5), who belongs to the second and third categories, carried out excavations of old kilns in Mino as well as a survey of Korean ceramics. He exhibited at the Paris Exposition of 1937 and held his first solo exhibition in 1941. Kaneshige Tōyō (1896–1967, cat. no. 3) and Miwa Kyūwa

(b. 1910, cat. no. 6) also achieved their first successes in the same period and both belong to the second category.

Koyama's historical thinking about craft formed the basis of government philosophy concerning Intangible Cultural Properties in the post-war period. This arose from the Law for the Protection of Cultural Properties, which was first promulgated in 1950. From 1952 through March 1954 a total of fifty-six craft skills were selected in five rounds, 'as Intangible Cultural Properties worthy of measures to support them'. These included: Shino glaze – Arakawa Toyozō; Oribe ware – Katō Tōkurō); Tenmoku glaze – Ishiguro Munemaro; incision and colour inlay in lacquer (kinma) – Isoi Joshin; costume dolls – Hirata Gōyō II; Kyoto yūzen – Tabata Kihachi. The first 'Exhibition of Craft Techniques Selected as Intangible Cultural Properties' was held in March 1954.

However, immediately following this exhibition, in May 1954, the Law for the Protection of Cultural Properties was suddenly modified. In accordance with new thinking concerning the 'designation of Important Intangible Cultural Properties' and the 'recognition of holders of Important Intangible Cultural Properties', the earlier designations of 'Intangible Cultural Properties worthy of measures to support them' were nullified. On two occasions in February and May of the following year (1955), a total of twenty-eight individuals and one group were recognized as 'holders' and 'group holders' respectively. These included: porcelain with overglaze enamel (iro-e jiki) – Tomimoto Kenkichi; iron-oxide glazed stoneware – Ishiguro Munemaro; yūzen dyeing – Kimura Uzan; 'sprinkled picture' (maki-e) lacquer decoration – Matsuda Gonroku; costume dolls – Hirata Gōyō II.

There were originally two criteria for deciding 'Intangible Cultural Properties worthy of measures to support them', which were '[skills] of particularly high value' and '[skills] which if they were not supported by the government were in danger of disappearing'. Thus, something of high value, such as Tomimoto Kenkichi's overglaze porcelain technique, which was not in danger of dying out, would not have been selected; whereas hand-crafted materials such as gold brocade for mounting paintings, karaori woven textile and ra silk gauzes would have been designated.

In March and November of 1952 examples of designated skills were displayed and the Committee of the Protection of Cultural Properties responded to suggestions made at that time to further differentiate within the designation system. For example, in the case of transmitted craft skills with special techniques, such as Shiraishi paper cloth (kamiko), the main effort was put into recording the technical process. In the case of skills possessed by individuals, organizations and geographical areas, however, such as Katō Hajime's overglaze technique (uwa-etsuke) and Arakawa Toyozō's Shino glaze, steps were taken to keep these techniques alive by means of financial support, donation of materials and by finding ways in which the works could be incorporated into modern lifestyles.

Changes made to the law in 1954 were an extension of this thinking. For example, 'high value' was now made the first consideration for designation. In December of the same year the policy of making records of technical processes was formalized with 'selection criteria for Intangible Cultural Properties for which steps should be taken to make records, etc.'. From that time until the present, policy concerning Intangible Cultural Properties has continued to have these two aspects: designation of holders, and the making of records.

What considerations were used to determine high value when making designations? The answer lies with the four different tendencies explored by individual craft makers, described above. This applies to all ceramic designations made in the first and second rounds. In the first, these categories were also applied to maki-e lacquer – Matsuda Gonroku, Takano Shō zan; costume dolls – Hirata Gōyō II, Hori Ryūjo; and in the second to yūzen dyeing – Tabata Kihachi, Ueno Tameji, Kimura Uzan, Nakamura Katsuma; chinkin lacquer – Mae Taihō; carved lacquer – Otomaru Kōdō; metal chasing – Unno Kiyoshi.

With passing years the system of Important Intangible Cultural Properties has broadened to include, for example, paper stencil-dyeing of textiles (katagami) and handmade paper (washi). In the case of group designations, there is considerable overlap with traditional craft production using industrial methods. In post-war Japan, with the shift from 'selection' to 'designation', an important criteria for judging the beauty of craft has been established. 'Traditional crafts' are but one form of craft that seeks modern expression, albeit a very important one for Japan. The significant question is: what kind of art should be produced on the basis of the system of Important Intangible Cultural Properties? The best art crafts of the last fifty years produced under these conditions are displayed in Crafting Beauty in Modern Japan. How will they be received? How can we assess a possible future for crafts? These are issues I would like us to explore together.

Continuity and Change – Understanding Japanese Art Crafts in Context

Nicole Rousmaniere

Japan has an extremely long and vibrant history of craft production, and the continuing dynamism and technical prowess of Japanese craft artists, working in a wide variety of media, is readily apparent today. To describe how this diversity of craft production developed and has come to be sustained is the main purpose of this introduction.

Examining modern Japanese art crafts in context encourages a deeper appreciation of many aspects of art-craft production in contemporary Japan. Uchiyama Takeo, Director Emeritus of the National Museum of Modern Art, Kyoto, has provided a clue to understanding one of the basic underlying principles of modern Japanese art crafts, when he draws our attention to a particular quote from the catalogue of the 1959 Nitten exhibition (see p. 30). There, an analogy was drawn with the philosophy of the seminal Japanese poet Matsuo Bashō (1644–94), who famously defined the basic principle of composing traditional haiku poetry in terms of 'continuity and change' (fueki ryūkō). Bashō's dictum was invoked in the 1959 catalogue to explain the true meaning of the word 'tradition' (dentō) in contemporary Japanese artistic production: a tradition which embraces, without contradiction, both continuity *and* change. The continuation of an artistic tradition must allow for and even encourage change, to keep that art form vibrant. This essay explores the dynamic between continuity and change, by examining case studies of the varied production of modern Japanese art crafts. It also examines issues surrounding their official recognition and their transmission. My aim is to encourage a deeper understanding and appreciation of Japanese art crafts in context.

Official recognition for Japanese art crafts

Many of the artists represented in this catalogue are known colloquially as 'Living National Treasures'. This term came into use shortly after World War II. In the immediate post-war recovery period (1945–52), when Japan was occupied by US troops and traditional art forms were considered to be threatened, the Japanese government enacted as a precaution various cultural property protection acts. In particular, in 1950, the Committee for the Protection of Cultural Properties (now the Bunkachō, or Agency for Cultural Affairs) developed a system of designating the craft or performance skills of particular artists as Intangible Cultural Properties' (mukei bunkazai). Public interest was inevitably drawn towards the person rather than the skill, however; hence the popular name 'Living National Treasure'. (As a rule, the more popular term has been used in this publication.) The system was revised in 1955 and many previously designated artists were re-designated, and others added. For example, the first ceramic artists to be designated under the new system were Hamada Shōji (cat. no. 2) for his Mingei (Folk Crafts) ceramic technique and Tomimoto Kenkichi (cat. no. 1) for his overglaze enamel technique on porcelain.

As the revised official term 'Important Intangible Cultural Property' (jūyō mukei bunkazai) implies, from this period onwards the government has officially recognized select individuals as 'holders' (hojisha) of specific techniques that have been determined to be worth preserving and perpetuating. In addition to individuals, collective or group designations are also made; for example, the Kakiemon and Imaemon ceramic workshops in Arita for their coloured overglaze enamel (iro-e) techniques.

Three criteria have been considered essential for 'Living National Treasure' designation: that the technique in question possesses high artistic value; that it occupies an important position in the history of Japanese art crafts; and finally, that it has distinctive regional characteristics. In addition to the honour of the designation, assistance is supplied to train successors to perpetuate the technique. To take the year 1994 as an example, thirty-nine special techniques of craft skills in nine categories were designated as important intangible properties, along with thirty-six special techniques of performing arts in seven categories. These designations of technique were awarded to fifty-three individuals and twenty-three groups overall.[1] Several new categories are added each year, including recently local theatrical expression from Okinawa prefecture.

As recounted in more detail in Prof. Uchiyama's essay, the Japan Art Crafts Association (Nihon Kōgeikai) was formed in

1955 – at around the same time as the 'Living National Treasure' system was being reorganized – to help administer and co-organize the Japan Traditional Art Crafts Exhibition (*Nihon Dentō Kōgeiten*) together with the Agency for Cultural Affairs. This exhibition is considered integral to the government's designation scheme and serves the dual purposes of promoting and developing domestic Japanese art-craft traditions while also presenting the work of the artists designated as Living National Treasures. The prestigious Japan Traditional Arts Crafts Exhibition, with a published catalogue, is held every autumn in Tokyo at the Mitsukoshi department store, and subsequently in eight other locations throughout Japan. The annual exhibitions have proved to be extremely popular with the general public and garner much media attention.[2] They have been organized for more than fifty years now with the help of The Asahi Shimbun (Asahi Newspaper Company) and NHK National Broadcasting, as well as other local media groups. Since 1960 the exhibitions have been open to general submission.[3]

Initially, in the first charter of the Japan Art Crafts Association of 1955, craft media for the exhibition were divided into five categories: ceramics, textiles, lacquer, metal and a category composed of dolls, wood and bamboo, and other items.[4] Two years later, in 1957, the categories were expanded to seven and they remain unchanged today: ceramics, textiles, lacquer, metal, wood and bamboo, dolls, and a category of other crafts that includes *kirikane* (applied cut metal foil), glass, cut stone, ink stones, and enamelling (*cloisonné*). Interestingly, while swordsmiths can also be designated Living National Treasures, swords are not included in the metal section of the exhibition. There are two main reasons for this. The first is that sword makers already had a special trust, Nihon Bijutsu Tōken Hozon Kyōkai (Society for the Preservation of Japanese Art Swords), formed for the preservation of their craft techniques in the immediate pre-war period, and therefore they did not need to be included in another association. A second fundamental issue is whether a contemporary sword represents an act of independent artistic volition or self-expression by the maker; or is it, rather, the consummate example of an artisan working at one with his material. Swords are not collected or displayed at the Craft Gallery of the National Museum of Modern Art, Tokyo (MOMAT), but rather at the Tokyo National Museum.

Regional expression

Japan is an island chain that covers over 370,000 square kilometres and is made up of four main and some 6800 smaller islands. The climate ranges widely from sub-tropical in Okinawa prefecture to sub-arctic in the north. Much of the country is covered by mountain ranges, with only about thirteen per cent of the land fit for agricultural use. Since prehistoric times the coastline has changed considerably with fluctuations in the water level. In addition, some of the largest mountains are (or were) volcanic which, coupled with frequent earthquakes, has created a self-transforming landscape. The southern island of Kyushu is geographically close to the Korean peninsula. A swift current links southern China and Taiwan to western Kyushu. The southern chain of islands that compose current Okinawa prefecture (formerly the Ryūkyū Kingdom) were annexed as part of the Japanese Satsuma domain after an invasion of 1609. The variety of Okinawa's topography is reflected in diverse artistic forms and local styles. It has managed to preserve a culturally distinct identity through its art crafts. Vibrant textile traditions, for example, are represented by the works of two female artists, Taira Toshiko (cat. no. 55, fig. 1) and Miyahira Hatsuko (cat. no. 52) in this book. Okinawan textiles with their unique textures and colour combinations have influenced famous twentieth-century artists from a variety

Fig. 1 Taira Toshiko [55] boiling banana tree bark (*ūdaki*) at her workshop in Kijoka, Okinawa prefecture. 2006. Photograph by Yara Katsuhiko

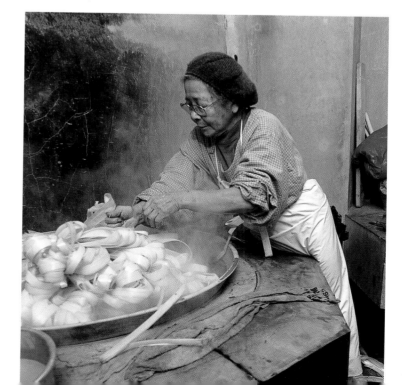

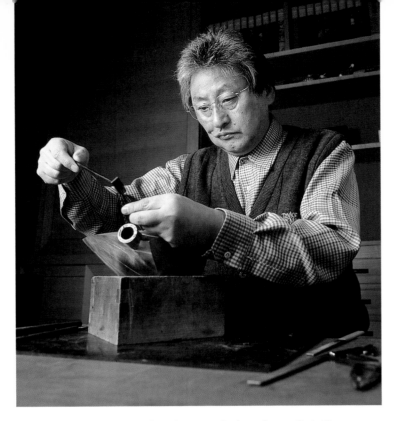

Fig. 2 Nakagawa Mamoru [85] applying metal inlay at his studio in Kanazawa, Ishikawa prefecture. 2005. Photograph by Hōchi Hiroyuki

of fields throughout Japan, including the potter Hamada Shōji (cat. no. 2) and the textile artist Serizawa Keisuke (cat. nos 32, 39).

Regional expression is one of the basic criteria considered in the designation of a Living National Treasure in Japan. This emphasis on regionalism goes back at least to the Edo period (1600–1868). Now there is the inevitable pull towards the major cities such as Tokyo and Osaka, where it has become quite easy to procure many different types of regional art crafts. Nevertheless, some artists have resisted the lure of city life and remained in their local area. Tokuda Yasokichi III (cat. no. 22, fig. 3), Nakagawa Mamoru (cat. no. 85, fig. 2) and Ōba Shōgyo (cat. no. 64) have all stayed close to their roots in Ishikawa prefecture. Others have chosen to move to another region of Japan to practise their vocation, such as Ōnishi Isao (cat. no. 74, fig. 5), who was born in Kyushu but now lives and works in Ibaraki prefecture in the east.

Craft traditions have evolved in particular regions of Japan for many reasons. The Arita area of Saga prefecture in Kyushu has been home to a thriving porcelain industry for almost four hundred years, one that is still strong today. Three artists in the current exhibition are from Arita – Imaizumi Imaemon XIII (1926–2001, cat. no. 14), Sakaida Kakiemon XIV (b. 1934, cat. no. 20) and Inoue Manji (b. 1929, cat. no. 24) – and all are designated Living National Treasures. Part of the reason why Arita became the location for porcelain production lies in its physical resources: porcelain stone was first located in Japan at Izumiyama in Arita around 1610. In addition, there are dense surrounding forests needed to fire the kilns, plenty of streams to help process the materials and sloping mountains on which to build the linked-chamber climbing kilns. An equally significant ingredient for early success was patronage, particularly important in the case of porcelain, which requires intensive labour and strong fiscal commitment. In the Edo period the Nabeshima samurai lords took an active interest in Arita ware, so ensuring its survival. Today the prefecture and other local interest groups also promote the ware and its artists. The Kyushu Saga Prefectural Ceramic Museum in Arita is at the forefront of porcelain studies and tries to place porcelain in historical context while also working with contemporary artists. Porcelain plays an important role in heritage tourism of the Arita area, and is promoted through annual festivals and other local initiatives. This same phenomenon is true in Okayama prefecture with Bizen ware, or Wajima in Ishikawa prefecture with its lacquer traditions. The combination of rich local resources and historical patronage systems, with access to trading routes, has helped to promote regional craft specialities. They are now considered a vital part of the cultural heritage of a particular region and actively fostered whenever possible.

Trends in twentieth-century Japanese art crafts

As has been described above, Japan's long history of varied crafts is deeply rooted in the local regions where they are produced. Throughout the early modern period, from the 1600s through 1800s, localized craft production was generally encouraged by the 260 or so regional samurai domains. With the upheaval in local structures that followed the inauguration of the Meiji era (1868–1912) and the subsequent abolition of privileged samurai status and regional domains in 1871, local craft industries had for the first time to compete nationally and internationally – without the support structures that they had enjoyed for several centuries previously. In addition, new

technologies and foreign goods began to enter Japanese markets, sharpening competition all the more.

The new Meiji government soon discovered that Japanese art crafts were popular abroad and could generate a much needed source of foreign currency. With this in mind, coupled with the growing feeling among *cognoscenti* that local traditions were in danger of being undermined, a series of Meiji-era initiatives were undertaken under the banner slogan of 'encouragement of industry' (*shokusan kōgyō*). In 1873 the new Meiji government participated in the Vienna International Exposition and received critical acclaim for its craft industries, ranked eighteenth out of thirty-one participating nations. This was seen as very encouraging for a newcomer.

In 1877 the first of five domestic exhibitions of the Meiji era was held at Ueno, Tokyo. The basket maker Shōkosai I (1815–97) won the prestigious Phoenix Prize at the exhibition and his basket was bought by the Meiji empress. This was thought to be one of the first instances of modern Imperial patronage of Japanese traditional crafts. Over the next few decades the Imperial family and the Imperial Household Ministry (Kunaisho) began to collect Japanese crafts and to commission artists to decorate spaces used by the Imperial family and their guests, also for formal state occasions. In 1890 Imperial patronage developed a step further with the establishment of the title 'Artist to the Imperial Household' (*teishitsu gigei'in*). The ceramic artist Seifū Yōhei III (1851–1914, cat. no. 117) was among a group of artists appointed to this prestigious title.

The first Bunten exhibition, a Salon-like national showcase for the fine arts, was staged in 1907 under the auspices of the Ministry of Education. Over the course of the twentieth century this major exhibition would go through many changes of name and organization. However, art crafts were not included in the Bunten exhibitions. Craft artists could only exhibit at an exhibition called the Nōten, the 'Concours Exhibition of Design and Applied Arts', which was sponsored by the Ministry of Agriculture, Commerce and Industry. After the sixth Nōten exhibition the title changed to the Ministry of Agriculture and Commerce Crafts Exhibition. Then in 1925 the Ministry of Agriculture and Commerce became two separate government divisions: the Ministry of Agriculture and Forestry, and the Ministry of Commerce and Industry. The Nōten exhibition's name was then changed to the Shōkōten or Ministry of Commerce and Industry Crafts Exhibition. Reorganization also occurred with the government's official art exhibition: in 1919 the Bunten was reorganized at the Teiten exhibition or Imperial Art Exhibition (*Teikoku bijutsu tenrankai*). Significantly in 1927 the eighth Teiten exhibition finally established a craft division – The Fourth Section. The inclusion of a craft section stimulated general interest and production and craft began to be viewed as a legitimate means of artistic self-expression, something that only rarely happened before in its history. Innovation and individuality were openly encouraged.

Immediately after World War II, in 1946, the Teiten exhibition's name was changed to the Nitten. The first exhibition in its new form was held that year and continues to be held to the present day. The Nitten's annual exhibition continues to include art crafts. The examples selected for exhibition stress individual creative expression above other criteria. Artists from the Nitten do not, as a rule, show in the Japan Traditional Art Crafts Exhibition and vice versa. Certain craft families are even split, with one member showing in the Nitten, and another in the Japan Traditional Art Crafts Exhibition.

In the post-war period, craft artists have tended to fall into one of four general categories: traditional craft artists (members of the Japan Art Crafts Association); independent creative craft artists who exhibit at the Nitten exhibition; functional craft artists; and, finally, those who reject both functionality and decoration. From the 1980s onwards, the Japan Traditional Art Crafts Exhibition has gained considerable popularity with its ideal of beauty in function and its emphasis on technique and the use of traditional materials as the springboard for new creativity.[5]

The transmission of Japanese art crafts in traditional contexts

There are multiple systems for the transmission of techniques among the traditional art crafts currently practised in Japan. The enduring 'head of the household' (*iemoto*) hereditary system has held sway in many branches of the arts since medieval times. It was particularly prevalent during the Edo period (1600–1868), for example in officially recognized schools of painting, such as the Kano, and in the various traditions of

tea practice (*chanoyu*) that trace their lineages to a common ancestor Sen no Rikyū (1522–91).[6] In families that follow the traditional *iemoto* system, techniques along with the title of head of the workshop are passed directly down to the eldest son, or a designated heir. This is the case with a number of the artists represented in this exhibition, particularly in the field of ceramics.

Records of the techniques practised by government-designated artists are collected by the Agency for Cultural Affairs and stored at the Tokyo National Museum. Originally these were written documents and samples of techniques, along with finished works. More recently, techniques are filmed by the Agency for Cultural Affairs.

In the section that follows, three case studies demonstrate the different ways in which the transmission of a particular technique – here in ceramic and lacquer crafts – combines with the artist's own personal history in the development of their individual style. Other methods of transmission may be sporadic or even esoteric (secret), such as from master to trusted pupil. The point of such a system of transmission is to protect knowledge of a technique. In metalwork or in ceramic, for example, knowledge concerning the colour of flames in the kiln is essential to the process of production. Experience is the essential ingredient for success in all art crafts.

Kutani ware ceramic artist Tokuda Yasokichi III

In 1953 the government designated Tokuda Yasokichi I (1873–1956) as the holder of an Intangible Cultural Property ('Living National Treasure') for his overglaze enamel decoration technique on Kutani ware. Yasokichi I was responsible for reviving the Kutani tradition of brightly decorated porcelain that had been famous since the Edo period (1600–1868) but had gone into decline in the subsequent Meiji era (1868–1912). Two years later Yasokichi I submitted panels with different colour glaze samples, tools, text of techniques and a large nine-lobed dish with cranes and pines in Kokutani ('old Kutani') style, now in the collection of the Tokyo National Museum. However, the designation system was altered in the following year, 1954, and he was temporarily declassified. Sadly, before he could be reclassified under the new system, Yasokichi I died on 20 February 1956. His grandson who had worked with him as

a youth, eventually followed his lead and became Tokuda Yasokichi III, who was designated a Living National Treasure in 1997 (cat. no. 22, fig. 3).

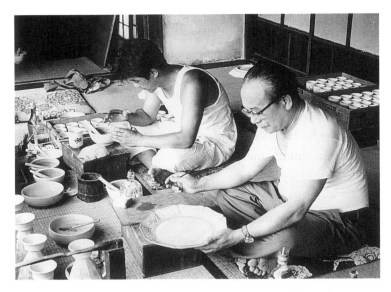

Fig. 3 Tokuda Yasokichi II and III [22] decorating Kutani porcelain in their workshop in Komatsu, Ishikawa prefecture. 1959. Photograph courtesy of Tokuda Yasokichi III

Yasokichi III recalls that in the summer of 1955 his grandfather had suffered a miled stroke and was unable to climb to the upper floor of their house where he had a laboratory for preparing coloured glazes. Yasokichi I asked his grandson to prepare the glazes for him, and would hand him pieces of paper on which he had written down the recipes for the specific glaze colours for which he was so famous. On these occasions he told his grandson: 'Treasure these colours as they'll earn your bread. Don't share them with anyone, not even with your father.' Six months later Yasokichi I died, leaving fifteen or so of the recipes for his grandson. This kind of secret transmission of techniques to a designated heir was also typically practised in porcelain production during the Edo period (1600–1868), as is shown by the example of Nabeshima wares. The overglaze enamel technique was introduced to Japan in the 1640s from China. Samurai lords of the Nabeshima family and their retainers went to great lengths to guard their version of the technique and prevent it from leaving the immediate vicinity of the production sites, keeping the

potters virtual prisoners at the official domain kiln at Ōkawachi (modern Imari city) during the period from the late 1600s until the early 1800s.

Yasokichi III has written that ten days after his grandfather's death, while praying at the family's altar, he realized that his grandfather had actually written many more recipes for glaze colouring in a code composed of characters similar to the ones used in the Buddhist sutras that were tucked away in the altar.[7] Yasokichi I had earlier advised his grandson to use code when writing down numbers for glazes, and he even showed him how to devise such a code. Yasokichi III was thus able to decipher his grandfather's recipes and ended up also giving them to his father. He feels Yasokichi I used code because he did not want other, non-designated ceramicists to make works that resembled his own after his death. In the Yasokichi I transmission story a test was created to see if the grandson would be able to decipher the information and so be worthy of inheriting the techniques. This is similar to many traditional stories of the transmission of knowledge in Buddhist temples. Fig. 3 illustrates young Yasokichi III working alongside his father Yasokichi II (1907–97), decorating Kutani porcelain in their workshop in 1959.

Yasokichi III continues to use the colouring typical of traditional Kutani wares of the Edo period, exploiting his grandfather's recipes, but he has developed a completely new contemporary style. He invented new processes of refining the ceramic body before firing and a new style of colour glazing, where the glassine colours themselves become the pattern. He polishes the body of the ceramic for many hours before firing until it is completely smooth, and then applies traditionally mixed colours in finely gradated bands. The work is then fired at a high temperature, higher than was traditionally used, which allows the glaze to fully mature and the colours to turn into a vibrant spectrum of light. The process is laborious and Yasokichi III works with up to ten people who he has personally trained over the last thirty years to keep his workshop running. Yasokichi III is in his mid-seventies and is still very active, constantly producing new works and exhibiting them worldwide.

Hizen ware ceramic artists Imaizumi Imaemon XIII and Sakaida Kakiemon XIV

Imaizumi Imaemon XIII (1926–2001) and Saikada Kakiemon XIV (b. 1934) were both born in the vicinity of Arita town, Saga prefecture. This is where the Hizen tradition of porcelain production and their lineages began and where their families and kilns are still based. It was at Arita in the 1610s that porcelain stone was first discovered and the first Japanese porcelains fired. The nascent industry was strongly fostered by the local Nabeshima samurai lords, closely regulated from 1637 onwards to encourage production and protect techniques from being copied by potential competitors.

Imaizumi's family traces its ancestry tentatively back to the Korean peninsula in the late 1500s, and certainly to the early porcelain-producing area of Arita and nearby Ōkawachi in the early 1600s. The family worked at the regulated domain kiln. Imaemon XIII was especially creative and while continuing the tradition of overglaze enamelling in the Nabeshima style, he developed his own original techniques which greatly revitalized the ware – a perfect illustration of continuity with change. Imaemon XIII breathed new life into the designs that he painted onto the porcelain bodies. He travelled throughout Japan to visit all kinds of art-craft production areas, not necessarily those related to ceramics. He was particularly interested in an early technique for decorating porcelain called *fukizumi* (literally 'blown ink'), where blue cobalt oxide was blown from a bamboo pipe onto the porcelain body to achieve a splashed effect. In Kyoto he met the *yūzen* textile artist Moriguchi Kakō (cat. no. 33), and they discussed the techniques used in textiles to achieve similar effects. Imaizumi returned to Arita, utilizing what he had been taught by Moriguchi to create his famous signature grey 'blown ink' *usuzumi* ground (actually uranium oxide). For his mastery of the overglaze-enamel technique he was awarded Living National Treasure status in 1989. Imaemon XIII has been succeeded by his second son, Imaizumi Imaemon XIV (b. 1963). Imaemon XIV graduated from Musashino Art University and is well versed in both traditional styles and new ceramic art. He has shown promising results in works that not only focus on the style of the overglaze design, but which also create interplay between the design and the vessel shape, in a fresh manner that sits well with the traditional Nabeshima

idiom. He currently runs the Imaemon workshop in Arita, is Director of the adjacent Imaemon Museum of Ceramic Art, and crafts his own signature pieces.

A document kept in the Kakiemon family archive (*Kakiemon monjo*) records that Sakaida Kizaemon (1596–1666) is thought to have taken or been given the name Kakiemon in honour of the bright-red colour of the overglaze enamel used to decorate porcelain he is said to have developed, that resembled the colour of the *kaki* (persimmon). The document also records that Kakiemon learnt the overglaze-enamel technique of decorating porcelain (*aka-e*, literally 'red painting') from a visiting Chinese merchant in the Nagasaki area and successfully repeated the process himself on Hizen porcelain in 1647. The present-day Kakiemon XIV still supervises a climbing kiln and the production of bright overglaze colours on white porcelain surfaces, similar to those made by his ancestors (fig. 4).

The Kakiemon workshop and climbing kiln received government-listed status in 1971 for the preservation of the overglaze-enamelling technique, and Sakaida Kakiemon XIV was personally designated a Living National Treasure in 2001 for his mastery of the technique. In addition to creating his own signature pieces, Kakiemon XIV runs an active workshop, which makes beautifully decorated ceramics for everyday use. He also researches the history of porcelain in Arita and the Kakiemon style of export wares. In that role he is currently the honorary chair of the government-designated Center of Excellence (COE) programme at the Kakiemon-style Ceramic Art Research Center at Kyushu Sangyō University, Fukuoka. His current work successfully combines his family's historical traditions with his own personal exploration of the Kakiemon style.

Lacquer artists Matsuda Gonroku, Murose Kazumi and Ōnishi Isao

Matsuda Gonroku (cat. no. 63) is the recognized modern master in the medium of lacquer. His career, spanning the twentieth century, provides the perfect perspective from which to view lacquer-art production in the modern era. Born in Kanazawa city in 1896, an area already famous during the Edo period for its Kaga *maki-e* – the application of gold foil to lacquer – Matsuda further continued that tradition. After this regional apprenticeship, however, he went on to study at the Tokyo School of Fine Arts (now Tokyo National University of Fine Arts and Music), graduating in 1919. There he was influenced by the ideas of the art theorist and educator Okakura Tenshin (1862–1913), although the two men apparently never met. More importantly, perhaps, he was introduced to a variety of different lacquer techniques and approaches; also to Chinese and Korean works. He became close at that time to the Director of the school, Masaki Naohiko (1862–1940), and to the famous industrialist collector Masuda Takashi (Donnō, 1848–1938). These friendships proved vital, suggesting new opportunities and giving him access to important historic lacquer works that were in private hands. All this served to advance his work in lacquer.

Matsuda's works exemplify the very discernible twentieth-century tendency to root artistic expression in past idioms, particularly of the Nara through Momoyama periods (about AD 700–1600). In part, this has reflected a desire to refresh native Japanese expression. However, the tendency has taken as its particular starting point two particularly cosmopolitan eras, the 700s and the late 1500s to early 1600s – periods when Japan was most actively engaged in international commerce and exchange. Another factor was that early in the 1900s

Fig. 4 Sakaida Kakiemon XIV [20] working in his studio in Arita, Saga prefecture.2005. Photograph by Yamasaki Shinichi

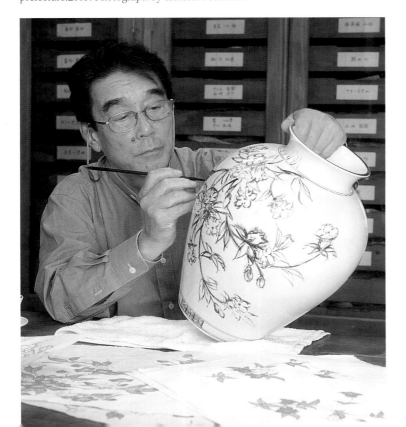

government, academics, artists, restorers and collectors all began to take interest in historic art patronage and to protect and preserve historical collections. For example, the famous Shōsōin treasure house of the AD 700s at Tōdaiji temple, Nara was opened first to artists and then, if only briefly and periodically, to the public. The collection was inventoried and certain works restored.

Matsuda himself participated in two major restoration projects. The first of these, in the early 1920s, related to a Chinese Han-period burial mound at Lelang, Pyongannam-do, in northern Korea.[8] The other comprised the restoration in 1962, partly at his own expense, of the Konjikidō hall at Chūsonji temple, Hiraizumi, the ancient power centre of the northern Fujiwara family in the AD 900s. Matsuda coined quite early in his youth a personal motto that was to sustain him throughout his career: 'Learn from people, learn from things, learn from nature' (*ningen ni manabu, mono ni manabu, shizen ni manabu*). The motto epitomizes his open attitude to acquiring knowledge from a wide variety of sources, traditional and modern.

Matsuda was particularly inquiring in his early years and took advantage of several opportunities that related to the use of lacquer in architectural settings. One of his first such experiences was to assist the design of a special room for the Imperial regalia on the new Imperial train, built for the accession of the Shōwa emperor in 1927. Soon afterwards he designed special rooms on two luxury ocean liners commissioned for sailings to Europe. In 1928 he worked on the interior of the residence of the Iwasaki family, who were wealthy industrialists. Matsuda travelled briefly to Europe in 1933, but decided after his return to focus his style in native aesthetics. Unfortunately, most of the buildings and ships were destroyed in World War II, as was Matsuda's own home in Ikebukuro, Tokyo.

After the war Matsuda's career followed an upward artistic trajectory, with ample official recognition awarded by the government. In 1947 he was made a member of the prestigious Japan Art Academy. In 1955, the first year of the government's reorganization of the designation system, he was made a holder of an Important Intangible Cultural Property (i.e., a Living National Treasure) for his 'sprinkled picture decoration'

(*maki-e*) lacquer technique. He was recognized again by the government as a Person of Cultural Merit in 1963, and in 1976 he received the very prestigious Order of Cultural Merit, which includes a stipend for life. In the post-war period, with the exception of the restoration work at Chūsonji temple, Matsuda concentrated on teaching and creating lacquer objects; some for actual use, some for display. His exquisite sense of style and use of precious materials reward the attentive viewer. A thorough knowledge of Japanese art history has clearly informed his work, and his style perfectly reflects the general trend in Japanese craft, mentioned above, of using past period styles as a fertile source for reinterpretation with a modern sensibility.

Another lacquer artist, Murose Kazumi (b. 1950, cat. no. 73), grew up working closely with his father in Ikebukuro, Tokyo, creating wares using a variety of methods but centred on the 'sprinkled picture' (*maki-e*) technique. Fig. 8 shows lacquer works by him displayed as they would be used for dining. Murose's father was a student of Matsuda Gonroku and Murose himself spent time in his youth listening to and watching Matsuda working with lacquer. Murose also graduated from Tokyo National University of Fine Arts and Music, in 1974, and started showing at the Japan Traditional Art Crafts Exhibition almost immediately. Based in Tokyo, he currently divides his time between creating lacquer works, repairing older pieces and studying lacquer history and techniques. Murose observes that many techniques are not passed on verbally from teacher to apprentice or from father to son. Rather, they are experienced. Sitting next to his father over a period of many years, working together and observing, he has found that he, too, knows instinctively what to do and how to do it.

Ōnishi Isao (b. 1944, cat. no. 74), on the other hand, comes from an entirely different style of lacquer making, with a different philosophy (fig. 5). Self-taught, he creates wonderfully perfect, large lacquer dishes and bowls using the 'hoop built core' (*magewa-zukuri*) technique of bending strips of wood into rings and fitting them tightly together. In his studio in Ibaraki prefecture, Ōnishi works on his own, making everything by himself, including all of his tools and work surfaces. He alone works from start to finish on all of his lacquer pieces.

Various methods for the transmission of crafting skills have

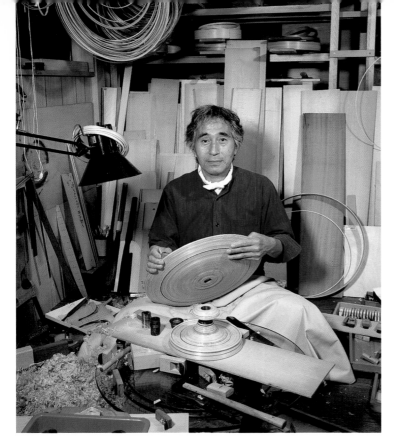

Fig. 5 Ōnishi Isao [74] working at his studio in Chikusei, Ibaraki prefecture. 2006. Photograph by Tsutsumi Katsuo

The Crafts Gallery at the National Museum of Modern Art, Tokyo has been at the forefront of educating the public about craft in Japan and its various manifestations. One interesting initiative that has caught the public's imagination is their 'Touch & Talk' series that is held regularly in both the Japanese and English languages. Before a general talk there is the opportunity for participants to take a closer look at works by famous artists and to see first hand the materials and techniques used. The Japan Art Crafts Association, to celebrate their fiftieth anniversary in 2004, created a comprehensive listing and explanation of Japanese art crafts on their website, in both the Japanese and English languages, in order to reach out to a wider international audience of particularly the younger generation.[10] Art crafts have much enhanced significance in their various social contexts, in addition to their beauty as objects and as the manifestation of an artist's skill, as will be further discussed below.

Craft as performance

It may appear that the life of a craft object ends with the final phase of its production at the artist's studio, workshop or kiln. In many cases, however, a craftwork is made to be put to use imaginatively in performance, or in assemblages, which extend the creative process further and even serve to redefine the meaning of the piece itself. Such performances might include a whisked tea (*matcha*) or steeped tea (*sencha*) gathering, or a flower-arranging event.

There is an ancient belief in Japan, which dates back at least to the AD 200s, the end of the Yayoi period, that spirits dwell in trees. Trees and branches (especially pine) and floral arrangements are, to some today, still potentially a place where spirits might reside. With the introduction of Buddhism in the AD 500s, the practice arose of offering flowers (*kuge*) to the Buddha, which continues to the present day. 'Flower guessing' (*hana-awase*) contests were common by the 1300s among the nobility. And by the 1400s, flower arrangement (*ikebana*) emerged as a codified art form.[11] Initially intended for formal settings, flowers were arranged simply by being inserted vertically (*tate-bana*) in vases of either Chinese celadon porcelain or bronze, and these vases would in turn be placed onto lacquer dishes. The style of architecture of this time, *shoin*

been discussed above, illustrated by the life experiences of several artists. Transmission, preservation and development have many more dimensions. There has for some time been a movement in Japan to record and educate the general public about the many techniques and the crafts themselves, to build an audience for the wares that will help sustain Japanese art crafts in the future. Various public, academic and privately funded groups are active in recording art-craft techniques, and many regional initiatives have been recently undertaken. There is a sense of urgency to this overall project as it is generally felt that traditional art crafts are endangered by the onslaught of cheaper mass-produced wares from the global marketplace. While the web and international markets can bring advantages in addition to the challenges, it is certain that without continued effort to sustain traditional techniques, many will cease to exist in the near future. To give just one important example: there are currently only twenty sap-gatherers (*kakiko*) for lacquer production working in Japan nationwide. It is estimated that over ninety per cent of the liquid lacquer used to produce finished lacquer products in Japan today is sourced from China.[9]

zukuri, incorporated an alcove (*tokonoma*) where artwork such as hanging-scroll paintings and vases with flowers could be placed (fig. 7). In informal settings a more relaxed style of flower arranging developed, called *nageiri-bana* (literally, 'thrown-in flowers'), with the stems arranged as naturally as possible. Flowers for both styles of arrangement would be selected on the basis of the season, their colour and smell, and how they would harmonize with the rest of the décor of the room.

With the supremacy of the warrior class and the enhanced importance of impressive formal display in the 1500s, flower arrangement took on grander forms and a new style called *rikka* came to the fore. The magnificent *rikka* style of arranging emerged in Kyoto, then spread to Osaka and, later, Edo (modern Tokyo), along with the fashion for gatherings to prepare and serve whisked tea. The *rikka* style required the use of many flowers, which were artfully arranged in the vase in formal composition. Painted and printed manuals for this style were devised. The more informal *nagaire* style of flower composition became popular with the merchant class and it too was formalized by the 1600s into the *seika* ('living flower') style. During the Edo period (1600–1868) this technique was also much appreciated by scholars and aficionados of 'steeped tea' (*sencha*, fig. 7). From the 1600s onwards all styles of flower arrangement tended to use bamboo baskets – originally from China, later made in Japan. Modern bamboo baskets for flowers are included in this catalogue (cat. nos 92, 93, 99, 100). It is rewarding to visualize flowers in these baskets, but it should also be understood that many contemporary artists create their works primarily as sculptural forms that are not necessarily intended to be functional.

The custom of drinking tea has a venerable history in Japan that stretches back to the AD 700s. At first it was simply boiled. Formal tea gatherings (*chanoyu*, literally 'boiling water for tea'), that continue in many styles today, began in the 1400s in the courts of the imperial family and ruling Ashikaga military family, centred in the Higashiyama district of Kyoto. The original focus of such events was the display of rare (often Chinese) objects, accompanied by poetry recital, music and other arts. This was also the occasion for drinking whisked tea. After the civil wars that racked Kyoto in the later 1400s, the

practices of formal tea drinking were further refined by Murata Jukō (1422–1502) and Takeno Jōō (1502–55). Imbued with Zen teachings brought from China, the serving of whisked tea became more sober in style. It was now predicated on the principle of various unities: unity of the participants; unity of the group of tea utensils; and unities of spirit, season and place for that brief interlude in time. Tea customs were further developed by the most famous tea master Sen no Rikyū (1521–91), who created a more personalized style of tea, one that focused on the moment: each guest and each meeting were treated as singularly important, for that moment could never be recreated.

The utensils used for the serving of whisked tea are of the utmost importance in creating the mood, harmonizing the group of participants and displaying the host's taste. Tea bowls made of stoneware hold pride of place in the proceedings, such as the one that artist Suzuki Osamu created and is holding in his hands (cat. no. 30, fig. 6; see also cat. nos 7, 21 and 26 for other bowls used for whisked tea). It is important to imagine the frothy bright-green tea inside the creamy-white glazed bowl that Suzuki holds. Enjoying the contrast between the thick green tea and the soft feldspathic glaze of the bowl is an aesthetic moment central to the tea experience. Once the tea has been drunk, the bowl is turned in the hands and admired, even turned over to examine and comment on its footring. So

Fig. 6 Suzuki Osamu [30] with a teabowl made by himself, at his house in Tajimi, Gifu prefecture. 2006. Photograph by Tsutsumi Katsuo

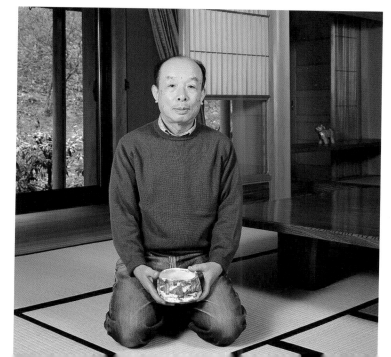

the humble footring, otherwise unseen in daily life, becomes a vital element of the bowl's overall aesthetic. This is nowhere more the case than with Miwa Jusetsu's 'rugged Hagi' (*oni-Hagi*) bowl, with its highly exaggerated footring (cat. no. 21).

Other utensils essential for whisked tea gatherings include cast-iron kettles, with their deliberately induced patinas (cat. nos 77, 80) and water jars (*mizusashi*) used for storing water to replenish the kettle, made from ceramic, lacquer and metal (cat. nos 6, 62, 65, 83, 88, 89). Proud of its long history and traditions, the world of tea continues to exert a strong influence on art-craft production today, and continues to have a very significant presence among the works displayed at the annual Japan Traditional Art Crafts Exhibition.

Gatherings for steeped tea (*sencha*) developed at a later period in Japan, introduced from Ming China in the early 1600s. The basic

the liquid into small cups made of porcelain. Okakura Tenshin, in his famous *Book of Tea* (1906), explains:

> The Cake tea which was boiled, the Powdered tea which was whipped and the Leaf-tea which was steeped, mark the distinctive emotional impulses of the Tang, Sung, and the Ming dynasties of China. If we were inclined to borrow the much-abused terminology of art-classification, we might designate them respectively, the Classic, the Romantic and the Naturalistic schools of tea.[13]

Steeped tea spread particularly in the 1700s, in the Kansai area around the cities of Osaka and Kyoto, where it was taken up by scholars interested in Chinese learning, and has continued to be popular until the present day. The utensils normally imitate Chinese examples. Bamboo is one of the materials of choice, not only for flower vases but also for stands.

Fig. 7 Hayakawa Shōkosai V [99] and Ogawa Koraku enjoying steeped tea (*sencha*) at Ogawa's house in Kyoto. 2006. Flowers are arranged in Hayakawa's basket, shown in the display alcove. Photograph by Kuwabara Eibun

philosophy followed was the Taoist one of living in harmony with nature.[12] Whisked tea involved pouring boiling water directly onto the powdered tea in the bottom of the bowl and whisking it into a froth. In contrast, steeped tea required hot water to be poured over tea leaves in a teapot, allowing them to steep and then pouring

Fig. 8 Lacquer wares by Murose Kazumi [73] filled with food prepared by Asami Kenji. 2007. Photograph by Ōhori Kazuhiko

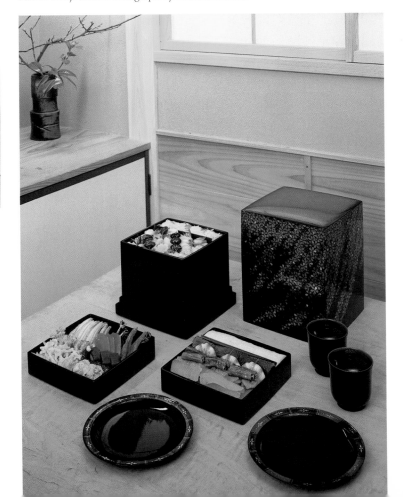

At tea gatherings, either whisked or steeped, the drinking of the beverage is only one part. The overall success of the event depends on the utensils combined, the guests invited and atmosphere created. It is a performance in which the objects play an integral role, not so much individually but as an ensemble. Special food is prepared to harmonize with the utensils, and the season, type of event and ingredients are all factors kept carefully in mind. Fig. 8 shows lacquer wares made by artist Murose Kazumi (cat. no. 73) filled with food appropriate for winter. Colour, texture, taste, fragrance and surroundings combine to make the experience a sensory delight.

Doll art

The range of expression in art crafts is by its very nature diverse. When we include all possible modern interpretations and hybrid forms, classification becomes even more challenging. To establish guidelines, the Japan Art Crafts Association recognizes all the main categories that are represented in this catalogue: ceramics, textiles, lacquer, metal, wood and bamboo, dolls and glass with other materials, such as gemwork.

The inclusion of dolls deserves further comment as it is an important yet little-analysed field of craft production outside Japan. The Crafts Gallery at the National Museum of Modern Art, Tokyo held a major exhibition of doll art in 2003, which attracted large audiences, particularly from among the younger generation.[14] Dolls mean many different things to different people. In Japan there is an impressive range of types, from different historical periods: prehistoric Jōmon figurines called *dogū*; medieval *hina* paper dolls used for protection or for purification; decorative dolls (cat. no. 123) used in the Dolls Festival (*hina matsuri*) held on 3 March every year to celebrate Girls Day; contemporary animated doll figurines and robots.

Hori Ryūjo (1897–1984, cat. no. 104) wrote a book in 1956 about her feelings when creating dolls, entitled *Dolls have Hearts* (*Ningyō ni kokoro ga ari*).[15] She highlighted the meaning of dolls as objects of affection. Some Japanese see them as magical, others as surrogates for humans, but what is certain is that everyone has a different personal experience with dolls, one that that is quite unlike any other art form, and indeed quite different from reactions to sculpture.[16] Dolls are particularly challenging for craft artists as they utilize a number

of different materials. Imai Yōko quotes Kawakami Nampo (1898–1980), who wrote in 1935 about dolls being exhibited at the Teiten (New Imperial Academy Exhibition):

> A doll is created using many complex materials and process. Many separate effects must achieve an internal unity of expression in the whole, in materials and methods. It is the synthesis of a wooden base, the coating with *gofun* (powdered shell), the colors, the clothing, that makes a doll different from a wooden carving…Compared to wood carving, doll making is architectural, making effective use of each of many materials. It is an art synthesizing painting and carving.[17]

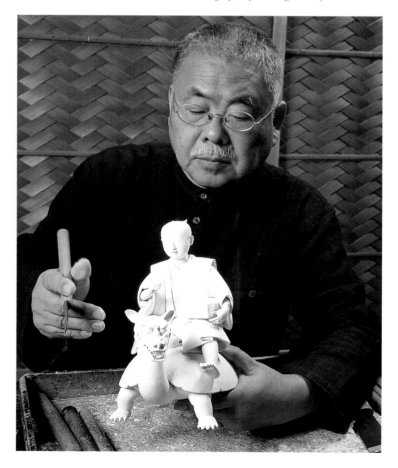

Fig. 9 Hayashi Komao [106] working on a doll at his studio in Kyoto. 2005. He has finished the core and already applied powdered shell (*gofun*) to make the surface texture even. It is at this point that he paints the features and adds the textiles to make the doll come alive. Photograph by Kumagai Takeji

Future possibilities

The future will undoubtedly present many exciting challenges for art crafts in Japan. It is a country where traditionally many groups have had differing definitions of what is craft, what is art and what defines tradition, and this diversity has surely been a sign of health. The fundamental vibrancy of art crafts in Japan is palpable. The Crafts Gallery at the National Museum of Modern Art, Tokyo, under the leadership of Kaneko Kenji, has in recent years staged a series of exhibitions that demonstrates this broad-ranging diversity, successfully addressing different audiences and proving that a single unified definition is not necessary for future survival. Just recently, in 2006–7, a large exhibition at the Crafts Gallery about the lacquer artist Matsuda Gonroku was staged at the same time as one about Yanagi Sōri, the famous designer and son of the philosopher Yanagi Muneyoshi (1889–1961), who first founded the Mingei (Folk Crafts) movement together with Bernard Leach and Hamada Shōji, was shown in the main building.

In 2006 the Crafts Gallery, collaborating under Kaneko's guidance with the Hagi Uragami Museum organized a fascinating exhibition of the work of Miwa Jusetsu (b. 1910, cat. no. 21).[18] Jusetsu was known as Kyūsetsu XI from 1967 onwards until he passed the Kyūsetsu title to his eldest son in 2003 and took the name Jusetsu. Born in Hagi, at the western end of the main island of Honshū, the historically important centre for the production of Hagi-ware ceramics, Jusetsu worked hard with his elder brother Kyūwa (Kyūsetsu X, 1895–1981, cat. no. 6) to revive the tradition and was eventually made a Living National Treasure in 1970, at the age of seventy-three. At the age of ninety-six he still makes ceramics, albeit on a more limited scale.

The Hagi-ware ceramic tradition is said to have begun with a Korean potter named Ri Shakukō, who shortly after 1604 built a kiln at Matsumoto Abuchō (modern Hagi city) at the request of the Mōri samurai lord.[19] Hagi ware was known throughout the Edo period from its straw ash glaze, distinctive body and Korean influence. The ware had gone into eclipse in the twentieth century, however, but the brothers worked hard to revive it. It was only in the post-war period that Jusetsu, having worked for over twenty-eight years at the pottery, had his first exhibition. From this point onwards he began to emphasize form over function, while still using traditional materials. After being designated a Living National Treasure, he focused his energies on teabowls, and developing his famous 'rugged Hagi' (oni-Hagi, literally 'demon Hagi') style. The bowls became larger and partially deformed. He added local grit to the clay to give it a rougher texture that occasionally made his hands bleed as he potted each piece. He further developed a technique that makes the glaze texture ripple and not adhere to certain parts of the surface by painting slip made of local clay on areas around the rim. But most of Jusetsu's energies are focused on the foot of each bowl. The footring is exaggerated, enlarged and articulated, giving it a life of its own. In tea gatherings as described above, foot rings would typically be examined as part of the ceremony, but Jusetsu has taken this phenomenon to an extreme. Ishizaki Yasuyuki writes that with his signature notched footring, Jusetsu is pushing the limits of expression, directing the work toward a sculptural form.[20]

Fig. 10 Sculptural work by ceramic artist Miwa Kazuhiko. 2003. National Museum of Modern Art, Tokyo. Photograph by Tanaka Gakuji

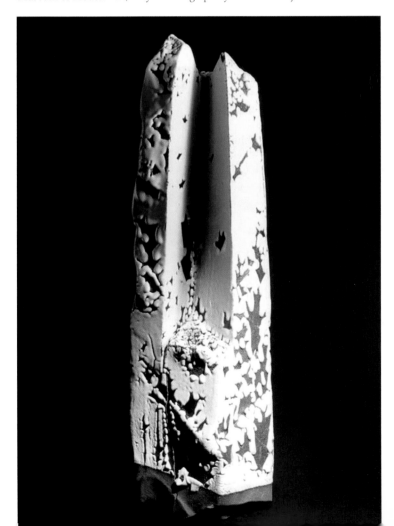

Jusetsu's genius is to utilize local traditional materials and methods, but to create a vehicle for his own expression. Essentially, the process is important to the outcome. He is involved in all aspects of production that combine to make the work a success: selection of the types of local clay and materials; individual deformations and painting on of slip and dipping of glaze; individual placement of each work in the kiln for a certain effect. It is the combination of these processes that allows him to achieve the expression he searches for in his bowls.

Jusetsu lives with his third son Miwa Kazuhiko (b. 1951) and his family and they all work closely together. While the oldest son has received the mantle of the Kyūsetsu name, the third son is free to explore his own individual creativity and has made a number of sculptural works that, while based on traditional techniques and glazes developed by his family, depart from the functional and enter the realm of sculpture. That such diversity of expression can be tolerated and even encouraged in a traditional regional craft area such as Hagi clearly illustrates multiple possibilities for the future of art crafts in Japan.

Notes

The author would like to thank the following who have assisted with illustrations for this essay: Asami Kenji, Higashi Mariko (The Asahi Shimbun), Moriguchi Kunihiko, Murose Kazumi, Ōhori Kazuhiko, Yamada Kyōko (The Asahi Shimbun).

1. http://www.ihbc.org.uk/UNESCO/intangible_assets.html
2. The catalogues are published online on the Japan Art Crafts Association website: http://www.nihon-kogeikai.com. Their mission statement is also published on their website in English as follows: The 'Nihon Kōgeikai intends to preserve the intangible cultural assets and train successors, conforming to the spirit of the law, by promoting further relations between artists and technologists to train the technique, making a profound study of traditional art crafts, as well as preserving and applying it to be improved, so that we would contribute to the improvement of culture. To popularize Japanese traditional art crafts, we hold some annual exhibitions by every branch office and section as well as by the head office under joint sponsorship. We also give a study workshop in training successors of Japanese traditional art crafts supported by a state subsidy.'
3. Rupert Faulkner, *Japanese Studio Crafts* (London: Laurence King and V&A, 1995), pp. 13–14.
4. *Nihon dentō kōgeiten no ayumi* (Tokyo: Hōshin shuppansha, 1994), pp. 286, 291.
5. Kaneko Kenji, *Gendai tōgei no zōkei shikō* [Rethinking Contemporary Art Ceramics] (Tokyo: Abe Shuppan, 2001), and Kaneko Kenji, 'Studio Craft and Craftical Formation', in Paul Greenhalgh (ed.), *The Persistence of Craft* (London: A & C Black, 2002), pp. 28–36.
6. For an introduction to the *iemoto* system see John Rosenfield (ed.), *Competition and Collaboration: Hereditary Schools in Japanese Culture*, (Boston: Isabella Stewart Gardiner Museum, 1993). See also Morgan Pitelka's informative book, *Handmade Culture, Raku Potters, Patrons, and Tea Practioners in Japan* (Honolulu: University of Hawaii Press, 2005), which examines the *iemoto* system with regard to the world of tea practice and utensils.
7. *Shodai Tokuda Yasokichiten* [Tokuda Yasokichi I Exhibition]. Komatsu City: Komatsu City Museum, 2006, pp. 12–13, 164.
8. Shimasaki Susumu, 'The World of Gonroku Matsuda', in *Matsuda Gonroku no sekai* [The World of Matsuda Gonroku] (Kanazawa City: Ishikawa Prefectural Museum of Art, Tokyo National Museum of Modern Art, Crafts Gallery, and MOA, 2006), pp. 18–19.
9. Tsukada Kyōko, 'We have Nurtured Trees since Time Immemorial to Get the Precious Drops', *Kateigaho International* (2007 Winter Edition), p. 39.
10. http://www.nihon-kogeikai.com/TEBIKI-E/2.html
11. MOA Museum of Art, Atami, *Ikebana bijutsu ten*, 1986.
12. Ogawa Kōraku, 'Sencha and Japanese Literati'. A lecture given at the conference *Beverages in Modern Japan and Their International Context, 1660–1920s*, sponsored by the Sainsbury Institute for the Study of Japanese Arts and Cultures at SOAS, London, 9 March 2001.
13. Quoted in Ogawa Kōraku, p. 2.
14. Kaneko Kenji and Imai Yōko (eds), *Contemporary Dolls: Formative Art of Human Sentiment* (Tokyo: The Crafts Gallery, The National Museum of Modern Art, Tokyo, 2003).
15. Hori Ryūjo, *Ningyō ni kokoro ga ari* (Tokyo: Bungei Shunjū Shinsha, 1956).
16. Imai Yōko, 'The Doll: Vessels of Pathos'. In Kaneko Kenji and Imai Yōko (eds), *Contemporary Dolls: Formative Art of Human Sentiment* (Tokyo: The Crafts Gallery, The National Museum of Modern Art, Tokyo, 2003), pp. 12–16.
17. Ibid., p.13.
18. The Crafts Gallery, The National Museum of Modern Art, Tokyo, and Hagi Uragami Museum (eds), *Jusetsu Miwa: A Retrospective* (Tokyo: The Crafts Gallery, the National Museum of Modern Art, Tokyo, 2006).
19. Ibid., p. 258.
20. Ibid., p. 259.

The Japan Traditional Art Crafts Exhibition: Its History and Spirit

Uchiyama Takeo

The 'Japan Traditional Art Crafts Exhibition' (*Nihon dentō kōgei ten*) – a well-known annual event in Japan – held its fiftieth show in the autumn of 2003. The first exhibition was held in the spring of 1954 at the main branch of the Mitsukoshi department store in Tokyo and was organized by the Cultural Property Preservation Committee and the Cultural Properties Foundation. Its full title was 'Japan Traditional Art Crafts Exhibition, Embodying Intangible Cultural Properties'. The Committee had been founded as an external organ of the Ministry of Education in August 1950 to implement the Law for the Protection of Cultural Properties promulgated in May of that same year. When the Agency for Cultural Affairs was later launched in 1968, the Committee became part of the Agency as its Department of Cultural Property Protection (now called the Department of Cultural Properties). The involvement of the Committee in the organization of the exhibition thus shows that the origins of the exhibition were closely connected with the Law for the Protection of Cultural Properties.

After its defeat in the Asia-Pacific war in 1945, Japan declared that it was going to contribute to the international community in terms of culture, not power. In reality, however, people were having a hard time just feeding themselves and it was feared that the dire financial and social situation might lead to a loss of much traditional heritage. Then, in January 1949, disaster actually struck: a fire destroyed the ancient, eighth-century wall paintings of the Main Hall of Hōryūji temple, near Nara. This made people acutely aware of the need for better protection of cultural properties, and the Law for the Protection of Cultural Properties was duly established in 1950. The tangible cultural properties to be protected were architecture, painting, sculpture, crafts and calligraphy, as well as other precious national assets such as historical sites, scenic sites and special plants and animals. In addition, certain intangible cultural properties were also protected: theatrical arts, music, craft techniques and others. Holders of these intangible cultural properties have come to be known popularly as 'Living National Treasures' (*ningen kokuhō*). The selection of the craft techniques to be given protection was made by the Cultural Property Preservation Committee. In Chapter 4 of the Law, which concerns Intangible Cultural Properties, there is this clause: 'Of the Intangible Cultural Properties, those that are especially valuable and are in danger of dying out without the government's protection are to be helped by ensuring that the holder of the property receives subsidy, supplies, or other forms of support.' The phrasing reflects the hard financial circumstances of the time. But it should also be noted that those craft techniques which were not a risk were not to be helped, however valuable they were.

In March 1952 the Committee selected Shino stoneware made by Arakawa Toyozō (1894–1985; fig. 11) and thirty-five other craft techniques to be given protection. In November of that year, Nabeshima porcelain with overglaze enamels (*iro*

Fig. 11 Arakawa Toyozō [7] taking a fired stoneware teabowl from the kiln. 1965. Photograph by Domon Ken

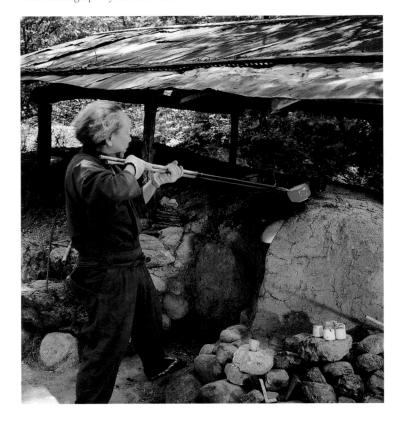

Nabeshima), made by Imaizumi Imaemon XII (1897–1975), and one other technique were added to the list.

The Law for the Protection of Cultural Properties emphasized that these cultural properties should also be made available to the public. The Cultural Property Preservation Committee was granted a budget for their public presentation in the fiscal year 1952, and this enabled the exhibition 'Craft Techniques Selected as Intangible Cultural Properties' to be held at the Hyōkei Hall of the Tokyo National Museum in March of the following year. This small show was the forerunner of the 'Japan Traditional Art Crafts Exhibition, Embodying Intangible Cultural Properties' held in March 1954 at Mitsukoshi department store.

In the case of the first Japan Traditional Art Crafts Exhibition, Embodying Intangible Cultural Properties, only artists and groups who had been designated as the holders of Intangible Cultural Properties were invited to participate. In May of the same year, however, the law was modified. New regulations were brought in for the designation of important Intangible Cultural Properties in response to the opinion that it was unfair that craft techniques not in danger of disappearance should be excluded from consideration. After this modification, the previous selections were nullified and, based on the new regulations, a first group of new selections was made in February 1955, and a second in May of the same year. The new guidelines for selection emphasized artistic value, importance in craft history, and local tradition. The title of holder of an Intangible Cultural Property was given either to an individual (individual designation), or to representative members of a group (group designation) in cases where the same technique was practised by a number of individuals without significant difference in style.

In the first selection, eighteen artists representing fourteen techniques were given individual designations. In the second, seven individual designations and one group designation were made. The techniques and artists chosen were:

Ceramics
Iron glaze stoneware – Ishiguro Munemaro
Shino stoneware, black Seto stoneware – Arakawa Toyozō
Folk Craft (Mingei) ceramic – Hamada Shōji

Porcelain with overglaze enamels – Tomimoto Kenkichi

Textiles
Edo 'fine pattern' (*komon*) – Komiya Kōsuke
'Middle size' stencil dyeing (*nagaita chūgata*) – Shimizu Kōtarō, Matsubara Sadakichi
Yūzen dyeing – Ueno Tameji, Kimura Uzan, Tabata Kihachi, Nakamura Katsuma
True indigo dyeing (*shō aizome*) – Chiba Ayano

Lacquer ware
'Sprinkled picture decoration' (*maki-e*) – Matsuda Gonroku, Takano Shōzan
Carved lacquer (*chōshitsu*) – Otomaru Kōdō
Incised and gold-filled decoration (*chinkin*) – Mae Taihō

Metal craft
Gong making (*dora*) – Uozumi Iraku I
Metal chasing (*chōkin*) – Unno Kiyoshi

Dolls
Costume dolls – Hirata Gōyō II, Hori Ryūjo

Included in this selection were Hamada Shōji (1894–1978), Tomimoto Kenkichi (1886–1963), Kimura Uzan (1891–1977), Matsuda Gonroku (1896–1986), Takano Shōzan (1889–1976), and Mae Taihō (1890–1977), who had all been regular participants in the mainstream government-sponsored Teiten-Shin Bunten-Nitten exhibitions (see also p.15). This reflected the fact that, as the result of the revision to the law, artistic merit was given more weight, in addition to technical excellence.

The Law for the Protection of Cultural Properties, promulgated in 1950, made craftspeople in various parts of Japan more aware of these issues, and regional craft associations started to be formed in 1951. Following the first Japan Traditional Art Crafts Exhibition, Embodying Intangible Cultural Properties in 1954, the proposal was made to combine the various regional craft associations into a national organization. In March 1955 the Committee for the Founding of the Japan Traditional Art Crafts Association met and agreed

to name the new organization 'Nihon Kōgei Kai' (Japan Art Crafts Association). In June of that year, the association was given the legal status of an 'incorporated association' (*shadan hōjin*), and in July it was formally established.

The rules of the association required a full member to be a good practitioner of the spirit of traditional Japanese crafts and dedicated to studying and mastering its techniques. In addition, they should have one of the following qualifications:

(1) An individual who has exceptional skills in a traditional craft

(2) An individual who has exceptional creative power and skill that are based on traditional craft techniques

(3) An individual who is particularly dedicated to studying and mastering traditional craft techniques and also has exceptional talent

At its founding the association had forty-seven full members:

Ceramics – 13 members
Arakawa Toyozō, Ishiguro Munemaro, Imaizumi Imaemon XII, Uno Sōtarō, Katō Tōkurō, Katō Hajime, Kaneshige Tōyō, Kawase Chikushun, Sakaida Kakiemon XIII, Tokuda Yasokichi I, Tomimoto Kenkichi, Nakazato Tarōemon XII, Hamada Shōji

Textiles – 10 members
Ueno Tameji, Kimura Uzan, Komiya Kōsuke, Shimizu Kōtarō, Serizawa Keisuke, Tabata Kihachi, Chiba Ayano, Nakamura Katsuma, Matsubara Sadakichi, Yamada Eiichi

Lacquer ware, wood and bamboo craft – 8 members
Isoi Joshin, Inaki Higashisenri, Iizuka Rōkansai, Otomaru Kōdō, Kiuchi Shōko, Takano Shōzan, Matsuda Gonroku, Mae Taihō

Metal craft – 9 members
Ishida Eiichi, Itō Tokutarō, Unno Kiyoshi, Uozumi Iraku I, Katori Masahiko, Kashima Ikkoku, Takahashi Sadatsugu, Kōsaka Yūsui, Naitō Shunji

Dolls – 5 members
Okamoto Shōtarō, Kagoshima Juzō, Noguchi Mitsuhiko, Hirata Gōyō II, Hori Ryūjo

Cloisonné – 2 members
Ōta Ryōtarō, Hayakawa Giichi

The inauguration ceremony for the association was held in August 1955, and branches were established in the Kantō, Tōhoku, Hokkaidō and Kinki regions. In the October of that year, the second Japan Traditional Art Crafts Exhibition was jointly organized by the association and the Cultural Property Preservation Committee under new principles. The first exhibition had simply presented the traditional craft techniques selected as Intangible Cultural Properties. In the second exhibition, however, the focus was on the artistic merit of the craft works. The show presented 164 works by three categories of craft artists: holders of Intangible Cultural Properties, full members of the Japan Art Crafts Association, and members of the association's branches. Among the holders, Ishiguro Munemaro (1893–1968) submitted no fewer than ten works.

The association's first Board Director, the Nihonga painter Nishizawa Tekiho (1889–1965), contributed an essay entitled 'On the Founding of the Japan Art Crafts Association' for the first issue of its journal *Nihon kōgei* (*Japan Crafts*), published 1 October 1955. In this essay he expressed his sympathy with the two great missions of the association:

The Japan Art Crafts Association [should make] works firmly based in the special character of the Japanese people, with roots in tradition, and which add a new breath of fresh air of the period in a good way. Only a Japanese and no person from another country can make these many different kinds of craft work. [They should be] unique works based on strong beliefs that are not easily swayed by the fashions of the day. The fundamental aim should be to get the world to recognize the spiritual core of Japanese crafts. This has great meaning and hope for me and has become the fundamental reason to get more and more involved.

There was another factor that has motivated me. This was the desire to discover and foster the wisdom that has been handed down in the rural areas and from that to discover and preserve the many and unique craft skills that continue from the past in our country. This seemed to me a very good aim.

Nishizawa also wrote the postscript for the catalogue of the second exhibition, which included these observations:

It is well known that Japanese crafts are lately attracting much attention abroad, and the fundamental reason they appeal to foreigners is because of their expressive qualities that are unique to the Japanese aesthetic sensibility.

It is of course important to keep up with the latest trends and newly invented materials in order to produce utensils and ornaments that are suitable for contemporary lifestyles, but artists should not get disconnected from the special qualities of Japanese crafts in their efforts to emulate new Western styles.

Members of this association should have an especially strong awareness for Japanese traditions, and should produce works that combine the exceptional techniques and processes which are unique to Japanese crafts with new, innovative elements. I believe that taking this approach will be the most effective way for Japanese crafts to win respect in the arena of world craft art.

This association is not about being hidebound by the word 'tradition', nor simply worshipping the culture of the past. Our foremost goal is to promote works that make the best of both Japanese traditions and elements learned from foreign countries.

In this sense the mission of this association is very significant and I feel that the responsibilities on us will be unusually heavy in the future. I ask everyone working in this field for continuing and ever greater support. There are many other groups of splendid craft artists in Japan, and each of them is ardently working towards its respective goal. Our association would like to contribute to the craft community by concentrating on winning recognition for Japanese crafts in foreign countries.

In these passages, Nishizawa summarized the role of the exhibition in the field of craft art: to encourage craft artists to take pride in the exceptional craft traditions of Japan and to create works fit for contemporary society based on this heritage; also to make Japanese crafts known in the wider world and to win them recognition. In the postscript quoted above, we can recognize the shift in principle that was made in response to the criticism of the first exhibition that, despite their technical excellence, the works included tended to be outdated in style and irrelevant to contemporary aesthetics or lifestyles.

The qualifications for participants to the third exhibition in 1956 were:
(1) An individual designated as a holder of an Intangible Cultural Property
(2) A full member of the Japan Art Crafts Association or a member of one of the association's branches
(3) An artist or craftsperson recommended by a board member or more than one full member of the Japan Art Crafts Association

For the second exhibition, screening by craft artists and scholarly specialists was introduced. From the third exhibition, only works by artists of categories (2) and (3) above were required to go through screening. As for works by the holders of Intangible Cultural Properties and exhibition judges, previously these had been included either unconditionally or by the decision of a selection committee. From 1956 onwards, however, they were required to undergo second-level screening like all other works. Thus the basic rules for screening were established by this year.

In 1958 a major dispute arose in the world of craft art. As mentioned above, many of the artists designated as holders of Intangible Cultural Properties in 1955 were also regular participants in the annual government-sponsored Nitten exhibitions. In 1957, at a meeting of the House of Representatives' Committee on Education, it was pointed out that, when selecting new members for the prestigious Japan Art Academy (Nihon Geijutsuin), the closeness of the Academy and the Nitten was producing unfair results. In response to this criticism, the Academy decided to completely withdraw from the running of the Nitten exhibition, and to entrust it from 1958 to a non-governmental incorporated body, the Nitten Association. This was the beginning of the so-called Shin Nitten, or 'new' Nitten. Following this decision, some members of the crafts section formed a group called the Fourth Section Association and submitted a written petition.

In the petition, they stated that, with the launch of the Shin Nitten, it was naturally expected that it would be run fairly and correctly. In reality, however, two distinct and contradictory groups of participants existed in the crafts section. The first group was composed of holders of Intangible Cultural Properties and other followers of the Japan Art Crafts Association, an organization that conflicted in its basic principles with the Nitten. The second group was made up of Nitten members who wished to promote the development of their own exhibition. They asserted that for the future preservation of the Nitten exhibition, it was crucial to remove this inner contradiction. Therefore they requested the Nitten Association to forbid those who were members of groups opposed to the basic principles of the Nitten from being given executive positions. They also requested that when establishing the management of the Nitten Association, executive officers should be selected widely from the membership, in a democratic manner.

In response, officers and advisors of the Nitten exhibition who were also members of the Japan Art Crafts Association presented a written statement saying that the above petition was mistaken in describing the Japan Art Crafts Association as a group that was opposed to the Nitten. It was an injustice to denounce them in this way, in light of the extensive contributions they had made to the government exhibitions ever since Section Four, the crafts section, was added in 1927 to the eighth Teiten exhibition, forerunner of the Nitten. They warned that if the demands of the Fourth Section Association were taken up at the inauguration of the Shin Nitten, it would do great harm to the development of craft art in Japan, with results that would be much regretted later.

This warning was ignored, however, and none of the former Nitten advisors who were also members of the Japan Art Crafts Association was included in the board of councillors of the Shin Nitten when the list was published in April 1958. Seeing this, seven former advisors, including Katori Masahiko (1899–1988), left the Nitten, along with more than twenty judges and Matsuda Gonroku (cat. no. 63), who was a trustee.

This incident can be regarded as the final clash between old and new groups inside the Nitten, but it also made clearer the character of the Japan Art Crafts Association. For the fifth exhibition in 1958, the word 'tradition' was omitted from the exhibition title. This can be understood partly as a proud declaration, after the struggle with the 'new faction' in the Nitten, that it was their exhibition which better represented Japanese crafts. But there were other factors at work as well. There had been a period following the war when there was a general rejection of all things traditional; there was even a movement to abolish altogether traditional Japanese-style painting, Nihonga. Yet this movement subsided and Nihonga painters came to realize that they could still explore new directions building on a basis of tradition. Nevertheless, there were still many among the younger generation of craftspeople who were not favourably inclined towards the connotations of the word 'tradition'.

Then in the following year, 1959, for the sixth exhibition, the word 'tradition' was put back into the title, which has remained unchanged ever since. No explanation was given for this change in the catalogue, except for the following passage in the 'Purpose of the exhibition':

Keeping tradition alive does not mean simply mastering the old techniques and adhering to them. Tradition is living and always in flux, like the principle of haiku poetry which was defined by the great Matsuo Bashō (1644–94) as 'continuity and change' (*fueki ryūkō*). In other words, true tradition has a fundamental essence that does not change over time, and yet like flowing water it does not stop for a single instant.

These statements seem to have been made in order to emphasize the significance of 'tradition' in its truest sense. The passage continued:

We believe that it is our noble duty today to put into practice the spirit of the Law for the Protection of Cultural Properties and to master and improve on the traditional craft techniques inherited from our forefathers, while at the same time creating craft art that is suitable for today's lifestyles and thereby building a new tradition.

This 'purpose' reflects a willingness to listen to criticism and also the strong desire for a new creativity in crafts.

For the seventh exhibition of 1960, the regulations concerning participants were abolished and the exhibition became an open public competition. The guidelines from that year have this simple line concerning qualifications: 'To participate in this exhibition, one should be a craft artist.' When the Japan Art Crafts Association was originally founded, craftspeople and artists were separately defined by the following qualification rules for full membership: (1) an individual who has exceptional skills in a form of traditional craft; and (2) an individual who produces creatively original and skilled works that are based on traditional craft techniques. This differentiation was ended, and all were now 'artists'. Works which were outstanding in technique but poor in creative originality continued to be submitted to the exhibition, and were causing problems of how to deal with them. They did not meet the artistic standards, but were technically good enough to be considered embodiments of techniques that deserved protection. A proposal was made to screen and show such works in a different category, but it was not adopted. Concerning works entered in the exhibition, the guidelines specified that they should be: (1) appropriate to the purpose of the exhibition; (2) made by the participants themselves; (3) produced within the past five years; and (4) previously unpublished. It was forbidden to submit works created by others. This is now accepted as a standard requirement in competitions, but has not always been the case: shortly after the much-awaited opening of the crafts section in the Teiten exhibition of 1927, it was pointed out that some people were showing pieces made by others, ignoring the regulation that required the submitted work to be the participant's own creation. At the time, there were the opinions that the creator's identity did not matter as long as the submitted work was good enough, or that in the field of crafts, a work supervised by an artist should be considered his work. It is true that traditionally crafts have been produced in Japan with different craftspeople working on each part or process, and in some forms of craft it is still impossible for a single artist to do everything himself. Yet, in principle, a work of craft entered for the exhibition is required to be made by the artist alone from design through execution. The situation is similar to the case of the so-called Creative Print (Sōsaku Hanga) movement of the Taishō era

(1912–26) in which the print as an artwork was expected to be designed, carved and printed by the artist himself.

The Japan Traditional Art Crafts Exhibition grew in size and prestige year by year to become a major arena of activity for the holders of Intangible Cultural Properties, Nitten members, Mingei (Folk Crafts) artists, members of Tomimoto Kenkichi's Shinshō Kōgeikai group, and many other formerly anonymous craft artists. In the second exhibition, Isoi Joshin (1883–1964), who was a regular participant in the Teiten-Shin Bunten-Nitten exhibitions, received the Cultural Property Preservation Committee Chairman's award for the lacquer technique of incised and colour-filled decoration (kinma) – traditional to Takamatsu in Kagawa prefecture – and was designated a holder of an Intangible Cultural Property in the following year for that technique. Sakaida Kakiemon XII (1878–1963) of Arita won the Japan Art Crafts Association award and gained wide recognition for his restoration of the milky-white porcelain body (nigoshide) dating from the mid-Edo period. Moriguchi Kakō (b. 1909), who produced kimono in the Kyoto yūzen dyeing technique (Kyō yūzen) with bold designs that could be

Fig. 12 Textile artist Shimura Fukumi [34] outside her studio at Sagano, Kyoto. 1999. Photograph by The Asahi Shimbun Company (Kobayashi Osamu)

called 'contemporary Rinpa' in style, received the Asahi Shimbun award. Moriguchi won another award in the third exhibition, and served from the fourth as a judge and a leader in the textile section. He is one of the many artists who established their careers through the exhibition.

The exhibition came to receive wide attention for many reasons. There was the presence of award-winning veteran artists such as Sasaki Shōdō, Nagano Tesshi, Kakutani Ikkei, and Masuda Mitsuo, who were known from the days of the Shin Bunten exhibition. Also impressive were the activities in ceramics of Shimizu Uichi, Okabe Mineo and Tamura Kōichi; in textiles of Shimura Fukumi, Ogura Kensuke, Suzuta Teruji and Matsubara Toshio; and in lacquerware of Ōba Shōgyo, Masumura Mashiki, Himi Kōdō and Akaji Yūsai. Furthermore

Fi.g. 13 Lacquerware artist Ōba Shōgyo [64] working at his house in Kanazawa, Ishikawa prefecture. 2006. Photograph by Tsutsumi Katsuo

there was a renewed appreciation for traditional arts resulting from growing social stability and economic growth. Probably encouraged by this supportive climate, the passage about being ready to listen to criticism and to change principles that had been adopted for the seventh exhibition's 'Purpose', mentioned above, was completely dropped for the eighth exhibition. It was replaced by a brief statement about the significance of 'tradition' and 'traditional crafts' and about the craft artist's duty

to refine even further techniques handed down from their forefathers and to apply them in creating new works that fill the needs of contemporary society. These same phrases are still used for the exhibition today.

Of the holders of the Intangible Cultural Properties, Matsubara Sadakichi died in 1955, followed by Sasaki Shōdō and Komita Kōsuke in 1961, Tomimoto Kenkichi and Inagaki Toshijirō in 1963, and Isoi Joshin in 1964. Their artistic beliefs and techniques were inherited by successors and pupils, but works with distinctive Mingei (Folk Crafts) and Shinshō-group styles, found in significant numbers in the early years of the exhibition, were gradually subsumed among pieces in more traditional styles.

None of the full members of the Japan Art Crafts Association from the time of its founding survives today, and the artists who first won recognition in the early exhibitions are now the oldest generation. Their pupils, who were born in the pre-war period and active as artists from the late 1960s, now lead the association. They are the third-generation members, and some fourth-generation artists are already producing respected work today. The Japan Traditional Art Crafts Exhibition now has a history of half a century and has contributed immensely to the development of craft art in Japan over these years. First of all, it has clarified the significance of 'tradition' and helped to define it for craft artists. Tradition is not simply 'preservation'. It is that element in creative art which does not change at its core but which changes constantly in its expression. The exhibition has also taught artists to keep contemporary lifestyles firmly in mind when creating their works. It has made another notable contribution by giving legitimacy to regional craft techniques and energetically promoting their development in a manner that is relevant to contemporary society. In the Edo period, regional craft techniques were created and fostered in many parts of Japan, and they were still continued during the Meiji era. But judged according to the Teiten exhibition's definition of 'art crafts' of 1927, they only had value in a local context and were not given their due exposure. The Japan Traditional Art Crafts Exhibition, however, has treated them as very significant craft techniques and helped them find new forms of contemporary expression.

Matsuda Gonroku, who was a native of Kanazawa in Ishikawa prefecture, and Otomaru Kōdō, who was from Takamatsu in Shikoku, played important roles in introducing trends and aesthetics prevalent in the major cities back to their hometowns. Other artists who stayed in their native districts, notably Isoi Joshin of Takamatsu and Mae Taihō of Wajima in Ishikawa prefecture, acted as inspiring teachers for the younger generation. The Japan Art Crafts Association currently has nine regional branches – Higashi Nihon, Tōkai, Kinki, Ishikawa, Toyama, Chūgoku, Yamaguchi, Shikoku and Seibu – and each is producing fine results by their energetic efforts.

The Japan Traditional Art Crafts Exhibition is also notable for its emphasis on technical excellence. For works which seek novelty through experiments in form, skilful execution has often been regarded as of secondary importance. In this exhibition, however, technique has always been considered an element integral to the work's artistic value. It has encouraged artists not only to use techniques learned directly from their teachers, but also to adopt from various periods in history other techniques more suitable to their own artistic goals and personal sensibilities and to study and improve on these. The application of such revived techniques has greatly widened the scope of modern craft art.

The Japan Traditional Art Crafts Exhibition, which represents crafts created with highly refined techniques worthy of the name 'Intangible Cultural Properties', has been one of the most significant influences in post-war Japanese craft art. Remaining true to its special character, it will surely continue to foster 'traditional crafts' in the next generation.

(This essay has been adapted from the version that first appeared in the catalogue *Waza no bi* [The Asahi Shimbun 2003]. We are grateful to Professor Uchiyama for his permission to re-publish it here.)

Fig. 14 Lacquer ware artist Isoi Masami [61] continues the traditions of his father Isoi Joshin in Takamatsu, Kagawa prefecture. He often derives motifs from his garden, where he grows more than ten different species of camellia tree. 2006. Photograph by Hōchi Hiroyuki

CATALOGUE

Ceramics

Textiles

Lacquer

Metal

Wood and Bamboo

Other Crafts

 Dolls

 Cut metal foil

 Glass

Craft Heritage

CERAMICS

The origins of Japanese ceramic craft stretch back into prehistory. Fragments recovered at the Odai Yamamoto site in Aomori prefecture have been radiocarbon-dated to about 16,500 years ago. The Neolithic period (12,500–300 BC) sustained rich earthenware-producing cultures, generally termed *Jōmon*, or 'cord marked', after the distinct rope-imprinted patterns found on many vessels.

In the AD 400s, stoneware technology (*sueki*, or Sue ware) was introduced from continental Asia. This high-fired technology brought significant, lasting changes to Japanese ceramic production. Intentionally glazed earthenware was produced in limited quantities during the Nara (710–794) and early Heian (794–1185) periods, in imitation of Chinese Tang-period 'three-coloured wares' (*sansai*). A current interpretation of this style can be seen in the work of Katō Takuo (cat. no. 18).

High-fired stoneware was often made without intentional glazing but nevertheless received spontaneous irregular coatings of ash-glaze during the firing process. Such wares became popular in the medieval to early modern periods in Bizen (modern Okayama and Hyōgo prefectures). Two modern interpretations are by Fujiwara Kei (cat. no. 9) and Isezaki Jun (cat. no. 28). In addition, a dish in this style by Kaneshige Tōyō (cat. no. 3) has a striking 'fire strands' (*hi-dasuki*) flame pattern, created in the kiln.

Surprisingly, painted underglaze decoration did not appear on ceramics produced in Japan until the later 1500s. One of the main centres was the Seto-Mino kilns (modern Aichi and Gifu prefectures). The pioneer Arakawa Toyozō (cat. no. 7) helped to revive Shino-type Mino wares in the modern era, both technically and through his historical studies.

The Mino-area kilns continued to be at the forefront of ceramic experimentation during the 1570s–1620s. Several other modern artists pay homage in their works to the expressive power of this key period: Suzuki Osamu (cat. no. 30), Okabe Mineo (cat. no. 8) and Katō Kōzō (cat. no. 26). Suzuki's and Katō's teabowls are perfect examples of form, function and decoration working together to enhance the pleasurable experience of a tea gathering.

Porcelain was first fired in the 1610s in the Saga domain in Hizen province, northern Kyushu. The wares produced there dominated the Japanese domestic and export market until the early 1800s. Hizen porcelains (also known as Arita or Imari ware) are still very significant, as seen in the works of Imaizumi Imaemon XIII (cat. no. 14) and Sakaida Kakiemon XIV (cat. no. 20).

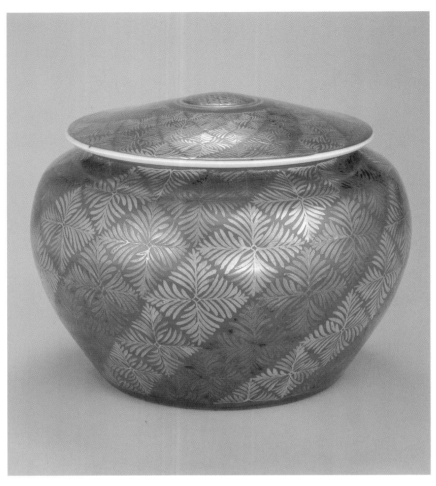

1
Covered jar with geometric pattern, 1953
Tomimoto Kenkichi (1886–1963)
Porcelain with overglaze enamels, gold and silver

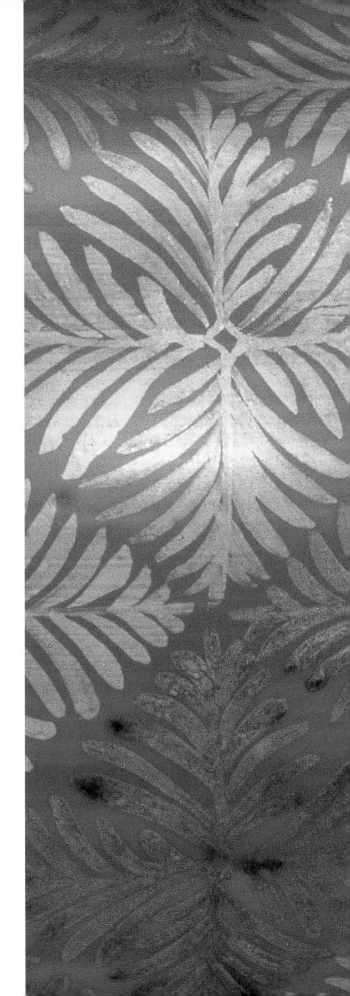

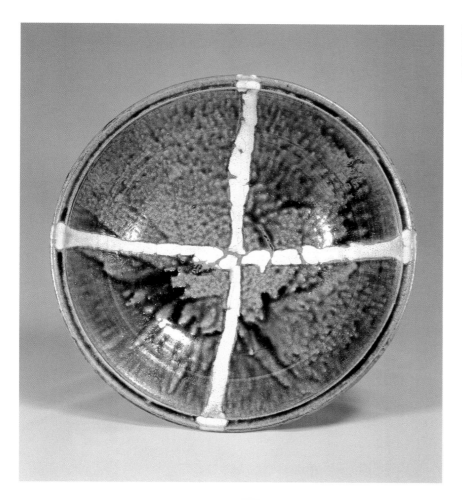

2
Large dish with cross design, 1955
Hamada Shōji (1894–1978)
Stoneware with slip and glaze

3
Large dish, 1957
Kaneshige Tōyō (1896–1967)
Stoneware, Bizen style

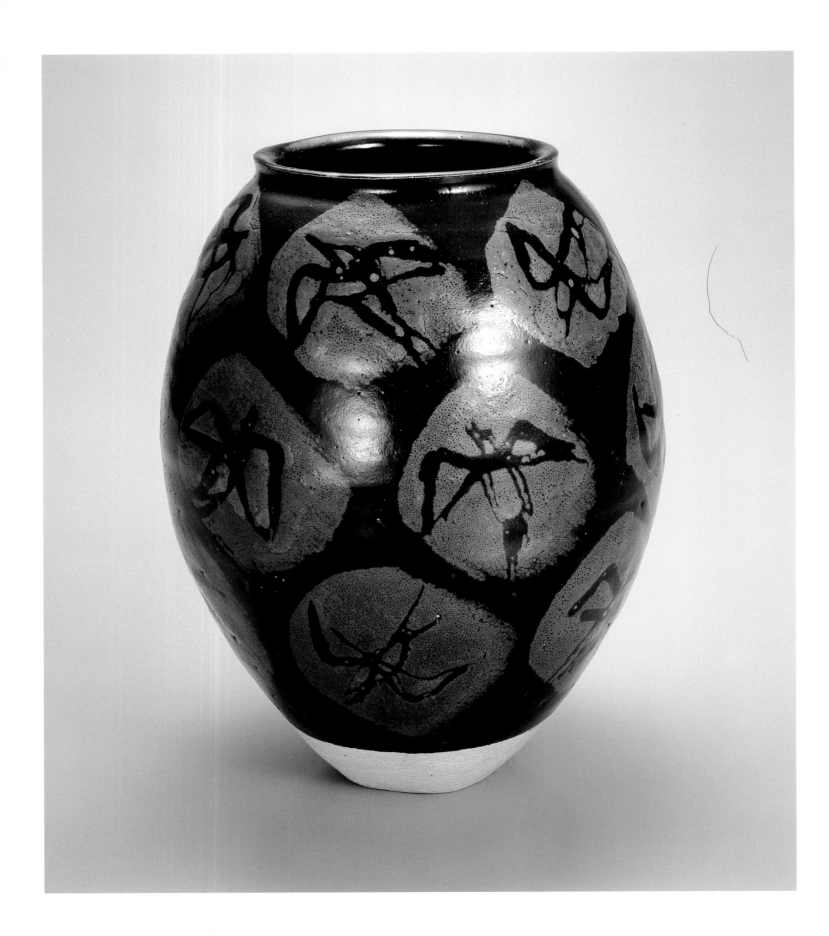

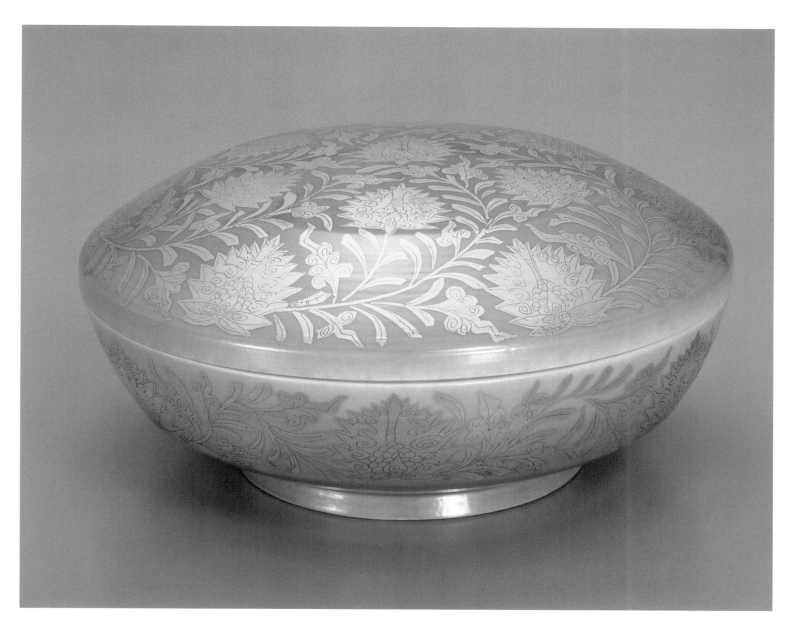

5
Lidded round container, 1958
Katō Hajime (1900–68)
Porcelain with yellow-green glaze and gold enamel

4
Jar with bird design, 1958
Ishiguro Munemaro (1893–1968)
Stoneware with black and brown iron-oxide
glazes

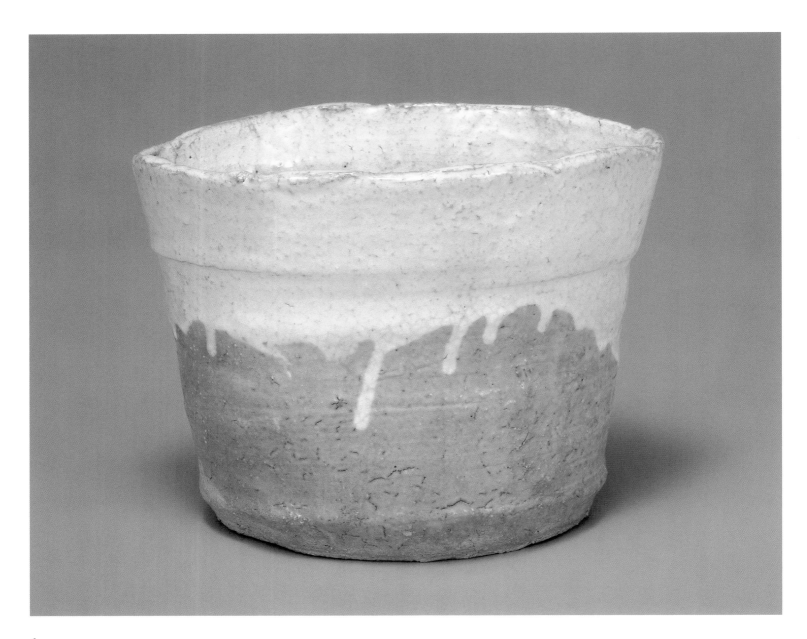

6
Water jar for tea gatherings, 1958
Miwa Kyūwa (1895–1981)
Stoneware, Hagi style

7
Teabowl, 1960
Arakawa Toyozō (1894–1985)
Stoneware with glaze, Shino style

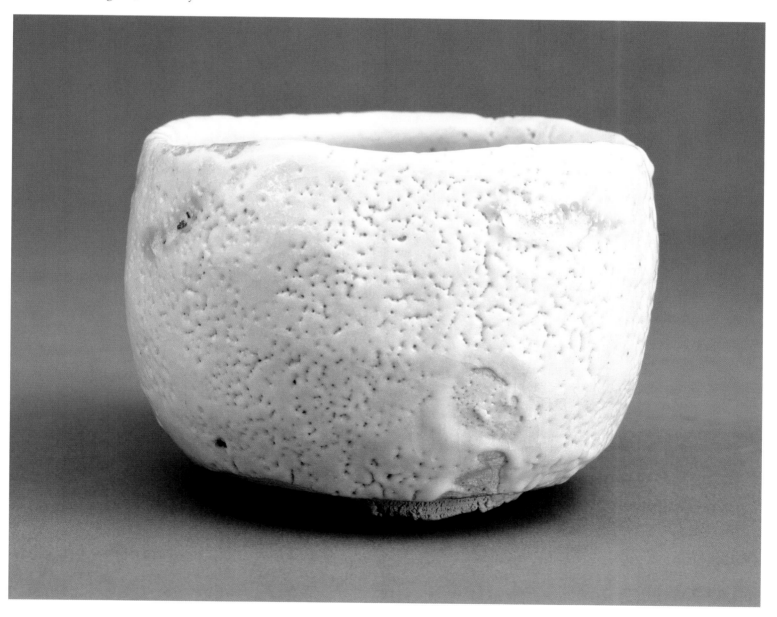

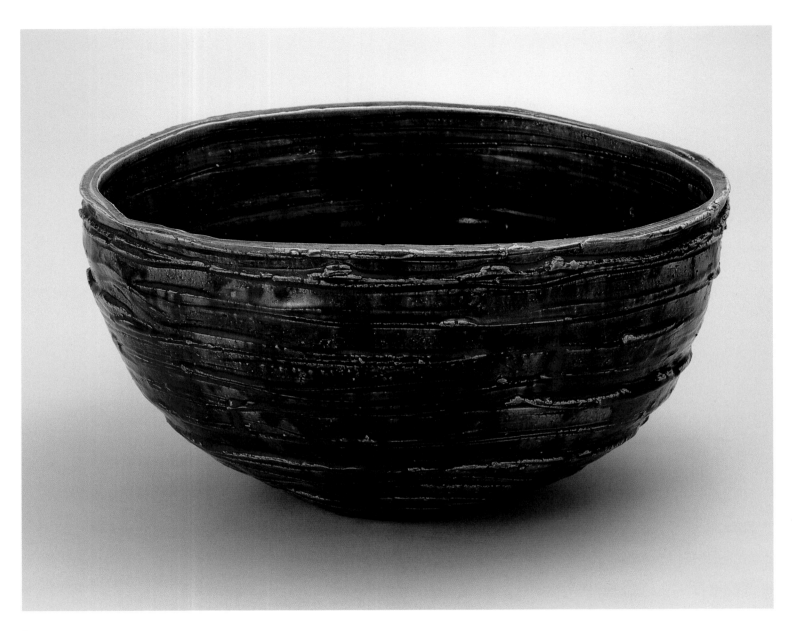

8
Large bowl, 1962
Okabe Mineo (1919–90)
Stoneware with copper-green glaze, Oribe style

9
Cylindrical vase, 1963
Fujiwara Kei (1899–1983)
Stoneware, Bizen style

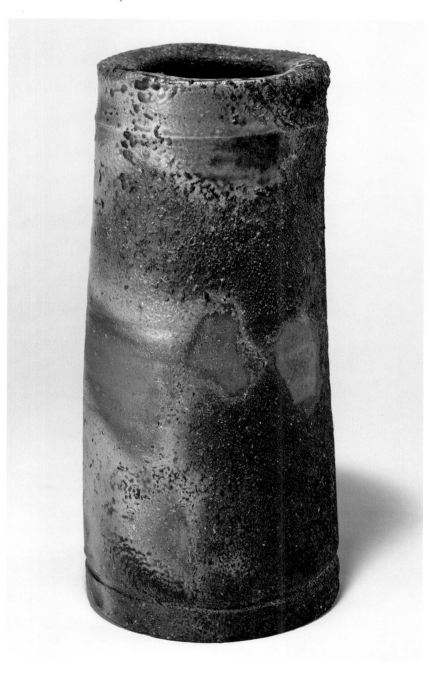

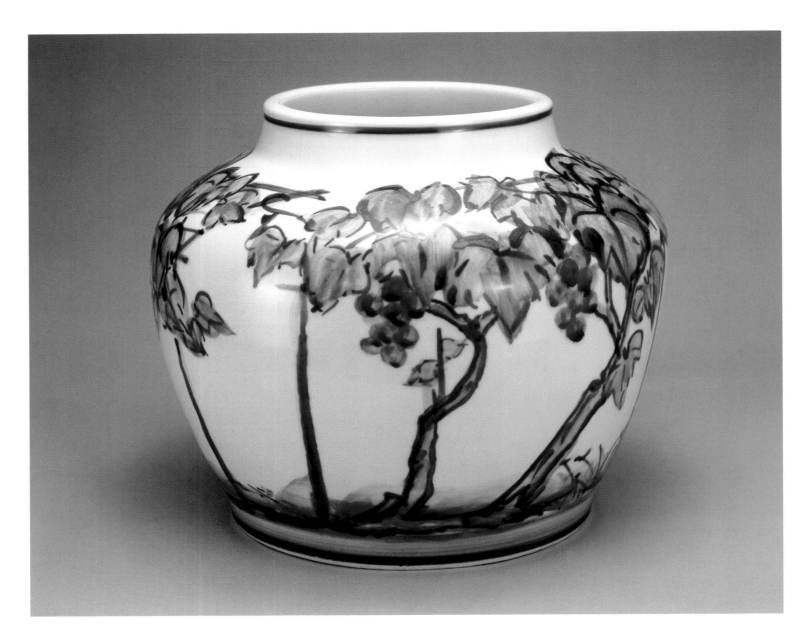

10
Jar with grapevine trellis design, 1964
Kondō Yūzō (1902–1985)
Porcelain with underglaze cobalt blue

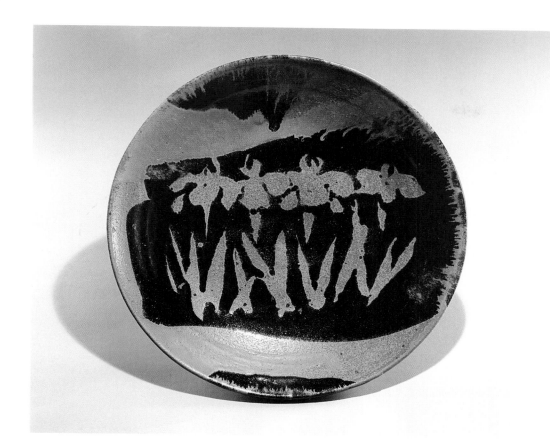

11
Large dish with iris design, 1965
Tamura Kōichi (1918–1987)
Stoneware with iron-oxide glaze

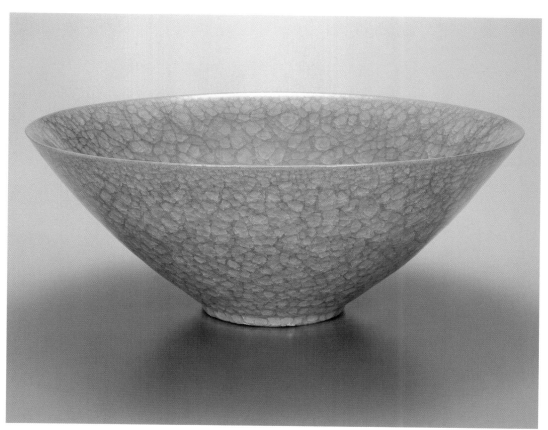

12
Large bowl with celadon glaze, 1973
Shimizu Uichi (1926–2004)
Stoneware with glaze

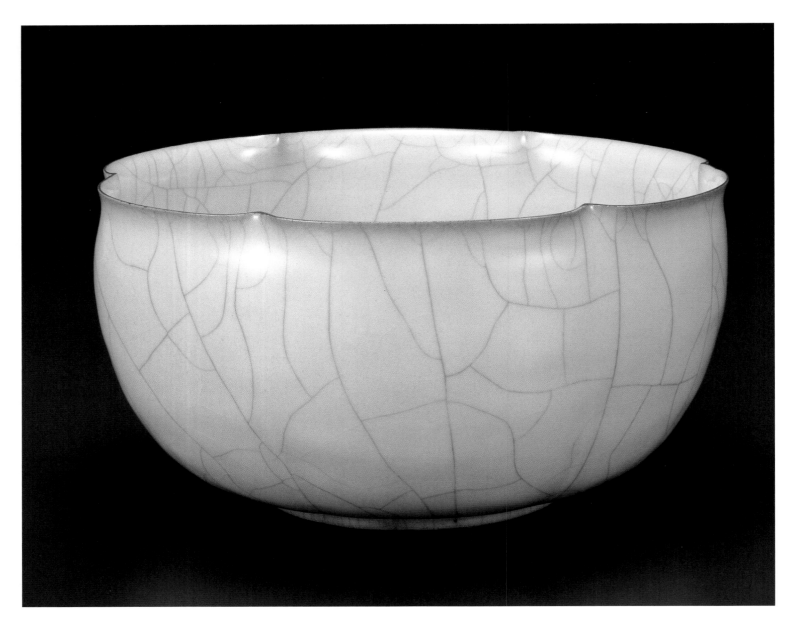

13
Large bowl with celadon glaze, 1976
Miura Koheiji (1933–2006)
Stoneware with glaze

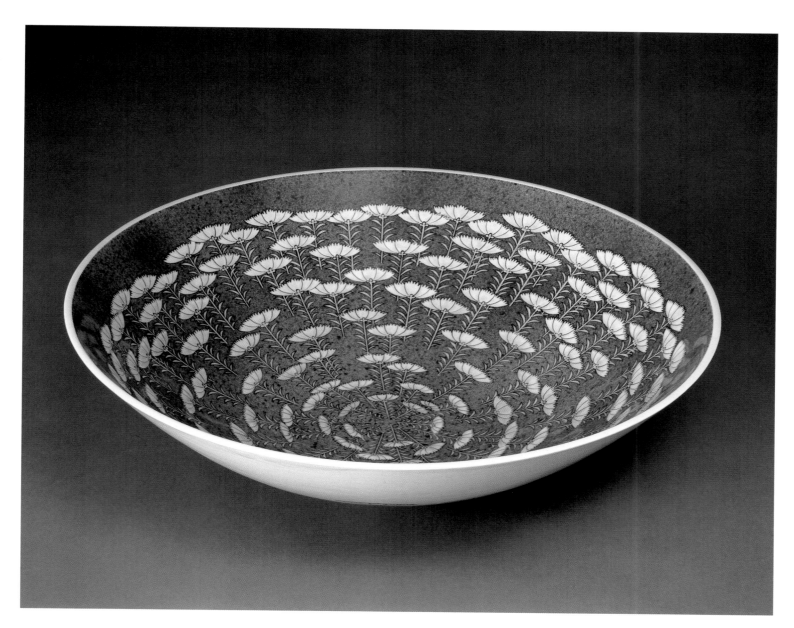

14
Bowl with floral design, 1978
Imaizumi Imaemon XIII (1926–2001)
Porcelain with underglaze uranium oxide
(*fukizumi*) and overglaze enamels,
Nabeshima style

15
Large vase with decorative fissures, 1979
Matsui Kōsei (1927–2003)
Stoneware with three-layered clay

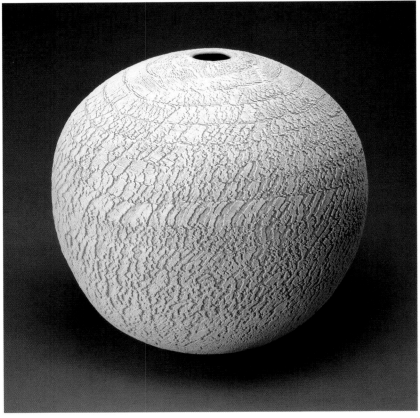

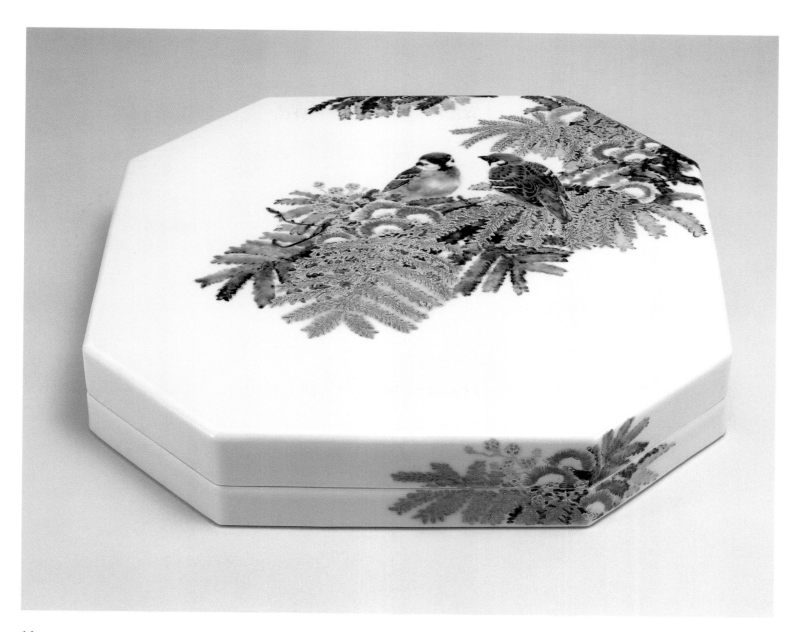

16
Lidded container with design of silk trees and sparrows, 1982
Fujimoto Yoshimichi (1919–92)
Porcelain with overglaze enamels and silver

17
Large dish, 1983
Tsukamoto Kaiji (1912–90)
Porcelain with underglaze cobalt blue

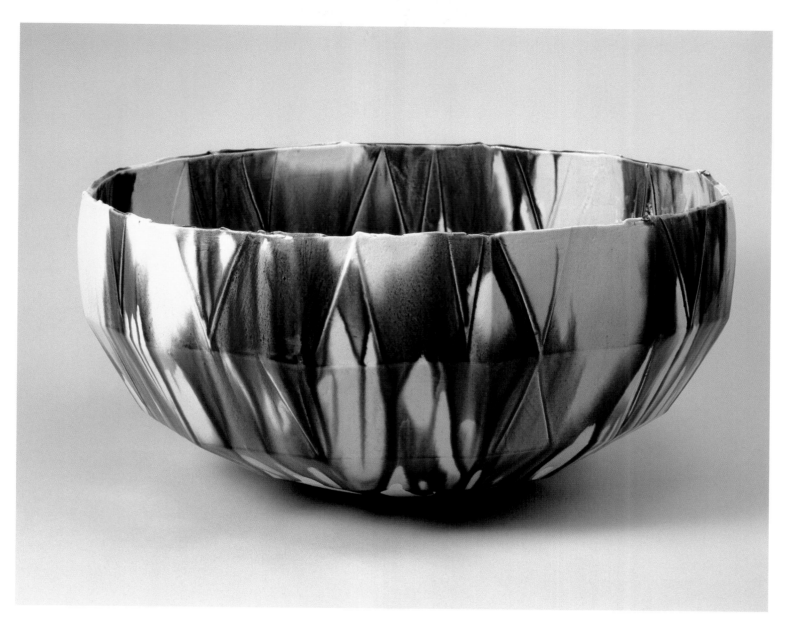

18
Vase, 'Blue Vessel' (*Sōyō*), 1984
Katō Takuo (1917–2005)
Stoneware with three-colour glaze (*sansai*)

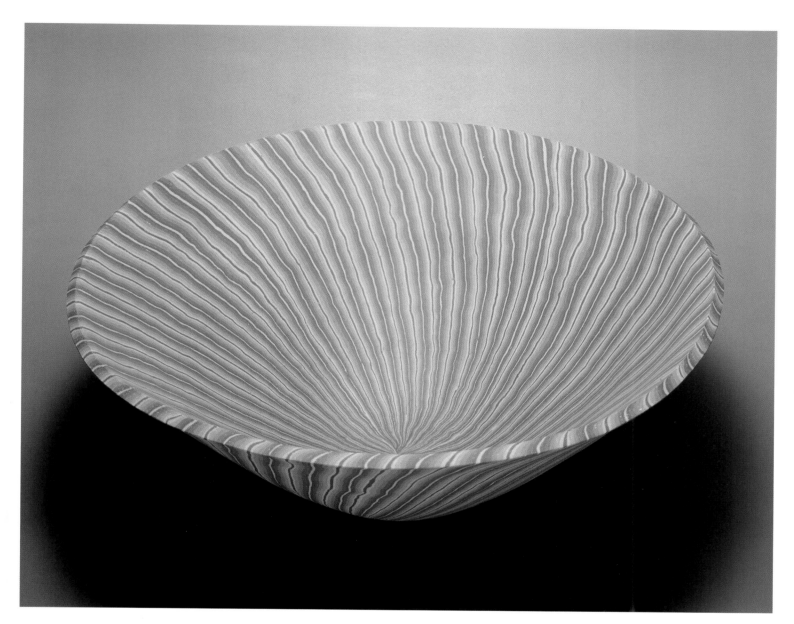

19
Bowl with striped design, 1985
Itō Sekisui V (b. 1941)
Stoneware with marbled clay, Mumyōi ware

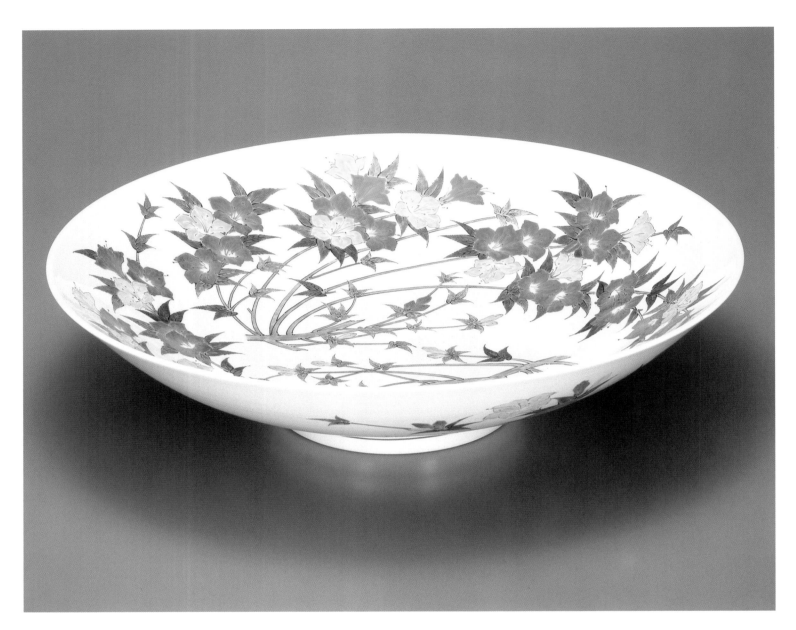

20
Bowl with azalea design, 1986
Sakaida Kakiemon XIV (b. 1934)
Milk-white (*nigoshi-de*) porcelain body
with overglaze enamels

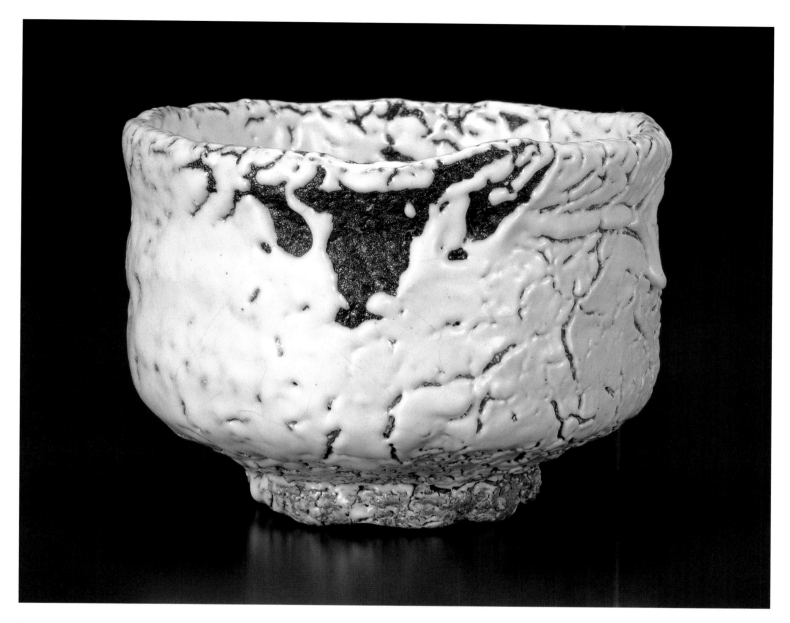

21
Teabowl, 1989
Miwa Jusetsu (b. 1910)
Stoneware, 'rugged Hagi' (*onihagi*) style

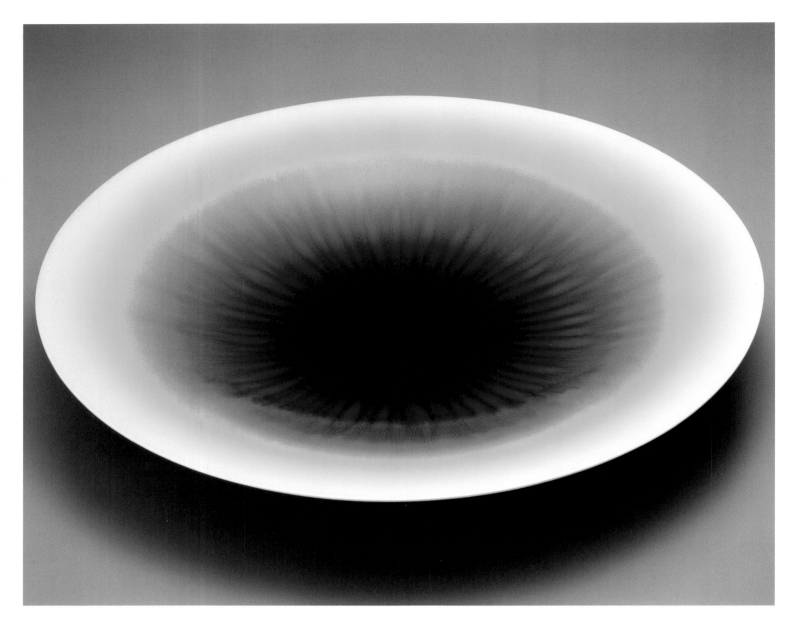

22
Bowl, 'Genesis' (*Sōsei*), 1991
Tokuda Yasokichi III (b. 1933)
Porcelain with vivid coloured glazes (*yōsai*)

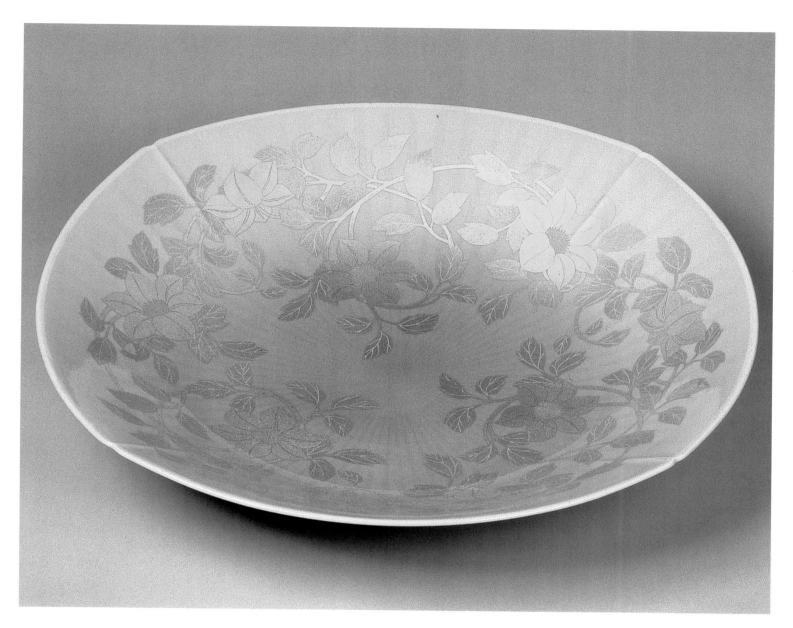

23
Bowl with clematis design, 1992
Yoshita Minori (b. 1932)
Porcelain with underglaze gold

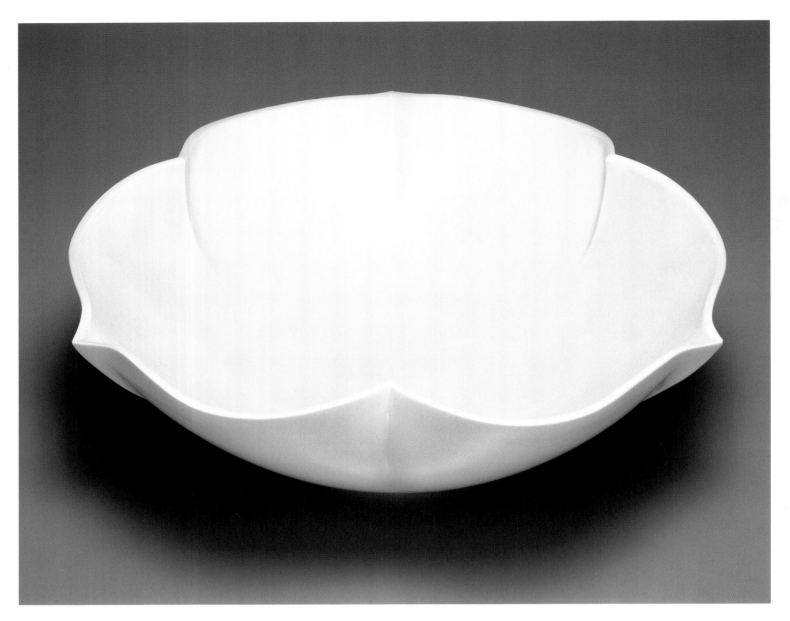

24
Flower-shaped bowl, 1996
Inoue Manji (b. 1929)
White porcelain

25
Jar with faceted body, 1996
Maeta Akihiro (b. 1954)
White porcelain

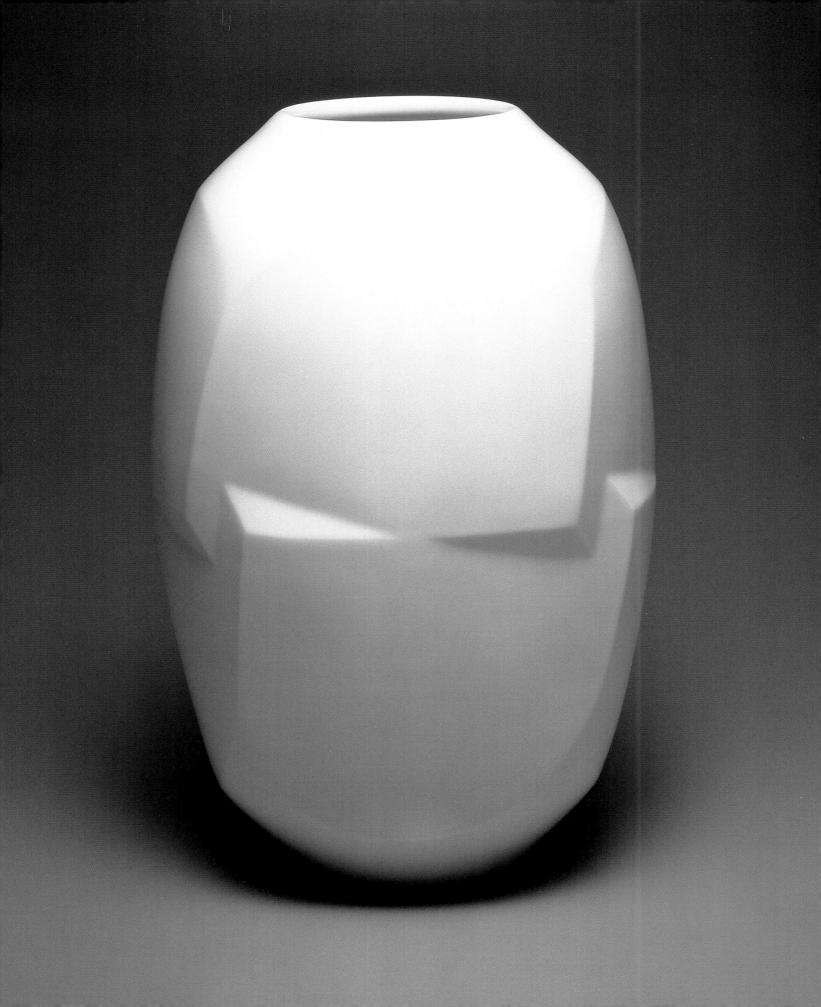

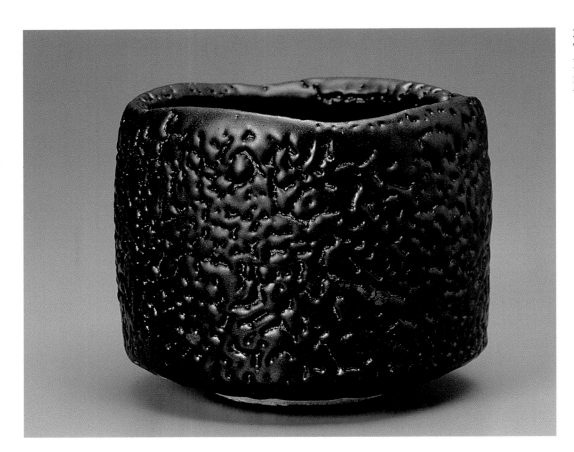

26
Teabowl, 2001
Katō Kōzō (b. 1935)
Stoneware with glaze,
black Seto style

27
Large jar with bird
and flower design, 2005
Hara Kiyoshi (b. 1936)
Stoneware with iron-oxide glaze

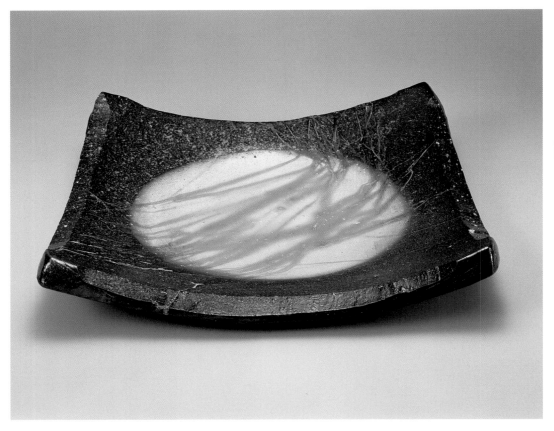

28
Rectangular plate, 2005
Isezaki Jun (b. 1936)
Stoneware, black Bizen style

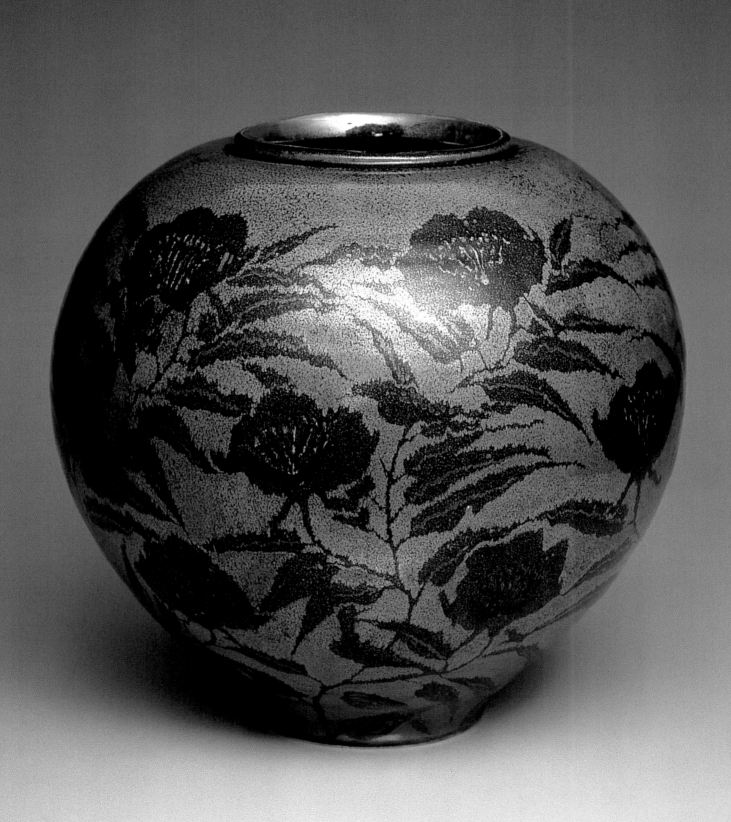

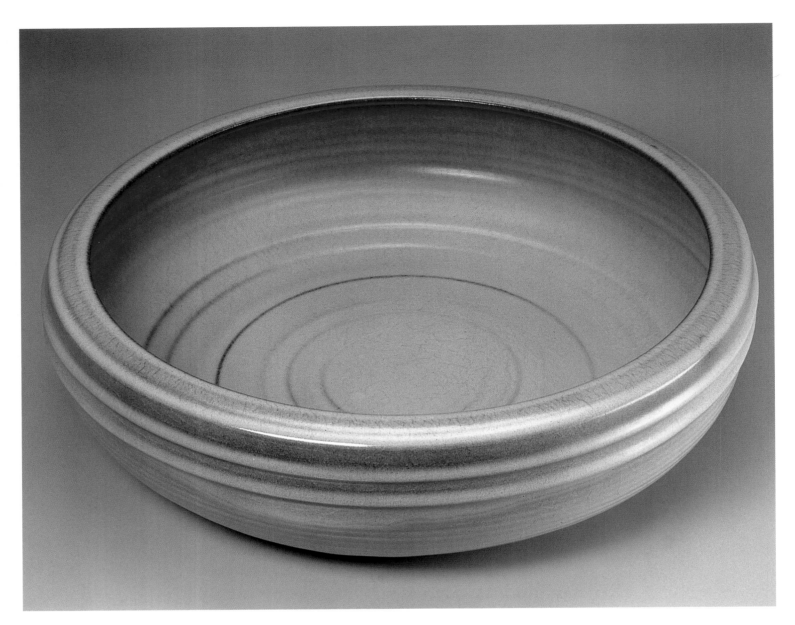

29
Large bowl with celadon glaze and incised
design, 2005
Nakashima Hiroshi (b. 1941)
Stoneware with glaze

30
Teabowl, 2006
Suzuki Osamu (b. 1934)
Stoneware with glaze, Shino style

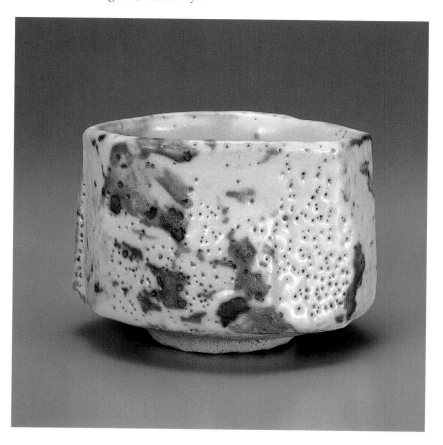

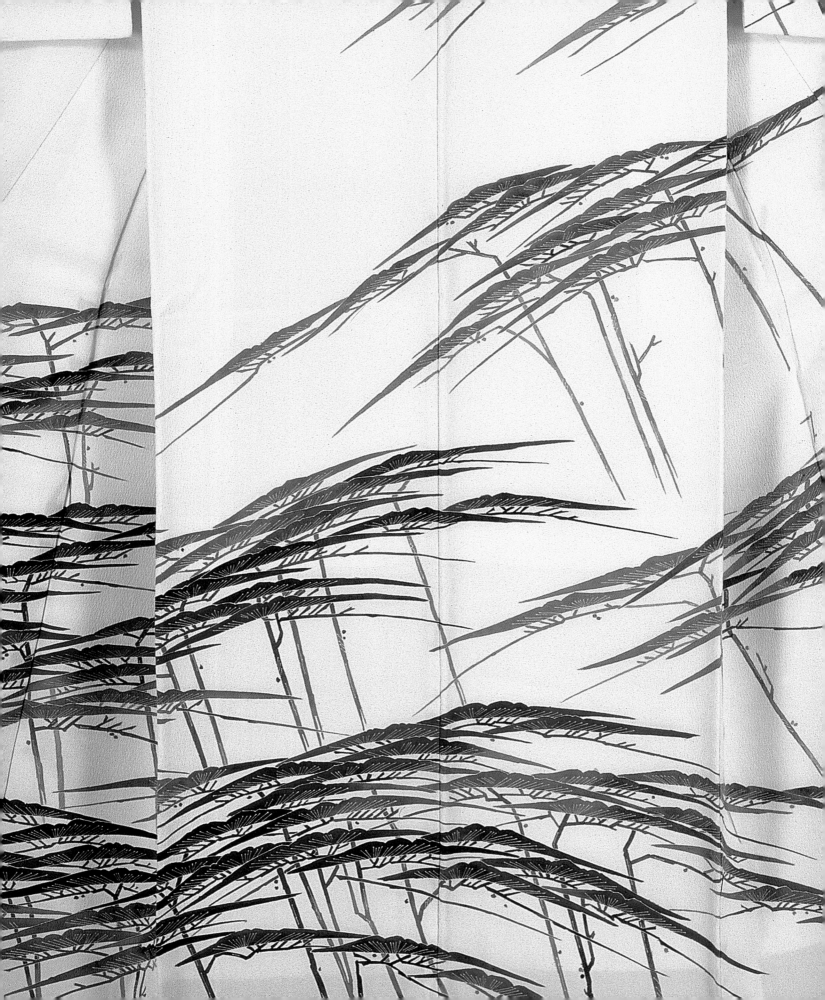

TEXTILES

Textiles in Japan fall into two categories according to their basic technique: dyeing or weaving; although these are often combined. The country's long textile history has been heavily influenced by China, Korea and other Asian countries, and, more recently, by the West. During the Edo period (1615–1868), the *kosode* (a robe with small sleeve-openings) – forerunner of the modern kimono – was developed for both men and women. Many new styles and designs were created, catering to both the samurai and merchant classes. In addition, regional domains fostered their own local industries, such as the Saga domain in Kyushu, which encouraged a type of woodblock-printed textile called Nabeshima *sarasa*. This technique has been revived by father-and-son artists Suzuta Teruji (cat. no. 43) and Shigeto (cat. no. 48).

Another region long known for its distinctive textile production is the Okinawan island chain in the far southwest of Japan. Two types were already prized in the Edo period as tribute goods for the Shogun: cloth woven from fibres of the banana plant (*bashō*); and high-quality ramie (*jōfu*), which is thin and appropriate to the warm climate there. These traditions are continued by two Okinawan women artists: Taira Toshiko (cat. no. 55) and Sasaki Sonoko (cat. no. 56).

The Edo period also saw the development of other complex textile techniques whereby the fabric carried vivid combinations of painted, woven and embroidered designs that moved with the wearer. Moriguchi Kakō's kimono (cat. no. 33) shows the fluidity of line and dynamism of pattern that can be achieved with *yūzen* dyeing. The method involves painting directly onto a prepared fabric with a rice-paste resist and then dyeing it in different colours. This time-consuming and skilled technique is continued by Moriguchi's son Kunihiko (cat. no. 45) at the family's workshop and residence in Kyoto.

In the Meiji era (1868–1912), new technology for the industrial mass-production of textiles entered Japan from the West. This presented a direct challenge and stimulus to those textile artists who dyed and wove by hand. Since the late twentieth century, several artists have studied and revived archaic, often labour-intensive traditions of textile art. Kitamura Takeshi works in the revived techniques of *ra* (figured woven silk gauze, cat. no. 53) and *tate-nishiki* (vertical brocade). These techniques first flourished in the Nara period (AD 710–94) but subsequently died out due to their fiendish complexity. Kitamura weaves on a large loom in his workshop in Kyoto, adding a modern sensibility to these ancient processes.

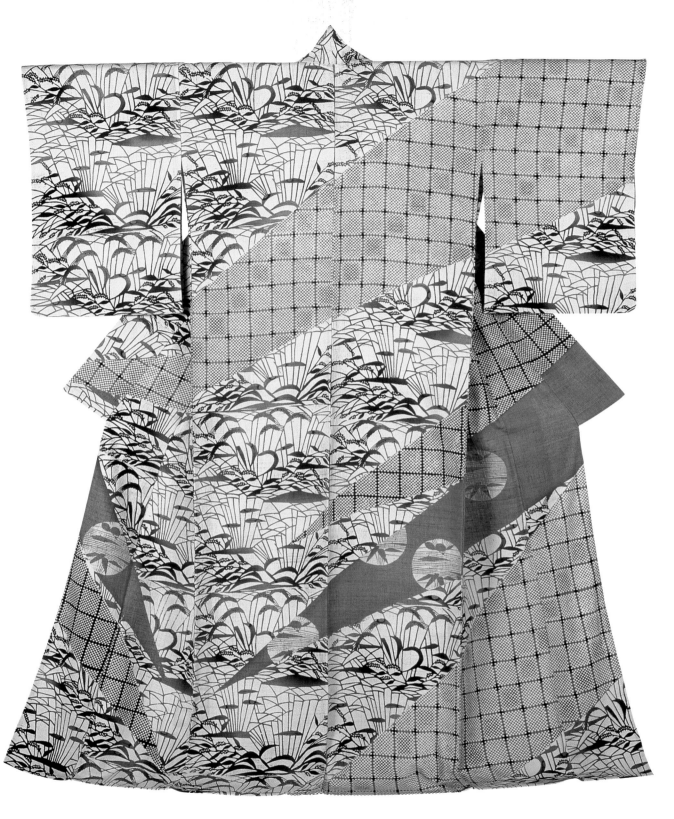

31
Kimono with design of wild plants,
bamboo grass and chequered pattern (*hitta*), 1955
Inagaki Toshijirō (1902–63)
Stencil dyeing on cotton

32
Door curtain (*noren*) inscribed
'This mountain path… (*Kono yama michi…*)', 1959
Serizawa Keisuke (1895–1984)
Stencil dyeing on cotton

33
Kimono with chrysanthemum-petal design, 1960
Moriguchi Kakō (b. 1909)
Yūzen dyeing on white pongee (*jōdai tsumugi*) silk

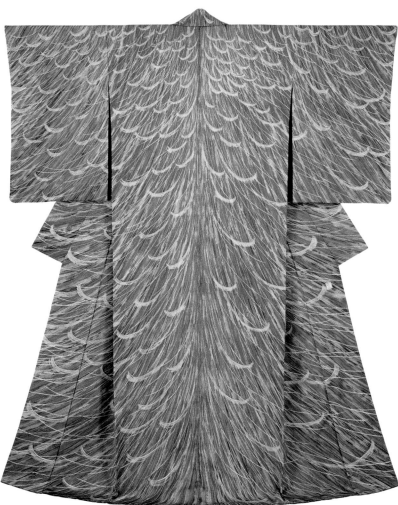

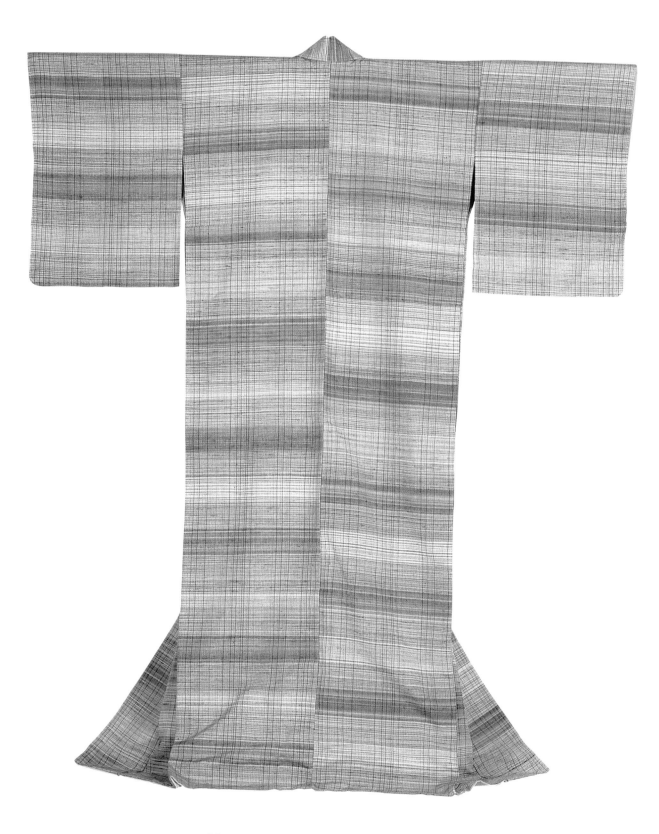

34
Kimono, 'Star Festival' (*Tanabata*), 1960
Shimura Fukumi (b. 1924)
Pongee (*tsumugi*) silk

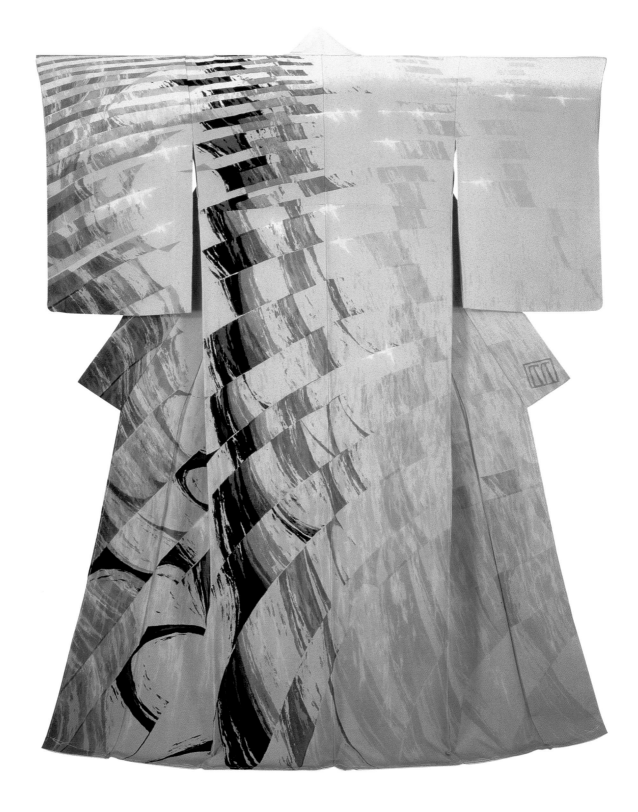

35
Kimono, 'Rippled Shadow' (*Yōei*), 1960
Tajima Hiroshi (b. 1922)
Yūzen dyeing on crêpe silk

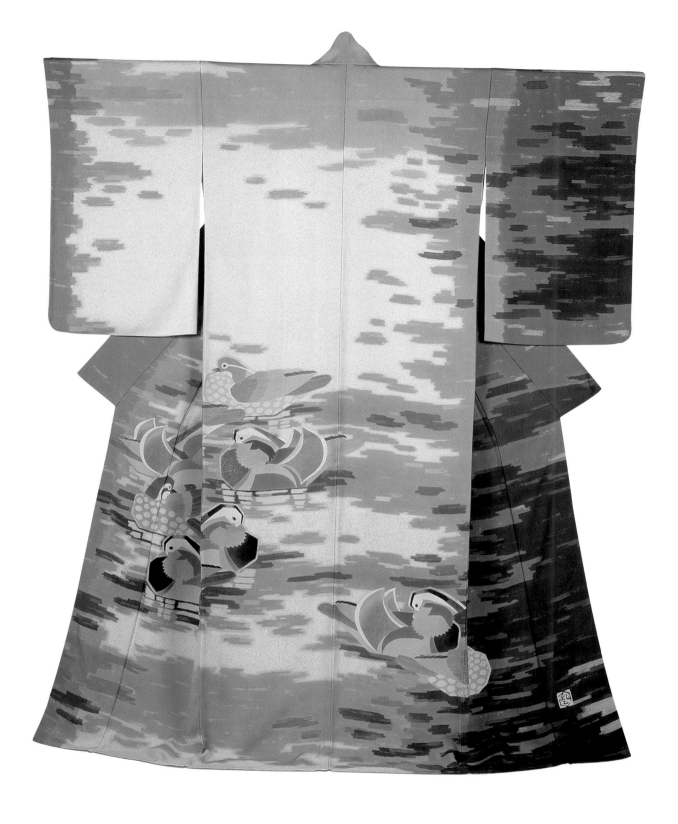

36
Kimono, 'On the Water' (*Fuyū*), 1961
Hata Tokio (b. 1911)
Yūzen dyeing on crêpe silk

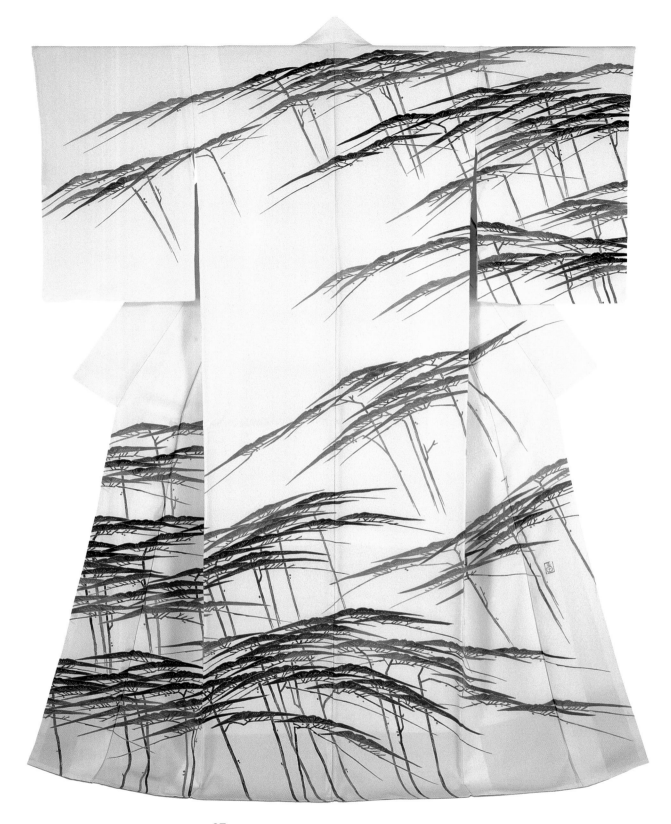

37
Kimono, 'Refreshing Hill' (*Sōkyū*), 1966
Yamada Mitsugi (1912–2002)
Yūzen dyeing on crêpe silk

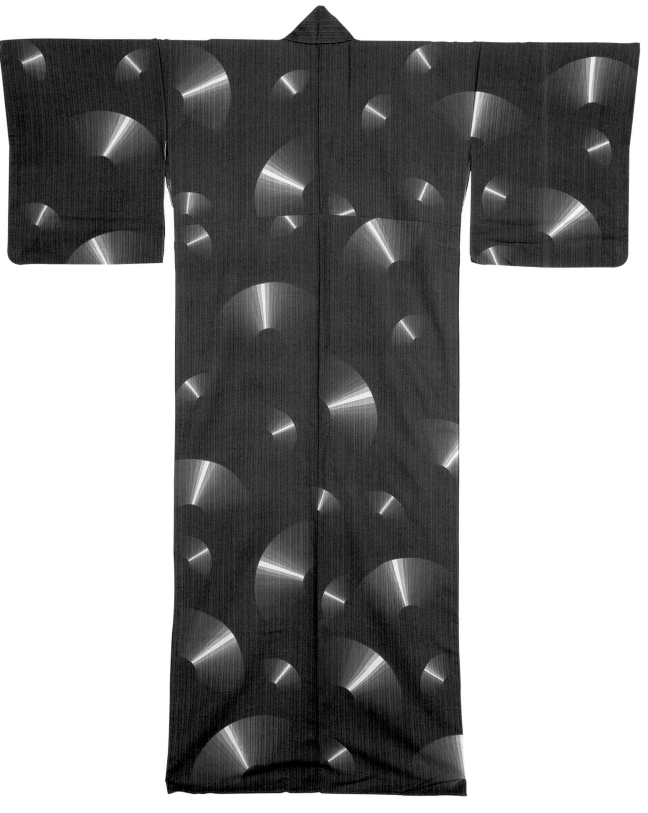

38
Kimono, 'Melody' (*Senritsu*), 1968
Matsubara Yoshichi (b. 1937)
Indigo stencil dyeing on silk

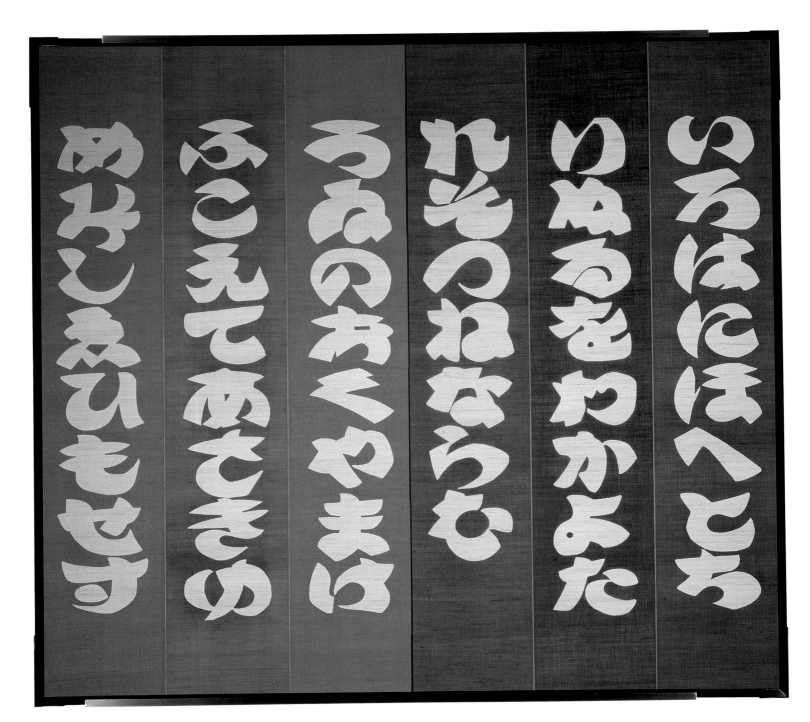

39
Two-fold screen, design of Japanese
syllabic characters in six columns, 1973
Serizawa Keisuke (1895–1984)
Stencil dyeing on cotton

40
Kimono with fine repeating pattern
(*Edo komon*) known as 'sliced pear', 1976
Komiya Yasutaka (b. 1925)
Stencil dyeing on crêpe silk

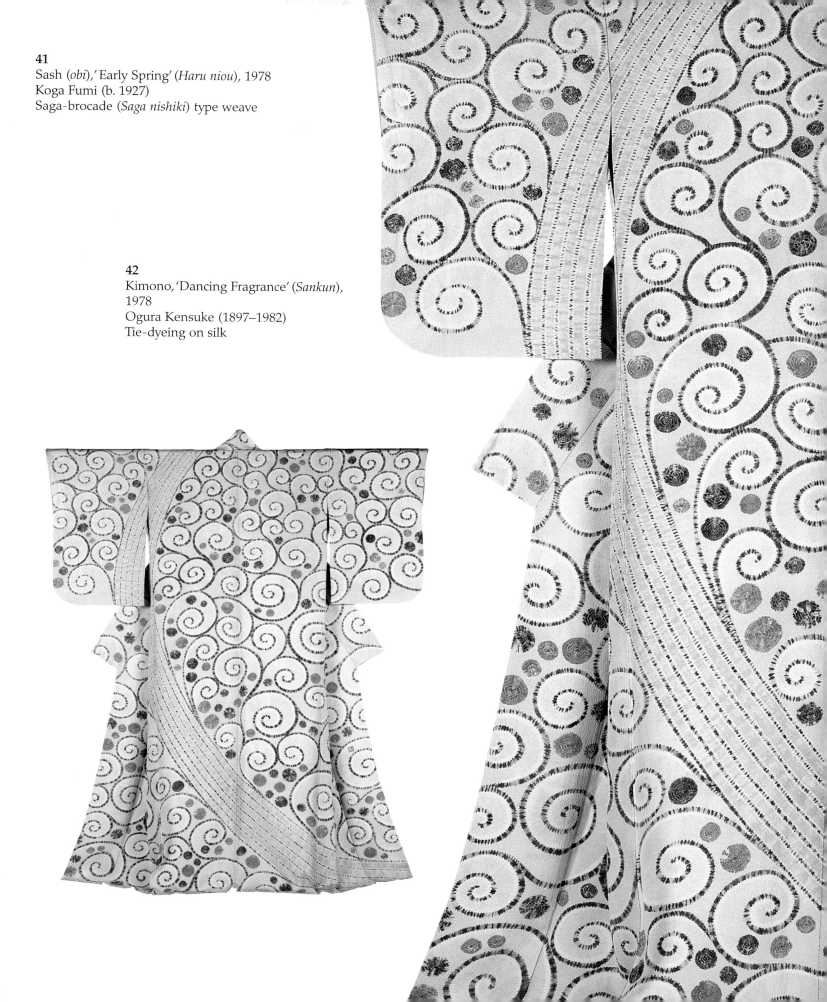

41
Sash (*obi*), 'Early Spring' (*Haru niou*), 1978
Koga Fumi (b. 1927)
Saga-brocade (*Saga nishiki*) type weave

42
Kimono, 'Dancing Fragrance' (*Sankun*),
1978
Ogura Kensuke (1897–1982)
Tie-dyeing on silk

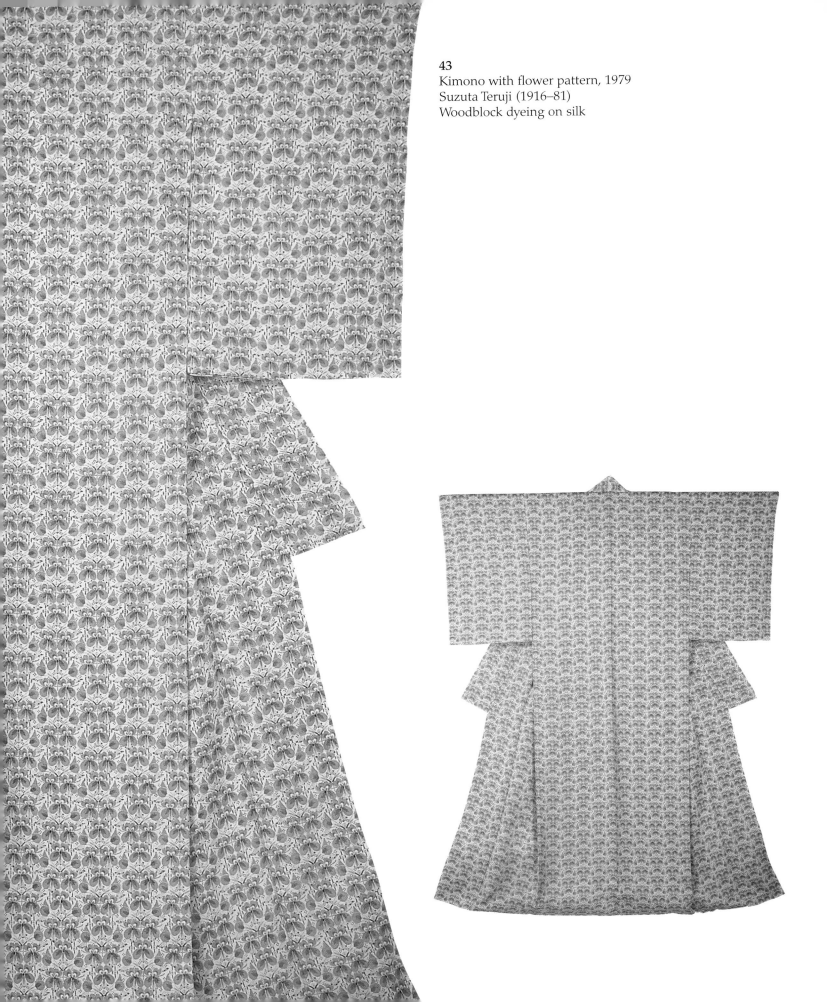

43
Kimono with flower pattern, 1979
Suzuta Teruji (1916–81)
Woodblock dyeing on silk

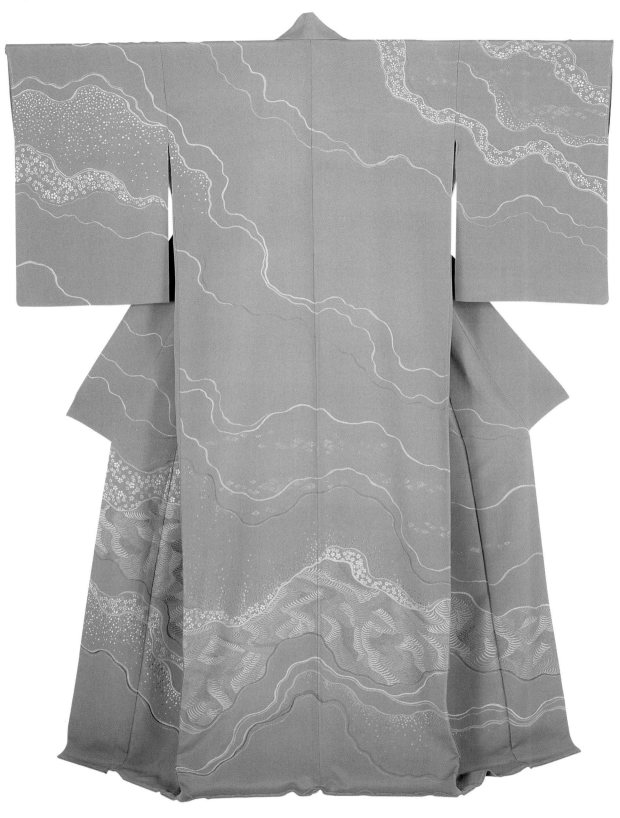

44
Kimono, 'Perpetual Recurrence' (*Seisei kyorai*), 1980
Fukuda Kijū (b. 1932)
Embroidered silk

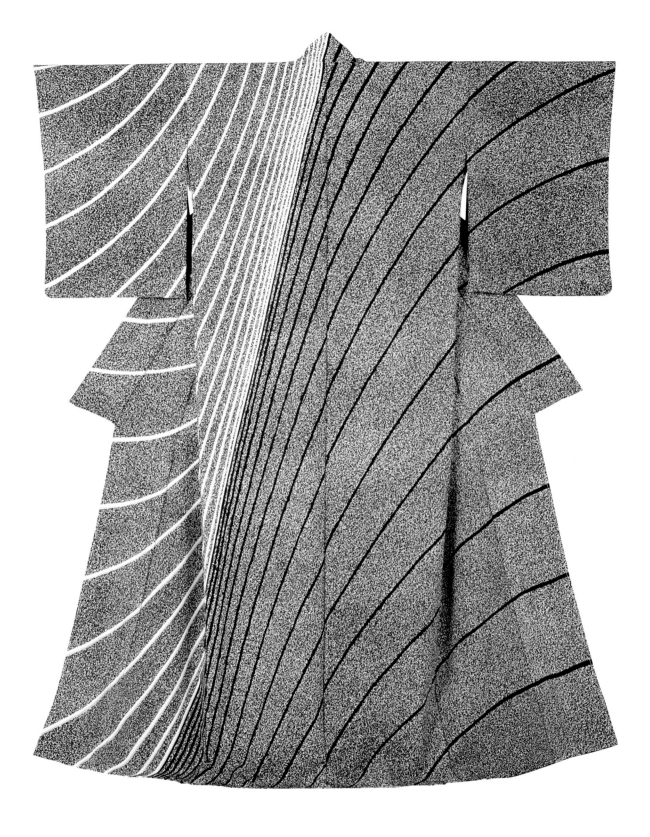

45
Kimono, 'Sand Flow' (*Ryūsa*), 1984
Moriguchi Kunihiko (b. 1941)
Yūzen dyeing on silk

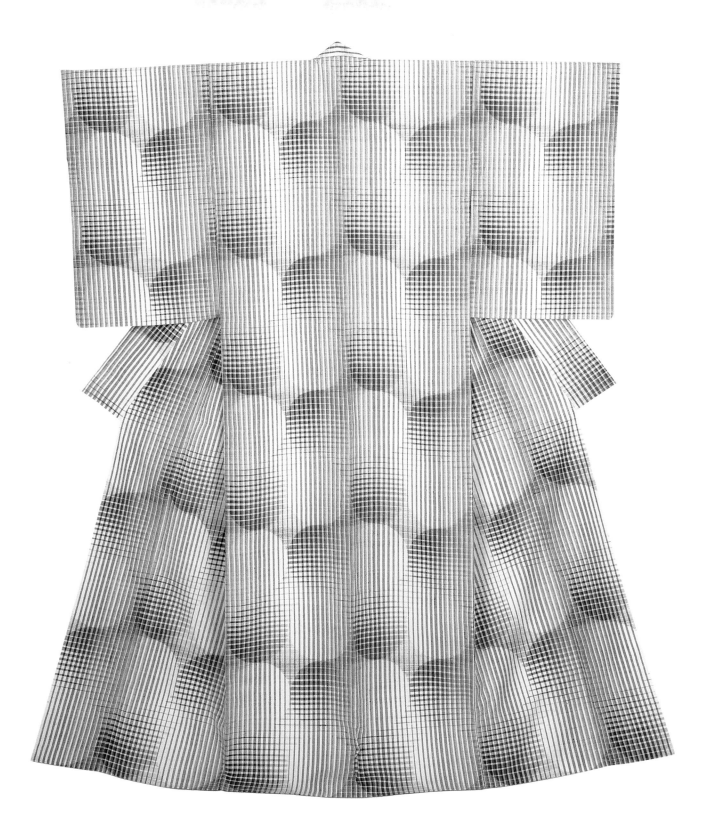

46
Kimono with striped and circular patterns, 1984
Munehiro Rikizō (1914–89)
Pongee (*tsumugi*) silk

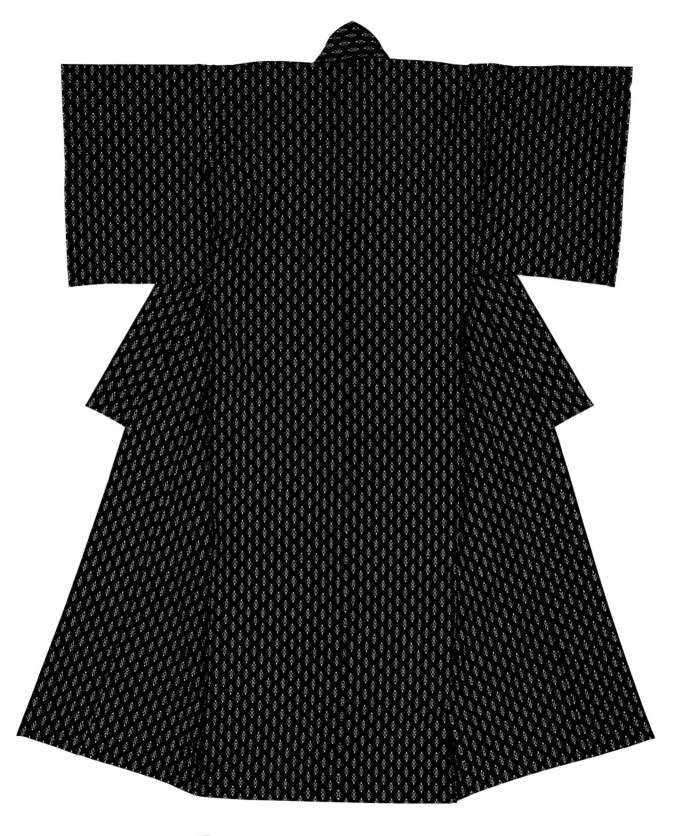

47
Kimono, 'Sapphire Blue' (*Safaiya buruu*), 1986
Moriyama Torao II (b. 1933)
Woven silk with *Kurume-gasuri* style pattern

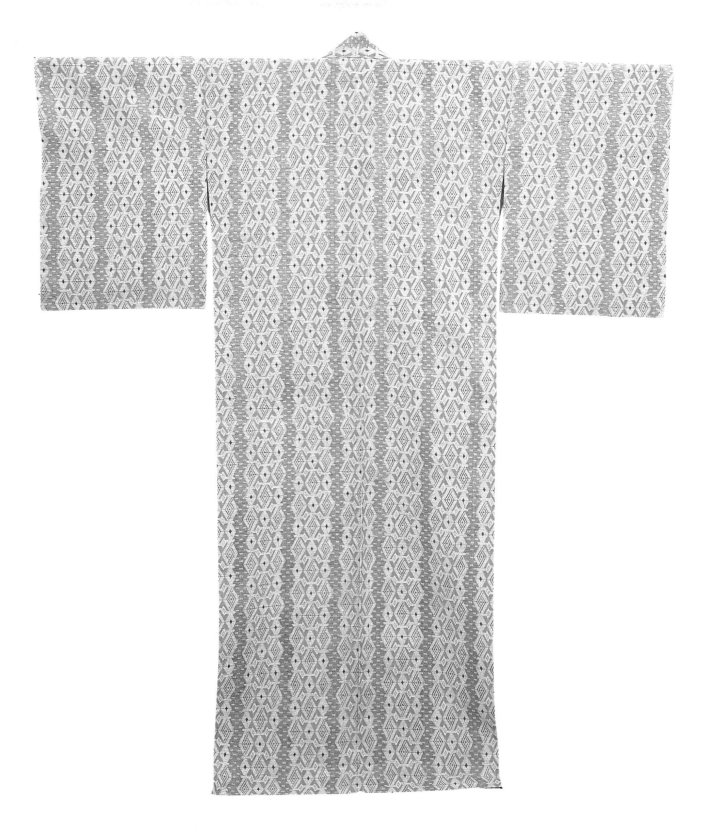

48
Kimono, 'Straw Mounds' (*Warazuka*), 1986
Suzuta Shigeto (b. 1954)
Woodblock and stencil dyeing on silk

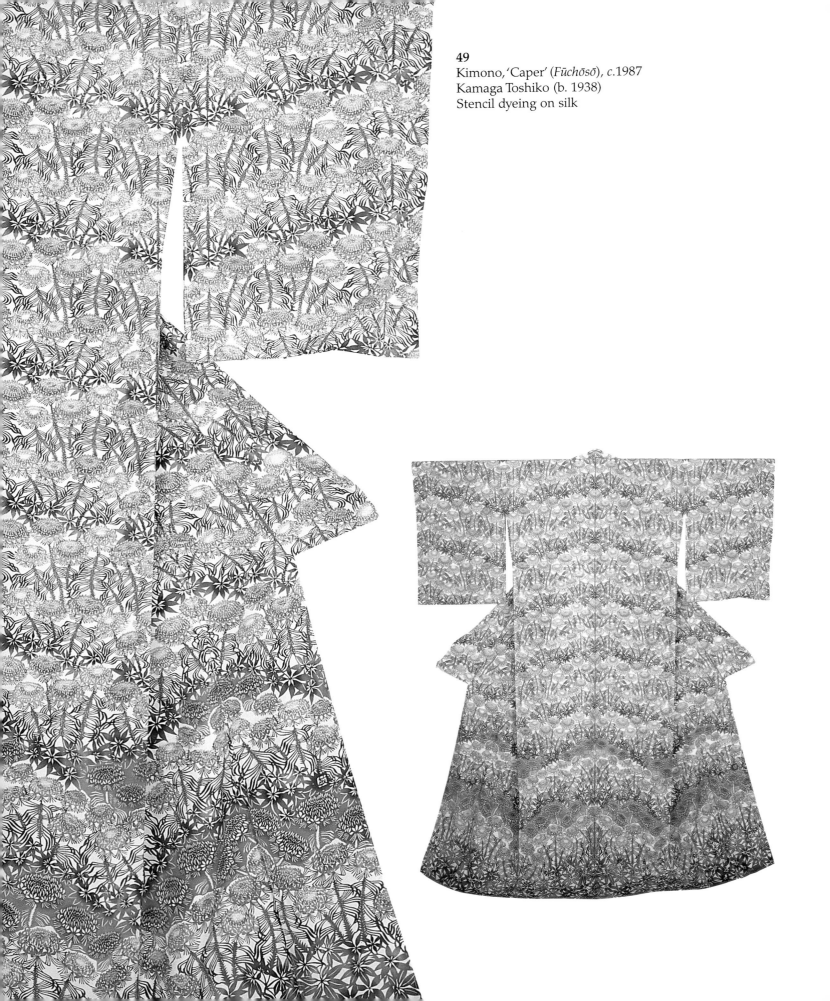

49
Kimono, 'Caper' (*Fūchōsō*), *c.*1987
Kamaga Toshiko (b. 1938)
Stencil dyeing on silk

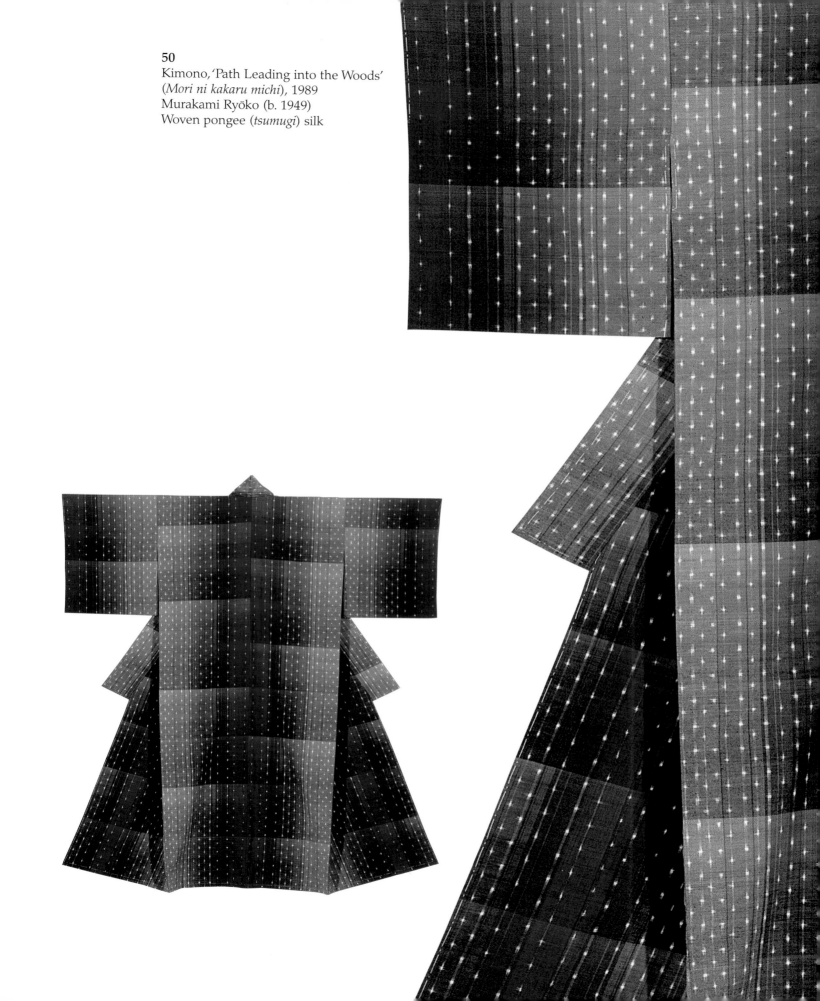

50
Kimono, 'Path Leading into the Woods'
(*Mori ni kakaru michi*), 1989
Murakami Ryōko (b. 1949)
Woven pongee (*tsumugi*) silk

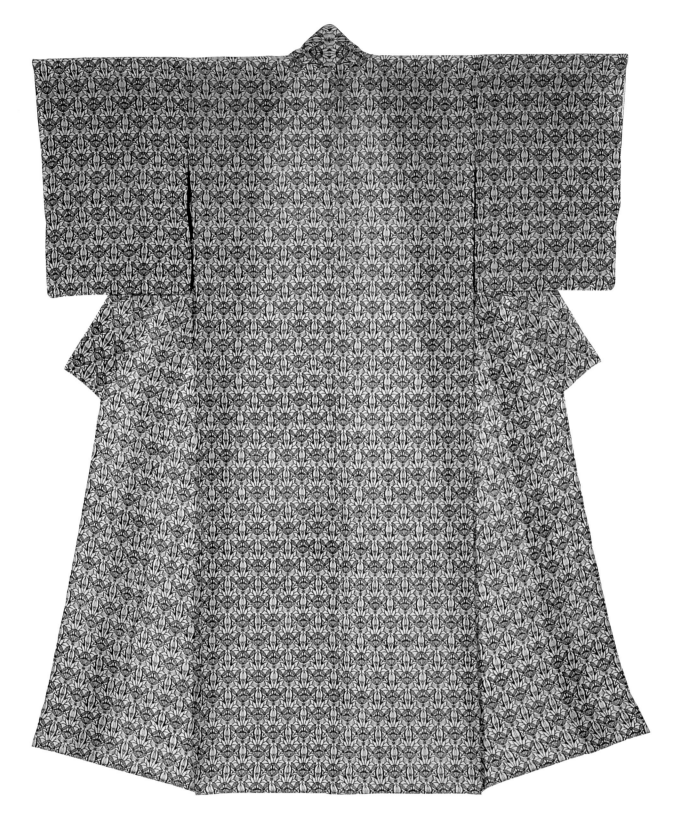

51
Kimono, 'Plants and Flowers' (*Sōka*), 1991
Tamanaha Yūkō (b. 1936)
Double-sided *bingata* stencil dyeing on ramie silk

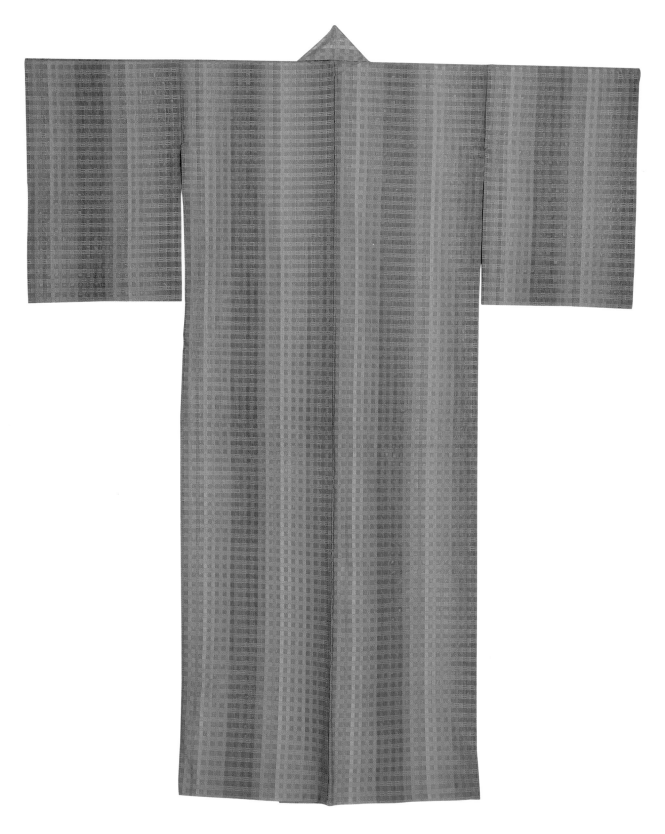

52
Kimono, 'Southern Sea' (*Minami no umi*), 1993
Miyahira Hatsuko (b. 1922)
Woven silk in *hanakura-ori* style

54
Sash (*obi*), 'Early Summer Breeze' (*Kunpū*), 2000
Hosomi Kagaku (b. 1922)
Figured brocade weave

53
Pale blue textile with transparent pattern,
1996
Kitamura Takeshi (b. 1935)
Woven silk fine gauze (*ra*)

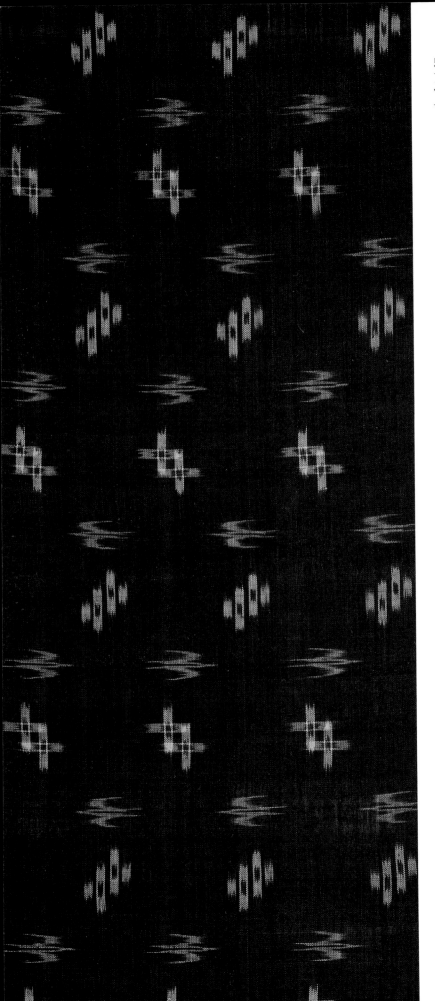

55
Dark blue textile with bird, flower and boat pattern, 2001
Taira Toshiko (b. 1921)
Woven banana-tree fibre

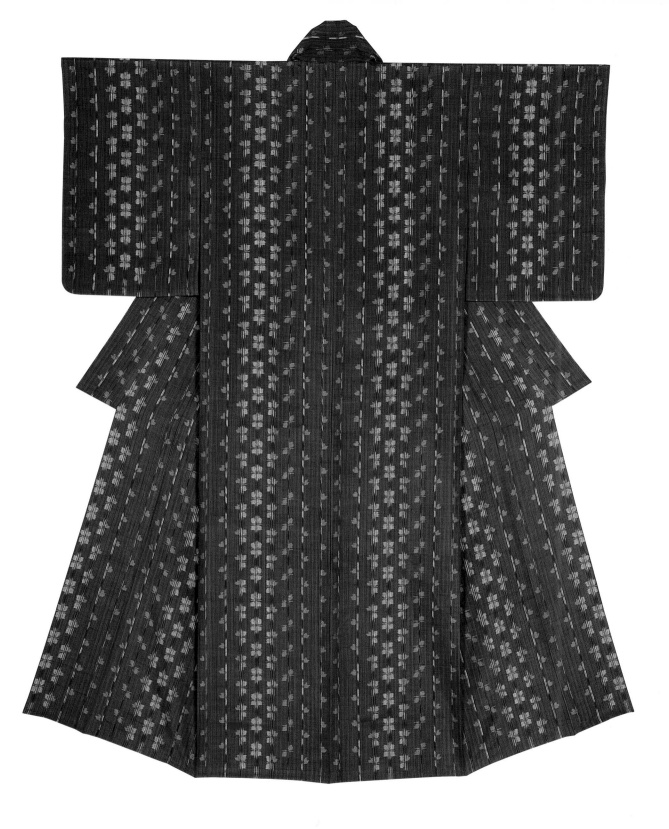

56
Kimono, 'Fragrance of the Breeze' (*Kaze no kaori*), 2005
Sasaki Sonoko (b. 1939)
Woven pongee (*tsumugi*) silk with *kasuri* pattern

LACQUER

Japanese lacquer is rich in variety, often using multiple decorative techniques that are both subtle and sophisticated. Lacquer is known for three unique qualities: its viscosity, making it an ideal binding agent; its long hardening time, allowing for sophisticated decoration of the surface; and its deep gloss. In addition, it is resistant to heat, liquids and acids.

True lacquer is only found in Japan, China, Korea and Southeast Asia and it has a particularly long history of production in the Japanese islands. The earliest excavated lacquerware so far recovered is from the Kakinoshima B site in Hokkaidō, which dates to the Initial Jōmon period, c.7000 BC. In the AD 500s new lacquer techniques were brought to Japan from continental Asia and it was particularly used to make Buddhist implements, armour and eating utensils.

There is an abundance of lacquer-producing trees in Japan, also a pronounced difference in the quality of the lacquer depending on the region. Lacquer is made from the sap that gathers between the bark and the trunk of the *urushi* tree. The bark is scored and the milky sap is carefully harvested. The sap changes colour once it oxidizes and it is further refined by heating and stirring.

Lacquer can either be applied directly to a substrate – such as wood, bamboo, paper, ceramic, metal, or leather – or it can be applied to a base that is already covered with a foundation layer. It is typically mixed with powdered metals or coloured pigment.

Many techniques have been developed for creating lacquer and ornamenting it over the centuries. Perhaps one of the most refined is the *maki-e*, literally 'sprinkled picture', technique first developed in the 1100s, in which gold powder is sprinkled onto wet lacquer. Many contemporary works still use this technique, and perhaps its most famous modern exponent was Matsuda Gonroku (cat. no. 63). Other important techniques include 'carved lacquer' (*chōshitsu*), as used by Otomaru Kōdō (cat. no. 62), and 'incised and colour-filled' (*kinma*), seen in the work of Ōta Hitoshi (cat. no. 69).

Kyoto was the centre of lacquer production throughout the Edo period (1600–1868), but other regions traditionally had thriving industries; for example, Wajima (in modern Ishikawa prefecture) and Edo (modern Tokyo). Japanese lacquer was important as a trade item and has been much sought after in Europe during the last 400 years.

57
Tray, 1957
Masumura Mashiki
(1910–96)
Lacquer on wood using
kanshitsu technique

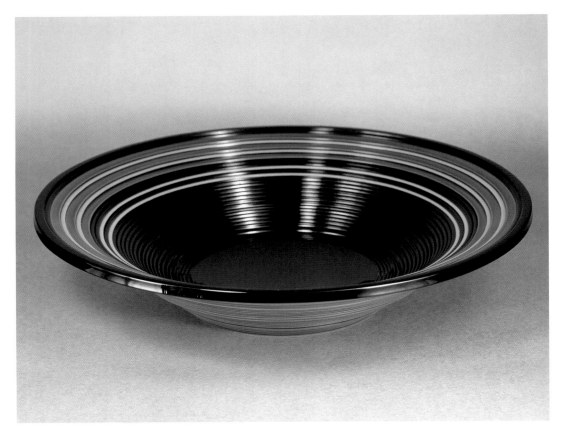

59
Bowl with circle design, 1961
Akaji Yūsai (1906–84)
Lacquer on wood using *magewa*
(hoop built) technique with
coloured lacquer

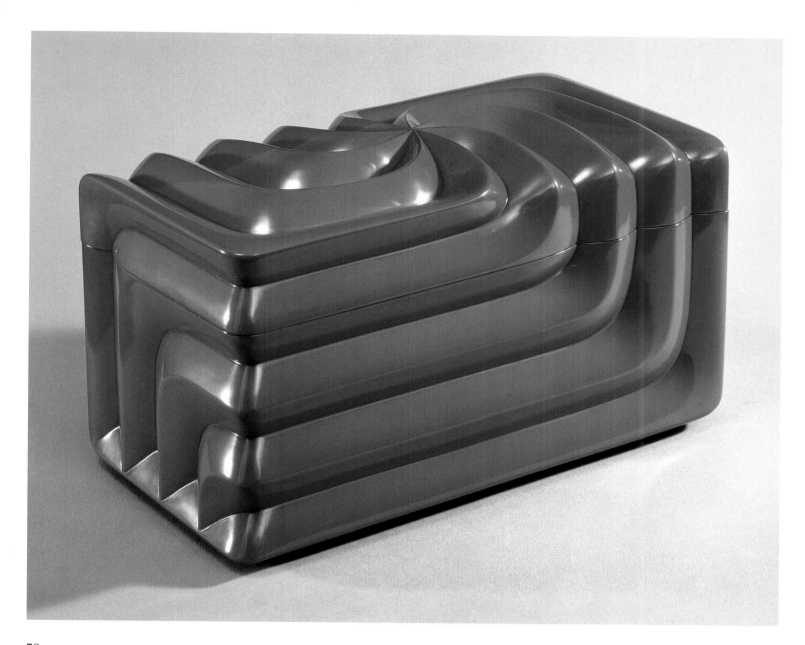

58
Ornamental box in a flowing design, *c.*1957
Kuroda Tatsuaki (1904–82)
Red lacquer on wood (*sekishitsu*)

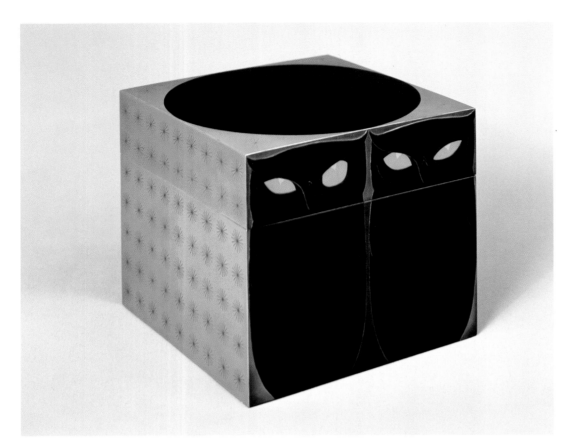

60
Ornamental box,
solar eclipse design, 1963
Taguchi Yoshikuni (1923–98)
Lacquer on wood with sprinkled
gold (*maki-e*)

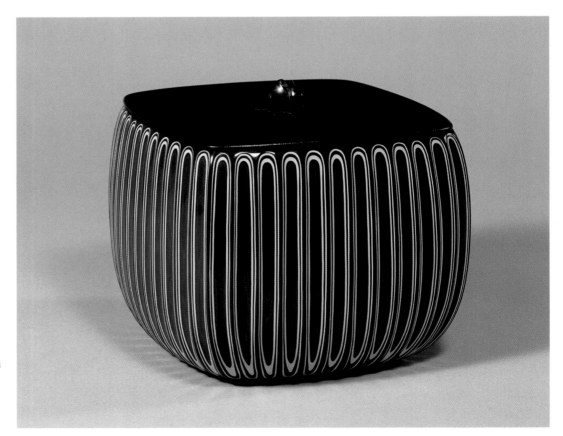

62
Water jar for tea gatherings with
trillium flower design, 1966
Otomaru Kōdō (1898–1997)
Lacquer on wood using layered
lacquer carving (*chōshitsu*)

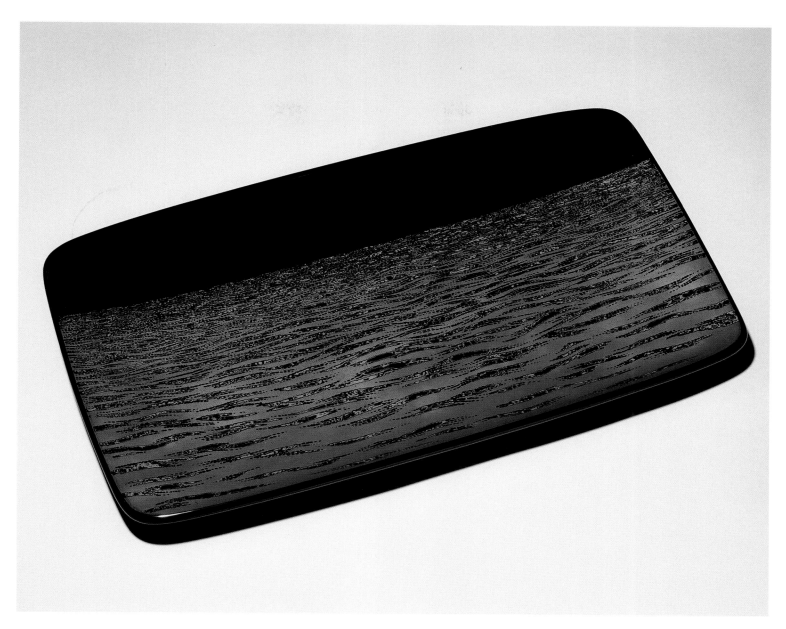

61
Incense tray with wave design, 1966
Isoi Masami (b. 1926)
Lacquer on wood with *kinma* technique

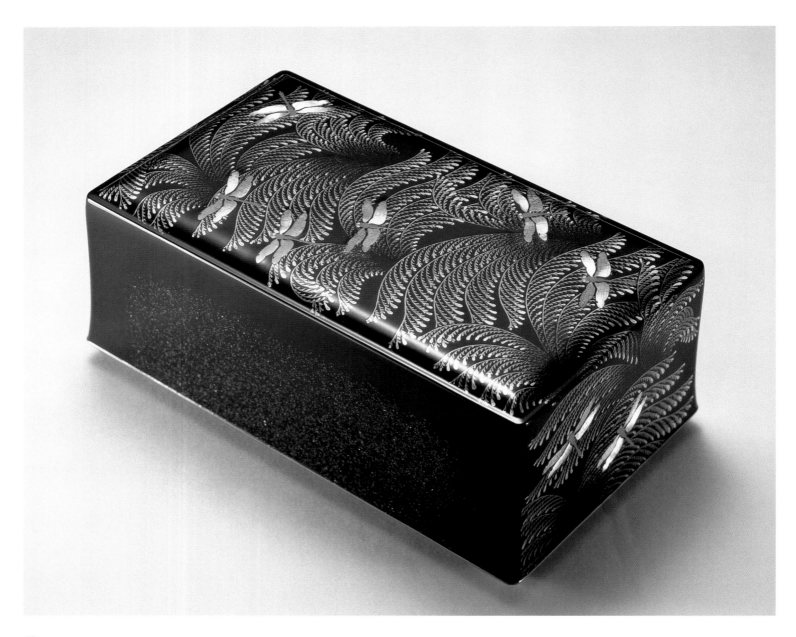

63
Box, 'Dragonfly' (*Akatombo*), 1969
Matsuda Gonroku (1896–1986)
Lacquer on wood, with mother-of-pearl
inlay and sprinkled gold (*maki-e*)

64
Letter box with crane design, 1973
Ōba Shōgyo (b. 1916)
Lacquer on wood with gold and silver using
hyōmon technique

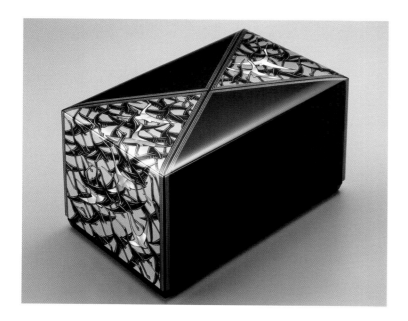

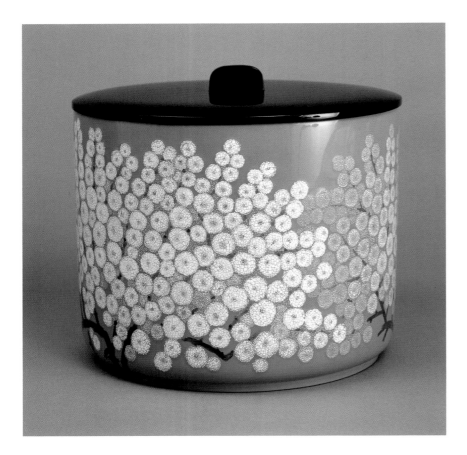

65
Water jar for tea gatherings, 'Spring' (*Haru*), 1976
Terai Naoji (1912–98)
Lacquer on metal with sprinkled gold (*maki-e*)

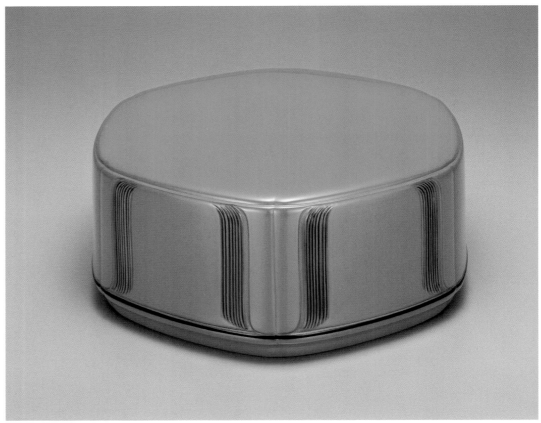

66
Incense case with lid, 1977
Shioda Keishirō (1926–2006)
Lacquer on wood using *kanshitsu* technique

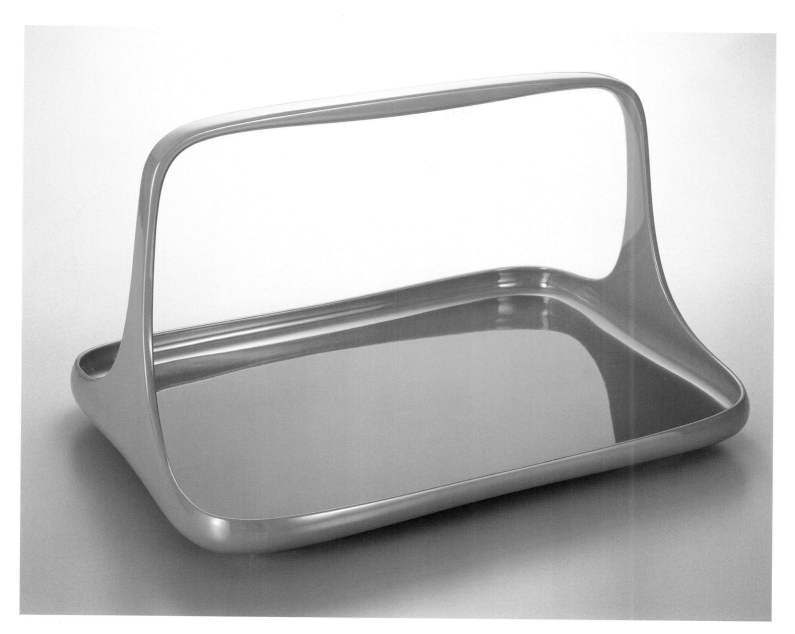

67
Tray with handle, 1979
Masumura Kiichirō (b. 1941)
Cinnabar lacquer on wood using *kanshitsu* technique

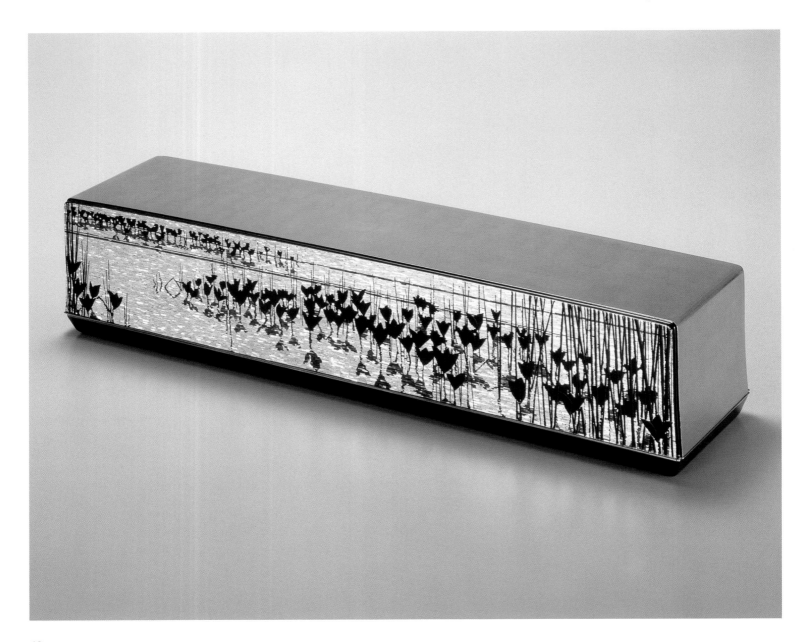

68
Tanzaku (poetry slip) box, 'Morning Oze' (*Oze no asa*), 1982
Sasaki Ei (1934–84)
Lacquer on wood with sprinkled gold
(*maki-e*) and coloured-shell inlay

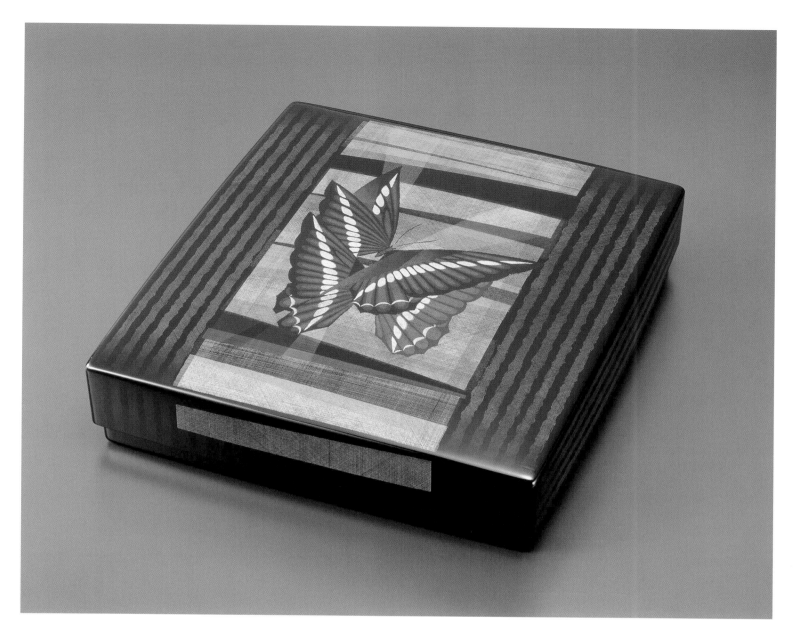

69
Letter box, 'Butterfly' (*Chō*), 1986
Ōta Hitoshi (b. 1931)
Woven bamboo base (*rantai*) with *kinma*
technique

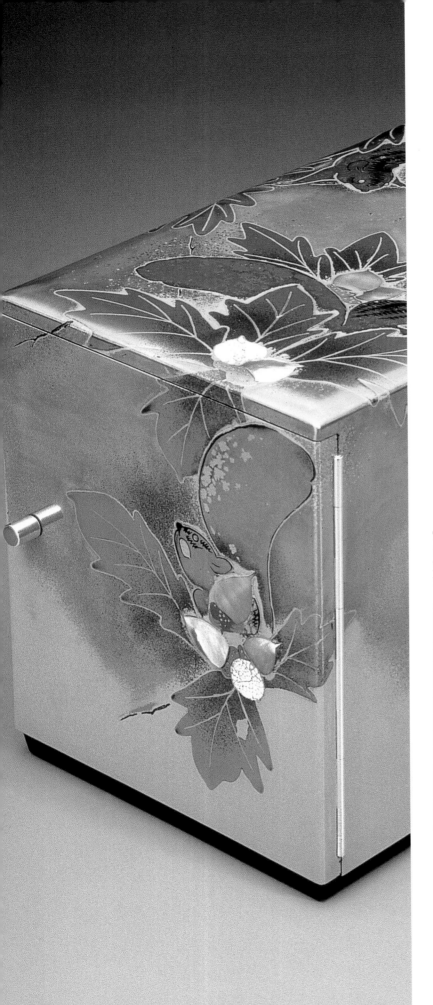

70
Small chest with squirrel design, 1987
Nakano Kōichi (b. 1947)
Lacquer on wood with sprinkled gold (*maki-e*)

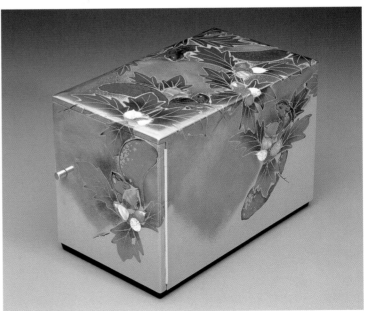

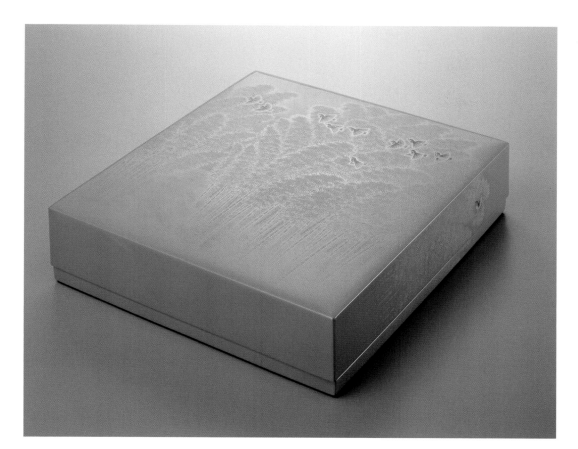

71
Writing-paper box, 'Morning Mist'
(*Asagiri*), 1998
Mae Fumio (b. 1940)
Lacquer on wood with gold inlay
(*chinkin*)

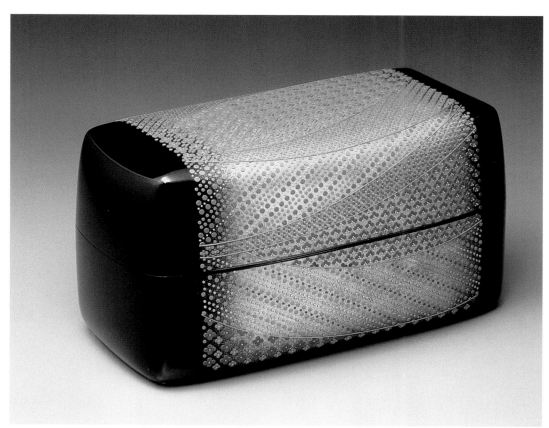

72
Box, 'Impressions of Ancient Tomb'
(*Koryōsō*), 1999
Yamaguchi Matsuta (b. 1940)
Lacquer on wood with coloured
lacquer appliqué using *kanshitsu*
technique

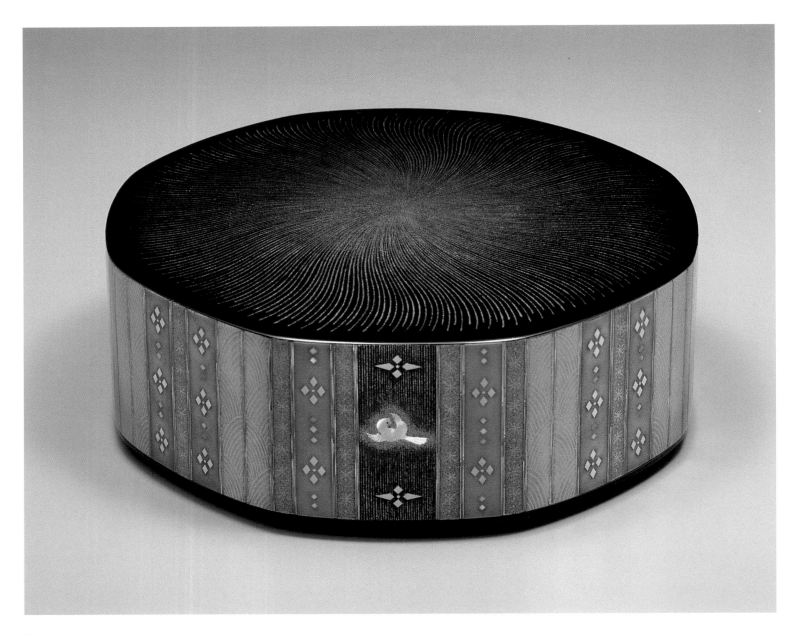

73
Ornamental box, 'Coloured Lights' (*Saikō*), 2000
Murose Kazumi (b. 1950)
Lacquer on wood with sprinkled gold (*maki-e*)
and mother-of-pearl inlay

74
Round tray in hoop-built (*magewa*) technique, 2000
Ōnishi Isao (b. 1944)
Black translucent lacquer (*tamenuri*) on wood

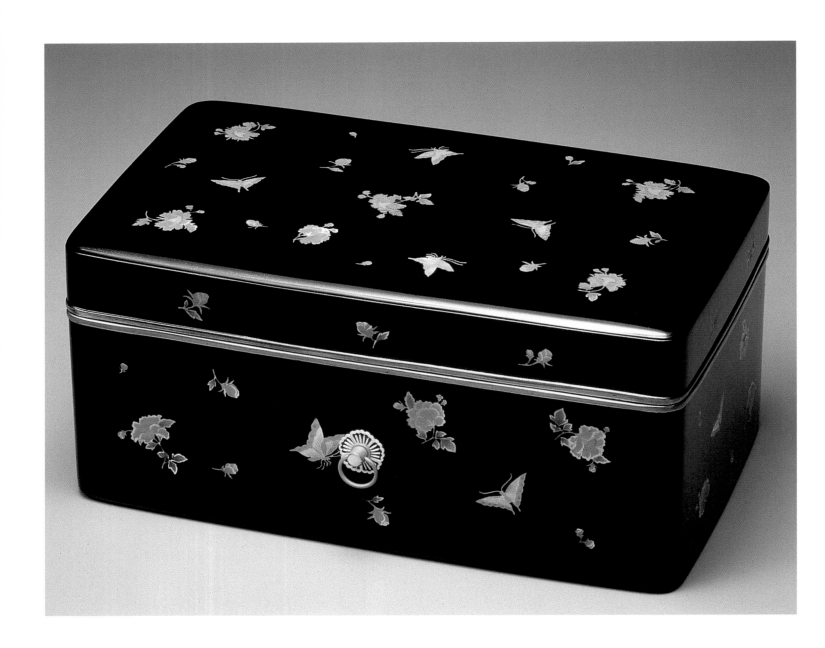

75
Box with butterfly and peony design, 2002
Kitamura Shōsai (b. 1938)
Lacquer on wood

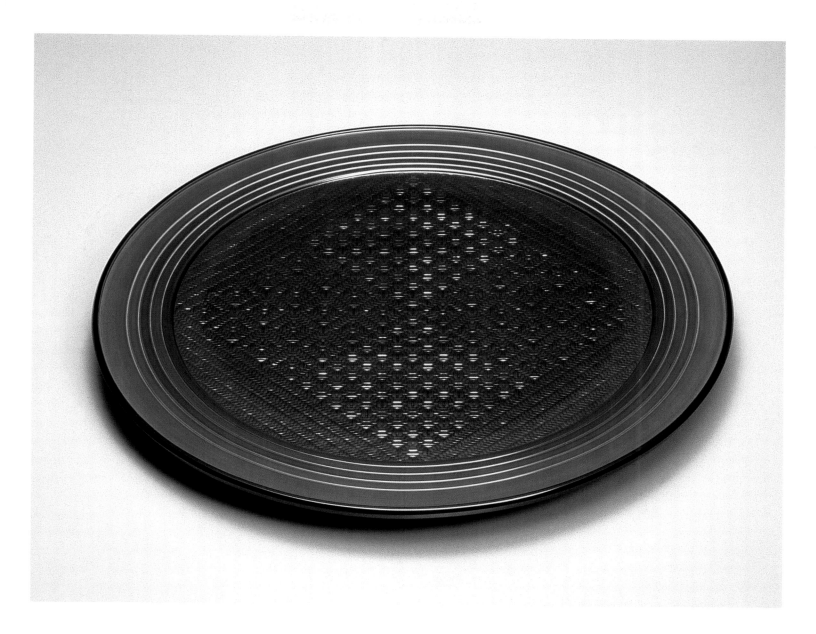

76
Round tray, 'Dawn', 2002
Komori Kunie (b. 1945)
Woven bamboo base (*rantai*) with hoop-built (*magewa*) technique

METAL

Metalworking utilizes a variety of techniques to melt, stretch or hammer the metal into the desired shape. In Japan five metals are considered to form the basis of all traditional metalwork: gold, silver, copper, tin and iron.

Metals first arrived in the Japanese islands at the beginning of the Yayoi period, about 500 BC. Although there is continuing controversy over the precise dating, bronze and iron appear to have arrived at about the same time, together with wet-rice agriculture. Early metal objects included bronze mirrors and swords, iron axes, arrowheads and agricultural implements.

Iron production underwent major growth in the Kofun period, about AD 250–600, when substantial quantities of iron goods, including swords, horse trappings and armour, were buried in large mounded tombs. Iron ore deposits are rare in the Japanese islands, and the main source may have been in the southern part of the Korean peninsula, particularly the kingdom of Kaya, near modern-day Pusan. A small number of gold seals have been found in Japan, sent by the Chinese imperial court in the 400s. Gilt-bronze items became common in elite material culture from the 500s.

Gilding continued to be an important technique during the Nara period (AD 710–94) when metal-working was used for Buddhist statues and ritual implements. The Heian (794–1185) and Kamakura (1185–1333) periods saw metalwork used to make elegant armour and lethal swords. During the Muromachi period (1333–1573) more cultural artefacts, such as iron kettles for tea gatherings, were added. Further mainstays of metalworking in the Edo period (1600–1868) were personal adornments, lanterns, temple bells, tools and utensils.

Contemporary metalworking has had to compete with industrial production, but has thrived through innovation based on tradition. The three major forming and decorative techniques are: casting, as seen in the iron kettle for tea gatherings by Kakutani Ikkei (cat. no. 77); hammering (Okuyama Hōseki, cat. no. 87); and chasing (Naitō Shirō, cat. no. 78). Inlay (*zōgan*) accounts for some of the most compelling decoration on metal surfaces, as seen in the hammered and inlaid silver vase by Ōsumi Yukie (cat. no. 84). Traditional Japanese alloys (metal mixtures) used for inlays include *shakudō* (copper and gold) and *shibuichi* (also known as *oborogin* or *rōgin*; copper and silver), which are now so well known in the West that they are often called by their Japanese names.

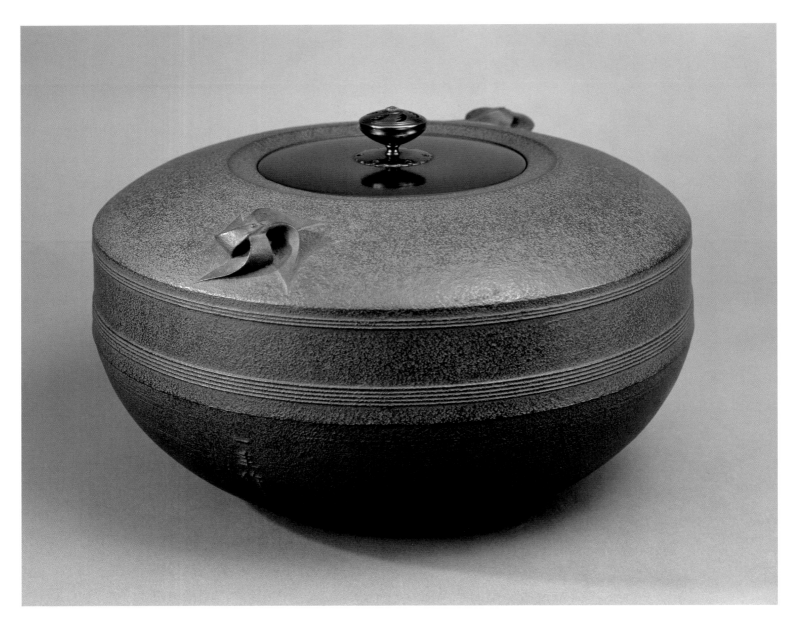

77
Kettle for tea gatherings in the shape of a toy top, 1961
Kakutani Ikkei (1904–99)
Iron

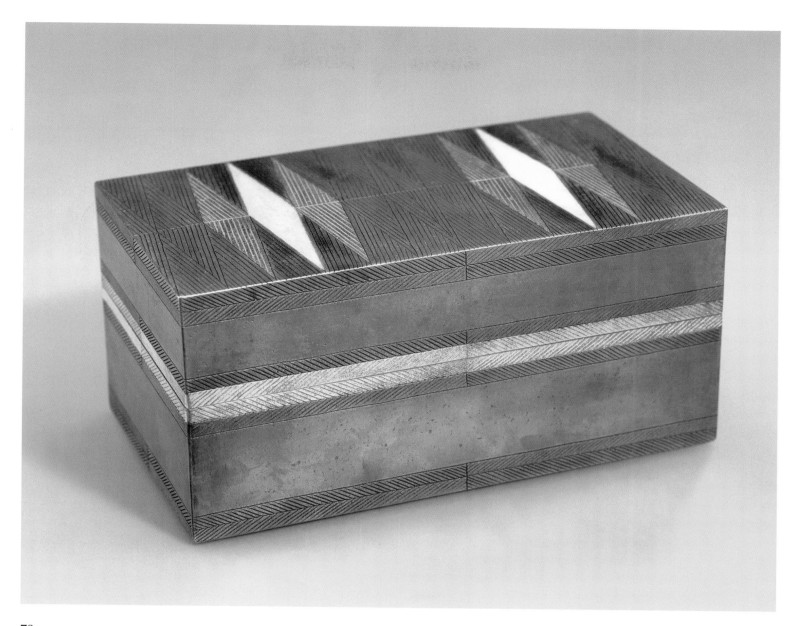

78
Oblong box with incised line pattern, 1962
Naitō Shirō (1907–88)
Brass

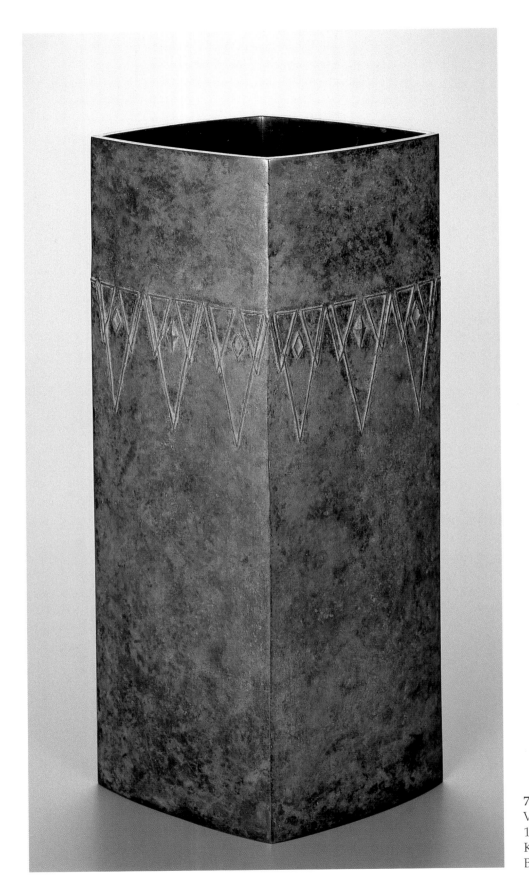

79
Vase with square sides and diamond motif,
1963
Katori Masahiko (1899–1988)
Bronze

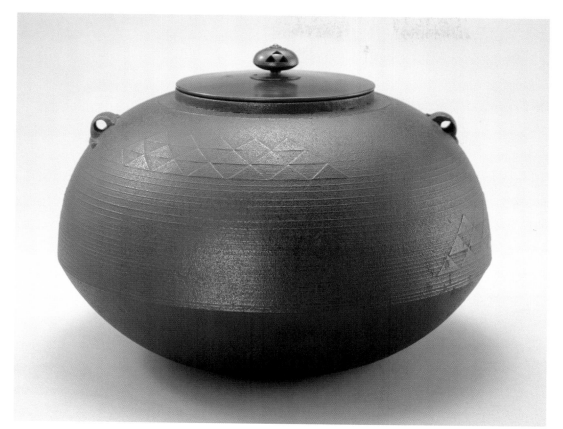

80
Kettle for tea gatherings with triangular wave pattern and jewel-shaped knob, 1965
Nagano Tesshi I (1900–77)
Iron

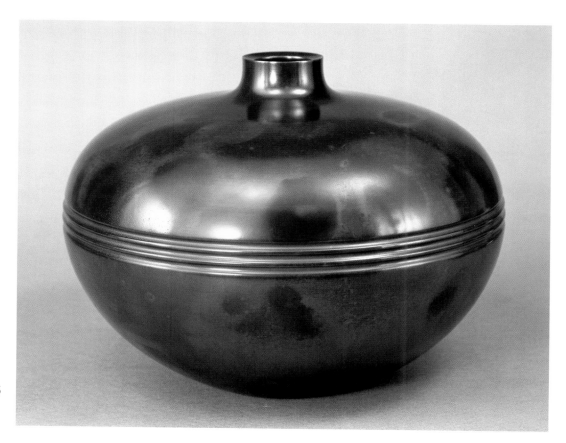

81
Vase with horizontal stripes, 1965
Takamura Toyochika (1890–1972)
Bronze

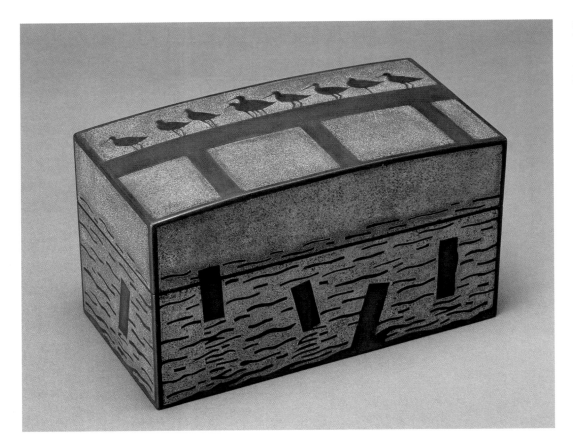

82
Letter box with snipe design, 1967
Masuda Mitsuo (b. 1909)
Wrought iron with silver inlay

84
Vase, 'Sea Breeze' (*Shiokaze*) 1986
Ōsumi Yukie (b. 1945)
Hammered silver

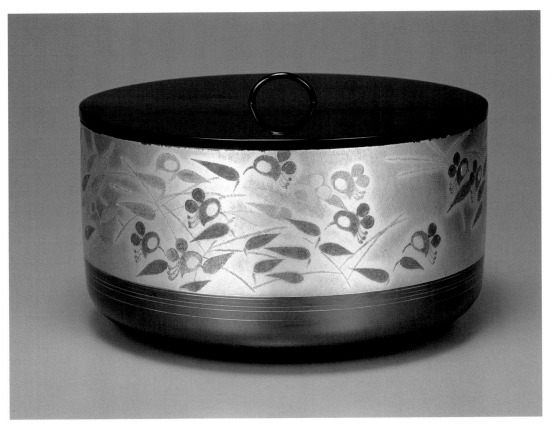

83
Water jar for tea gatherings with dayflower design, 1977
Kashima Ikkoku (1898–1996)
Silver, and copper and silver alloy (*rōgin*) with textile-imprint inlay (*nunome zōgan*)

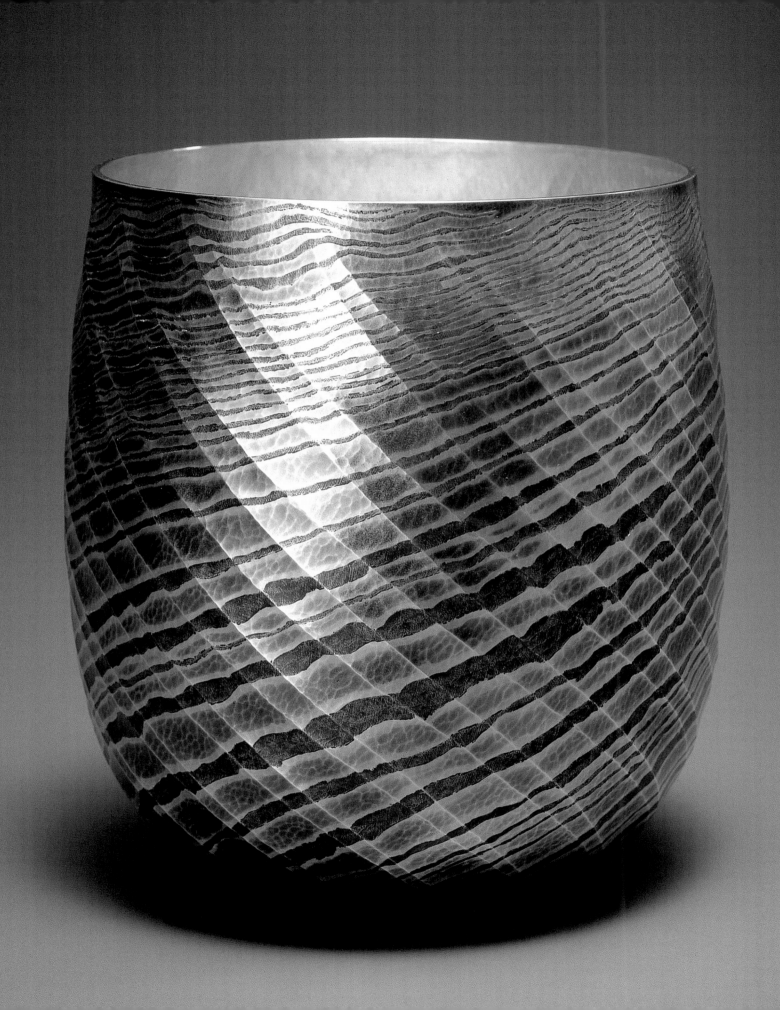

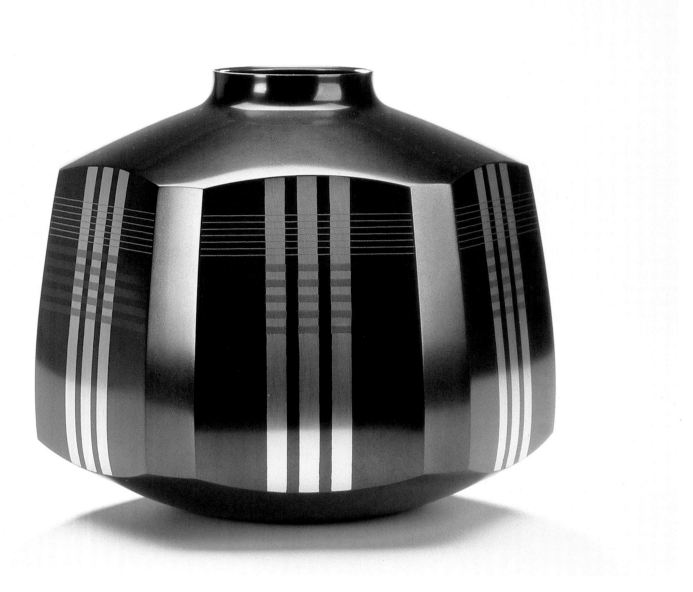

85
Vase with stripe design, 1988
Nakagawa Mamoru (b. 1947)
Caste copper inlaid with copper
and silver alloy (*rōgin*)

86
Flower vase, 1992
Saitō Akira (b. 1920)
Copper and silver alloy (*rōgin*),
lost-wax technique

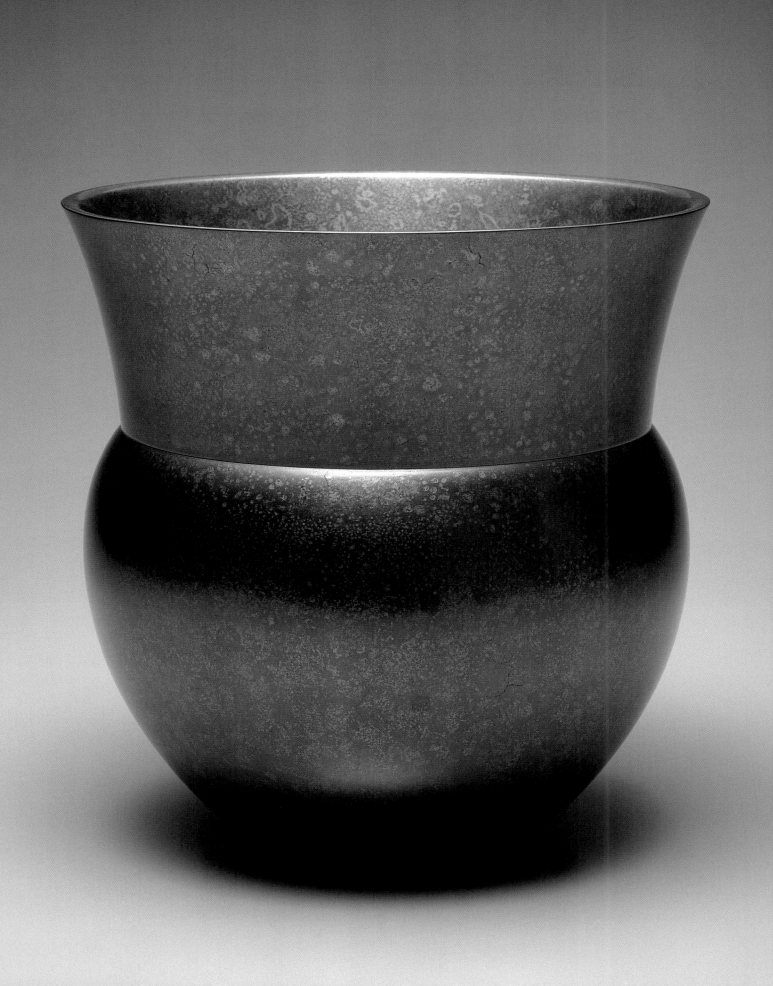

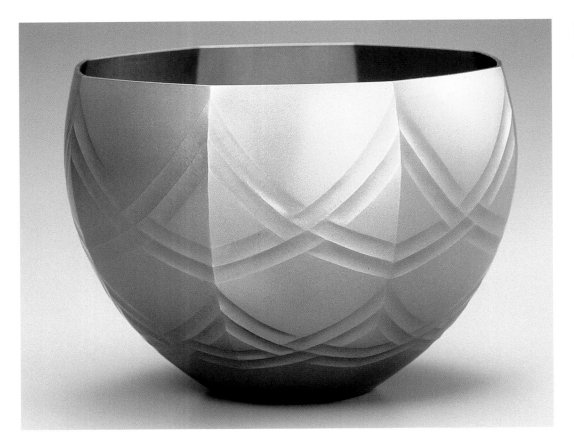

87
Bowl, 1997
Okuyama Hōseki (b. 1937)
Copper and silver alloy (*rōgin*)

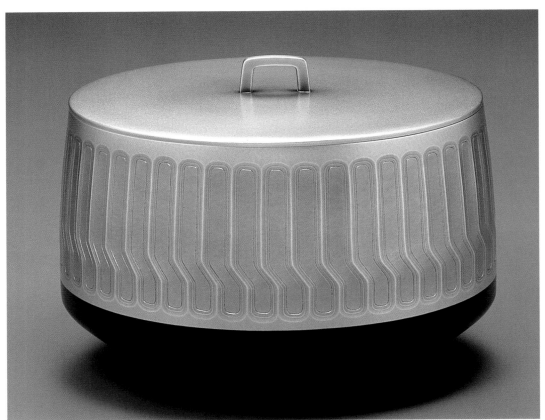

89
Water jar for tea gatherings, 1999
Tanaka Masayuki (1947–2005)
Welded silver and copper and gold
alloy (*shakudō*)

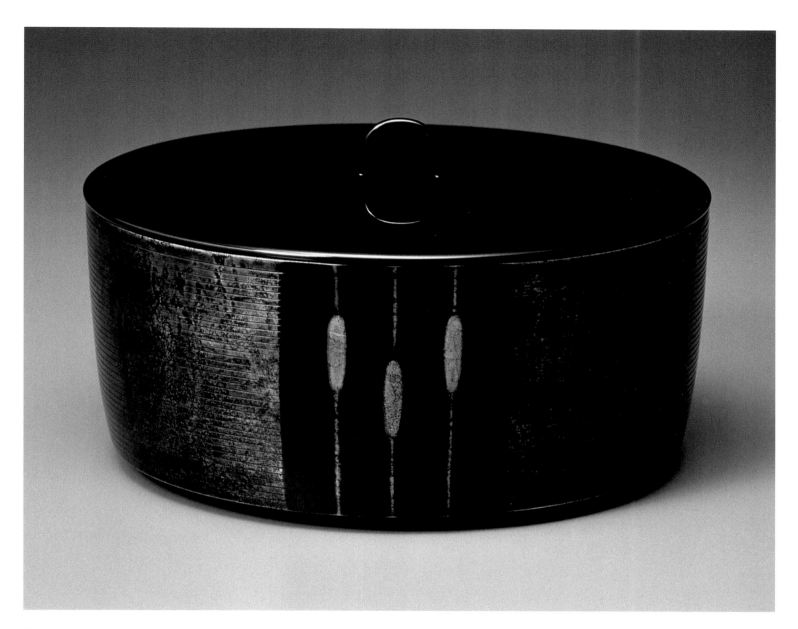

88
Water jar for tea gatherings with horizontal line design, 1998
Uozumi Iraku III (b. 1937)
Copper and tin alloy (*sahari*)

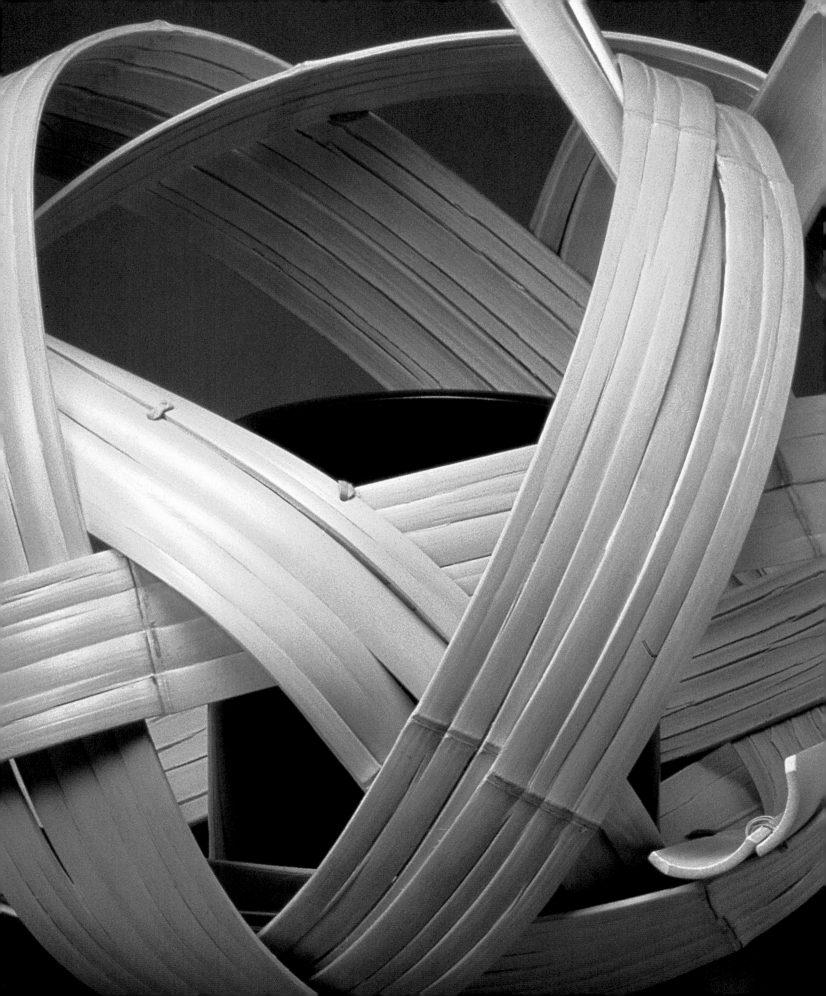

WOOD AND BAMBOO

Japan is often referred to as a 'wood culture'. Its varied geography produces an abundance of different trees, each with its own qualities that can be exploited through woodwork. Coniferous trees include cypress, cedar and pine; and broad-leaf trees include paulownia, mulberry, zelkova and chestnut. For woodworking, these are classified as hardwoods (mulberry, zelkova and persimmon) or softwoods (cedar, cypress and paulownia). Foreign woods such as ebony are also used.

A tree is typically left for several years after it is felled. It can then be cut either with the grain, which produces regular patterns, or across the grain. In general, the outer section of the trunk produces more attractive patterning. Three main methods of woodworking are used: carving from the block (as exemplified by the work of Nakadai Zuishin, cat. no. 95), turning (Kawagita Ryōzō, cat. no. 91), and bentwood work. This last method is sometimes referred to as 'hoop-built core' (*magewa-zukuri*) and is often combined with lacquer coating, as seen in the tray by Ōnishi Isao (cat. no. 74). Decoration usually consists of carving or inlay (Akiyama Issei, cat. no. 94).

Bamboo is found over the entire inland chain, in more than 600 varieties. However, only a limited number are suitable for weaving and basketry. To prepare bamboo, the stalks are harvested in winter when there are fewer insects. The stalks are then cut into strips, dried, degreased and the nodes removed. Many different techniques are used to form a basket and part of the interest lies in how these techniques are combined. The three most important are: weaving split strips; cutting round, unsplit bamboo canes; and weaving unsplit canes.

Basketwork was already produced in Japan during the prehistoric Jōmon period. Ceramic vessels found inside baskets excavated at Higashi Myō, Saga prefecture have been radiocarbon-dated to the Initial Jōmon period, about 8000 BC. Then, little survives of basketry work until the early modern period, when there was a revival of the medium based on imports from Ming China, particularly into the Kansai area.

During the Edo period (1600–1868), basket-making particularly flourished in the merchant city of Osaka and production is still partly centred there today. Other major areas are Tokyo and Oita prefecture in Kyushu, each with a different character and technical specialization. For several decades now, much of the demand for bamboo baskets has been from outside Japan. Recently, however, there has been a growing base of appreciation in Japan itself and the bamboo arts look set to enjoy a strong future.

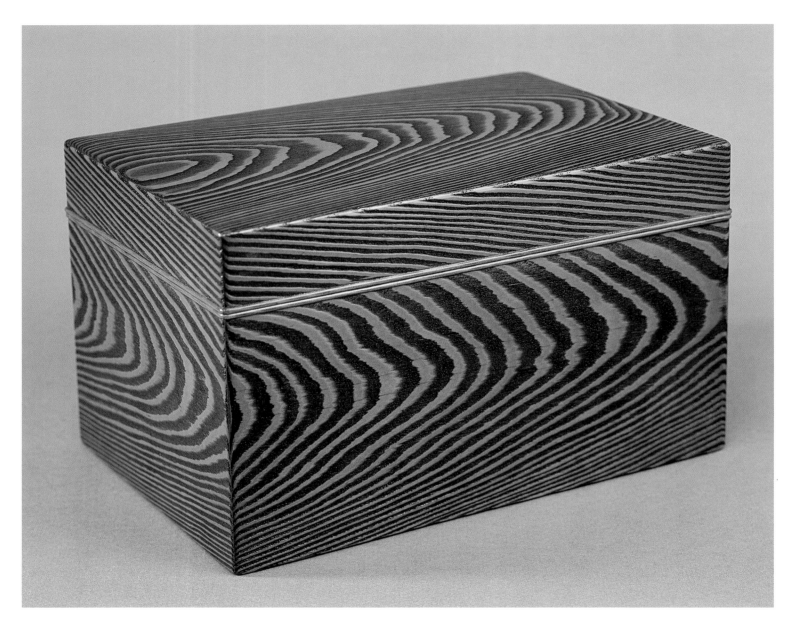

90
Box for utensils for tea gatherings, 1964
Himi Kōdō (1906–75)
Japanese larch, sand-polished

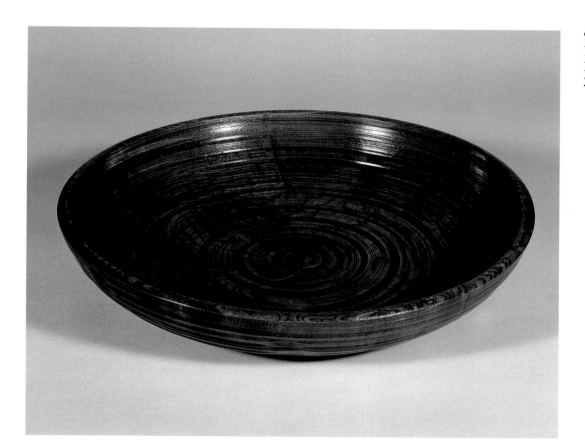

91
Large bowl, 1964
Kawagita Ryōzō (b. 1934)
Zelkova wood with clear lacquer

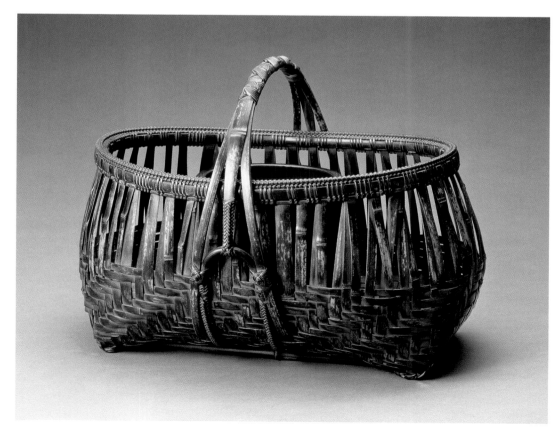

92
Flower basket, 'Fence' (*Magaki*),
1968
Shōno Shōunsai (1904–74)
Bamboo, double-wall weave
(*musō ami*)

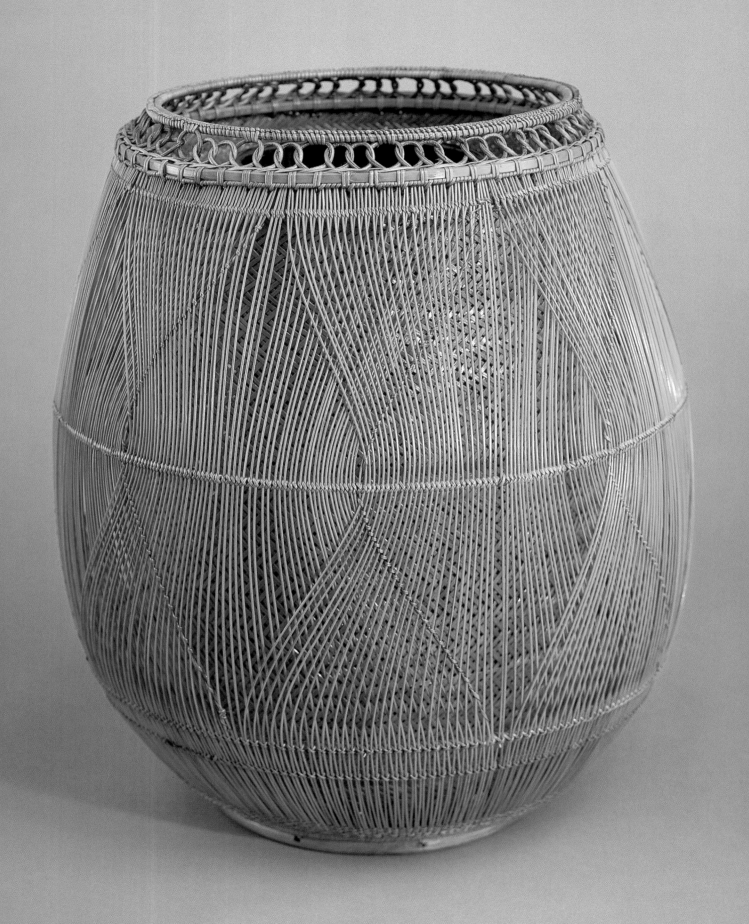

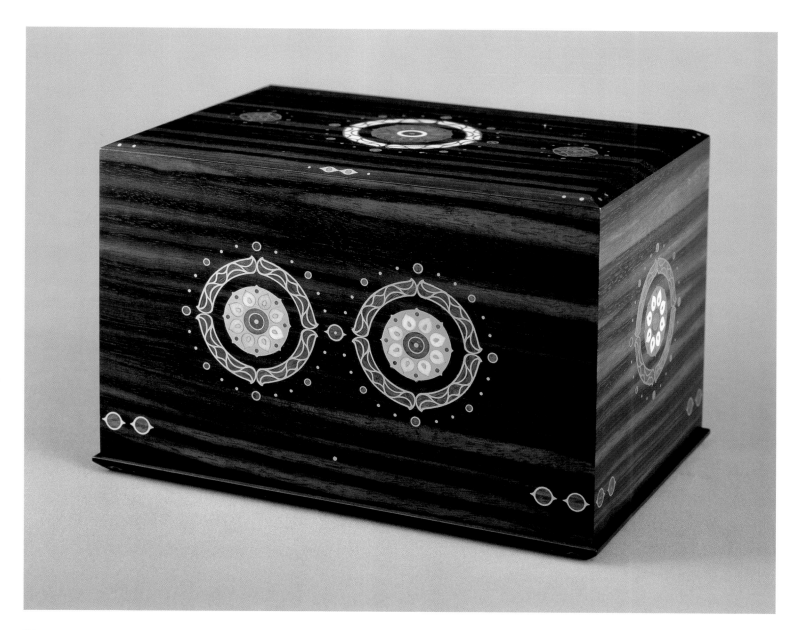

94
Seal box with inlaid flower circle design, 1981
Akiyama Issei (1901–88)
Striped ebony wood

93
Flower basket with leaf pattern in the weave, 1972
Maeda Chikubōsai II (1917–2003)
Bamboo

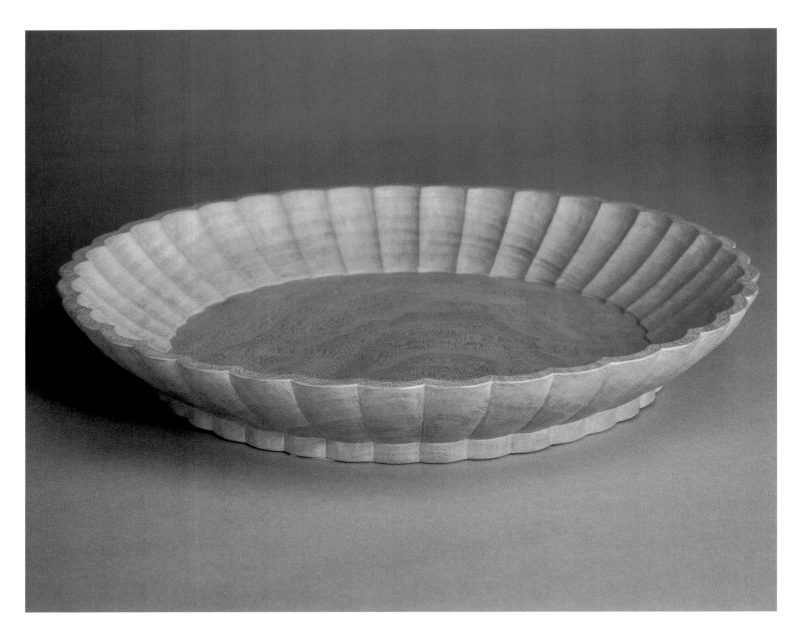

95
Flower-shaped bowl, 1981
Nakadai Zuishin (1912–81)
Paulownia wood

96
Small box. 1993
Ōno Shōwasai (1912–96)
Mulberry and mottled persimmon wood

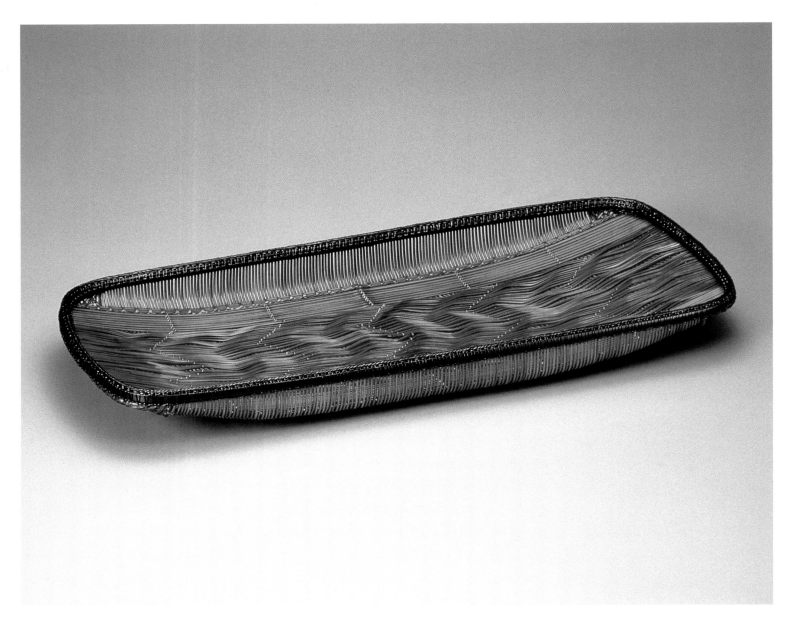

97
Basket, 'Shallow Stream' (*Seseragi*) with narrow wave design, 1997
Katsushiro Sōhō (b. 1934)
Split bamboo technique (*masawari*)

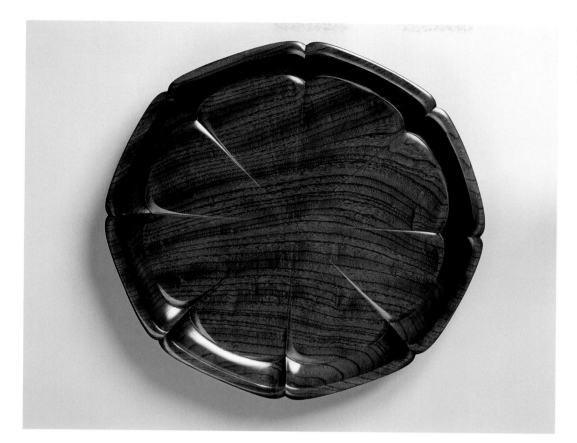

98
Tray with line design, 2000
Murayama Akira (b. 1944)
Zelkova wood with clear lacquer

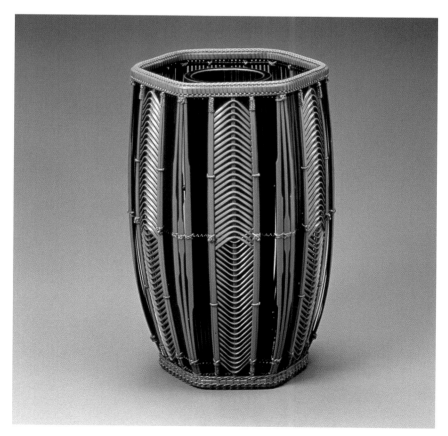

99
Hexagonal flower basket with herringbone design,
2001
Hayakawa Shōkosai V (b. 1932)
Bamboo

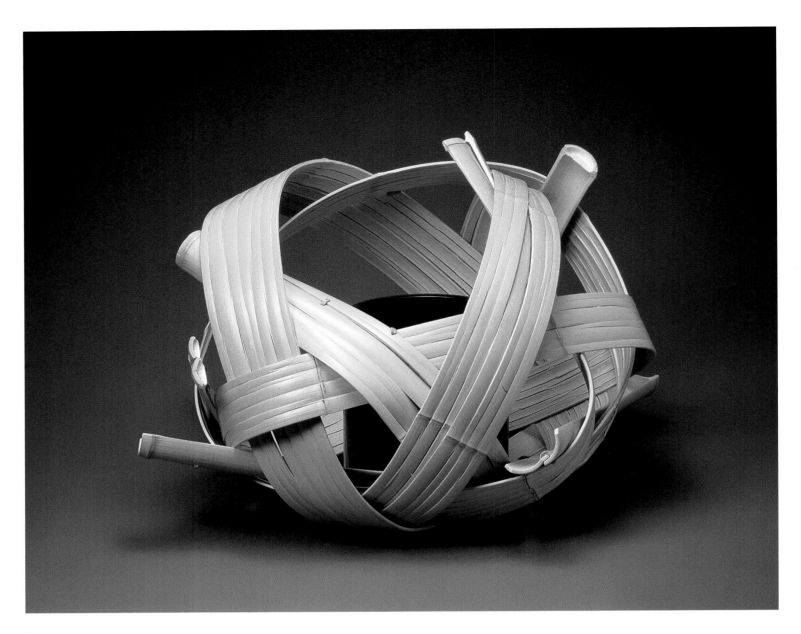

100
Flower basket, 'Open-mouthed Dragon' (*Donryū*), 2002
Iizuka Shōkansai (1919–2004)
Bleached bamboo (*shirasabi*)

101
Shikishi box with wood mosaic pattern, 2002
Nakagawa Kiyotsugu (b. 1942)
Aged cedar wood

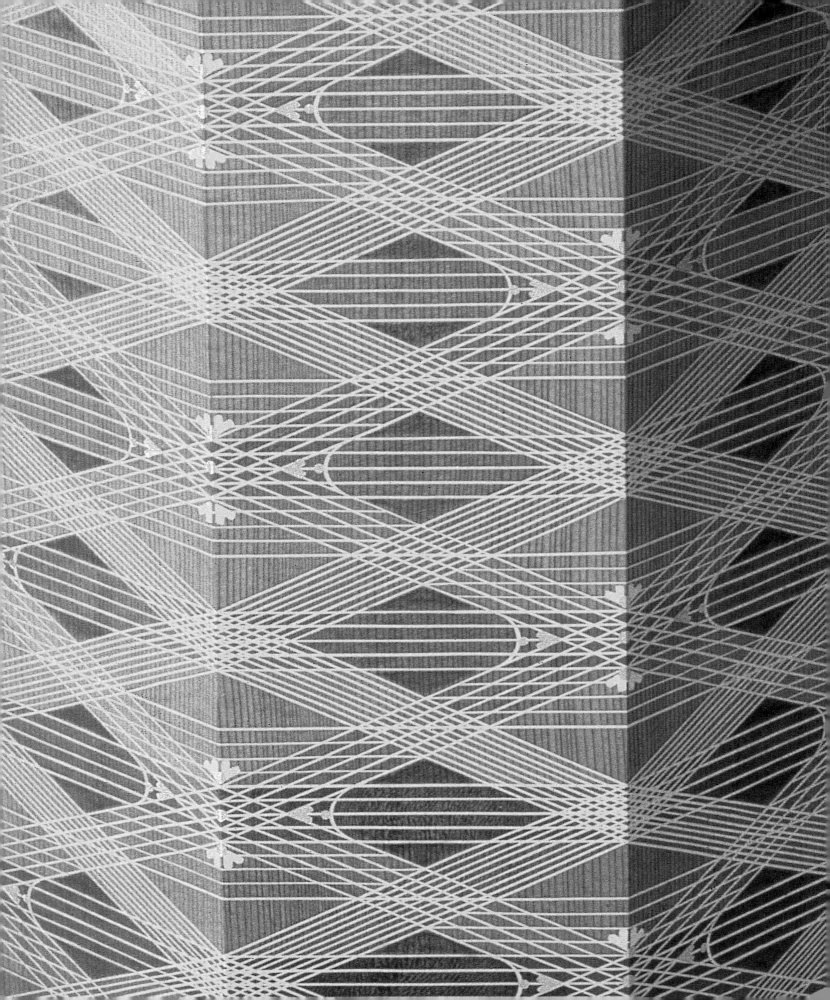

OTHER CRAFTS

In Japan there is an impressive range of doll types from various historical periods, each with a different associated meaning: prehistoric Jomon figurines called *dogu*; medieval *hina* paper dolls used for protection or for purification; decorative dolls used in the Dolls Festival (*hina matsuri*) held on 3 March every year to celebrate Girls Day; contemporary animated doll figurines and robots. Modern makers of art dolls draw from these traditions to create a wide variety of character dolls, using techniques of carving in wood, modelling in special paste made from paulownia wood sawdust, and applying beautifully decorated fabrics.

The use of cut metal foil, or *kirikane*, in Japan dates back to the Heian period (AD 794–1185) and was a decorative technique principally applied to Buddhist sculptures, implements, paintings and sutras. Very thin strips of gold or silver foil 1/1000 mm in thickness are attached to an object to create a refined yet opulent feel. The strips are extremely fine and tear easily and must be handled with utmost care, using tweezers and knives made of bamboo. The technique was particular-ly popular from about 1100–1500, but fell out of fashion due to its labour-intensive nature. *Kirikane* techniques were preserved only in Kyoto at two temples, Higashi Honganji and Nishi Honganji. Recently the technique has enjoyed a revival and artist Eri Sayako (cat. no. 109) has discovered new expressive applications that are quite distinct from its Buddhist origins.

Glass beads were first introduced into Japan from the Korean peninsula at the end of the Early Yayoi period, *c.*200 BC. From the early 1800s, cut glass (*kiriko*) started to be made in two distinctive styles in the Satsuma domain (modern Kagoshima prefecture) and Edo (modern Tokyo). The techniques still connect to those used today in works by Shirahata Akira (cat. no. 110) and Aono Takeichi (cat. no. 111). Three forming techniques in particular have become popular with artists: free blowing, mould blowing and *pate de verre*. This last technique, used by Ishida Wataru (cat. no. 112), is made from paste composed of ground glass mixed with a binding agent, which is placed in a mould and fired in a kiln to 1000°C.

102
Doll, 'In Leisure' (*Nodoka*), 1958
Hirata Gōyō II (1903–81)
Paulownia wood, paulownia sawdust paste (*tōso*),
cloth, powdered shell (*gofun*)

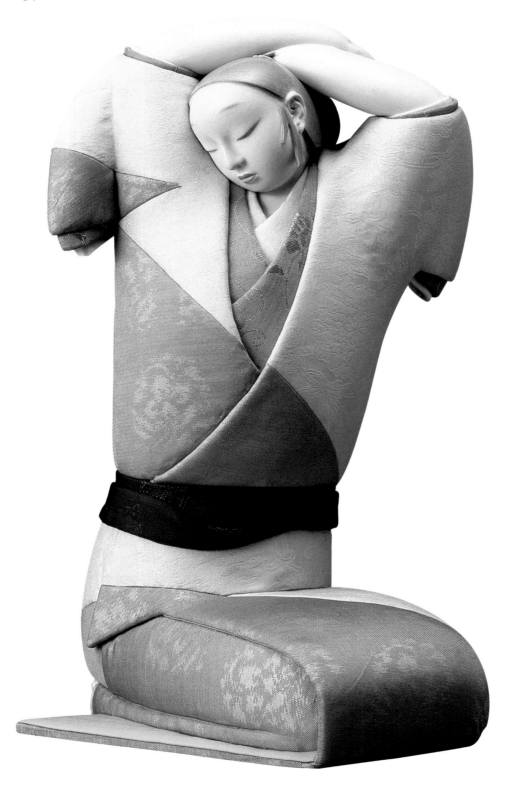

103
Doll, 'Ōmori gift' (*Ōmori miyage*), 1958
Kagoshima Juzō (1898–1982)
Papier mâché

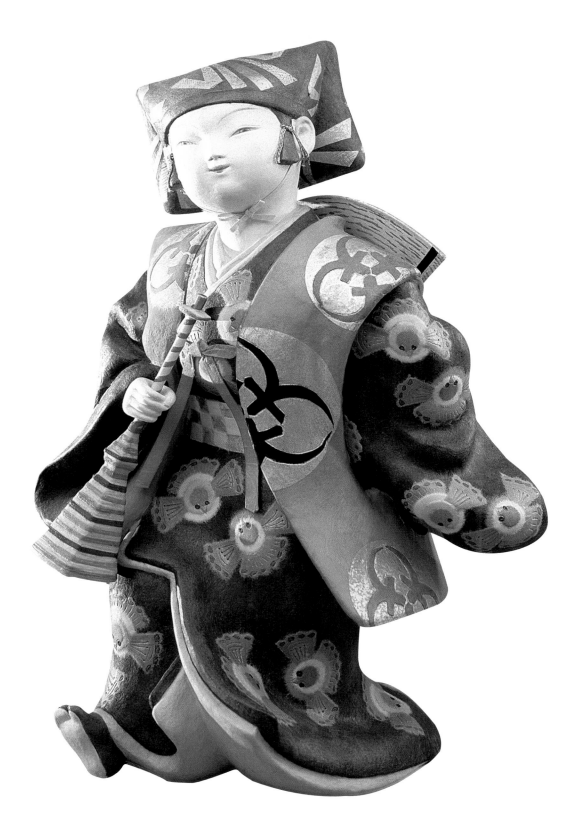

104
Doll, 'Old Mirror' (*Kokyō*), 1963
Hori Ryūjo (1897–1984)
Paulownia wood, paulownia sawdust paste (*tōso*),
cloth, powdered shell (*gofun*)

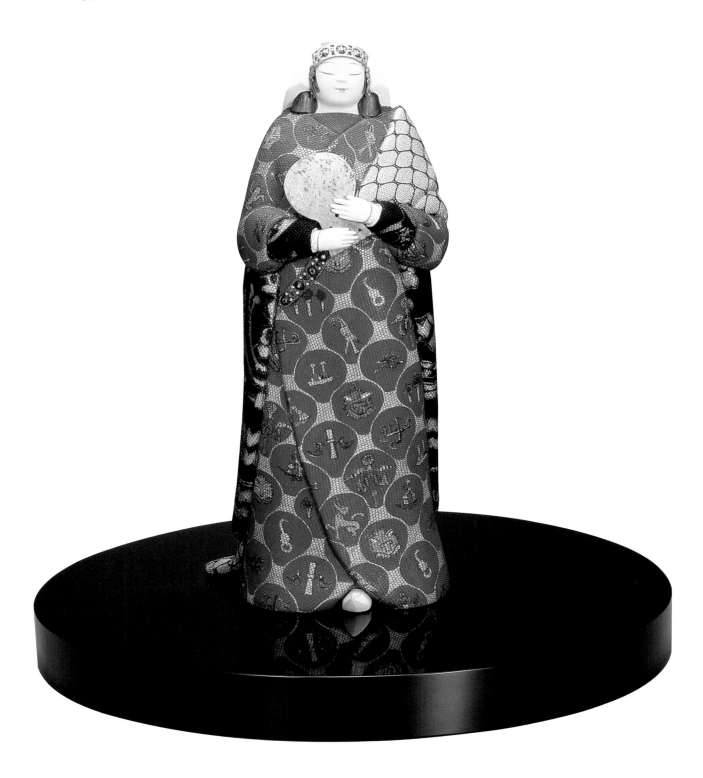

105
Doll, 'Naming a Child' (*Meimei*), 1980
Akiyama Nobuko (b. 1928)
Paulownia wood sawdust paste (*tōso*)

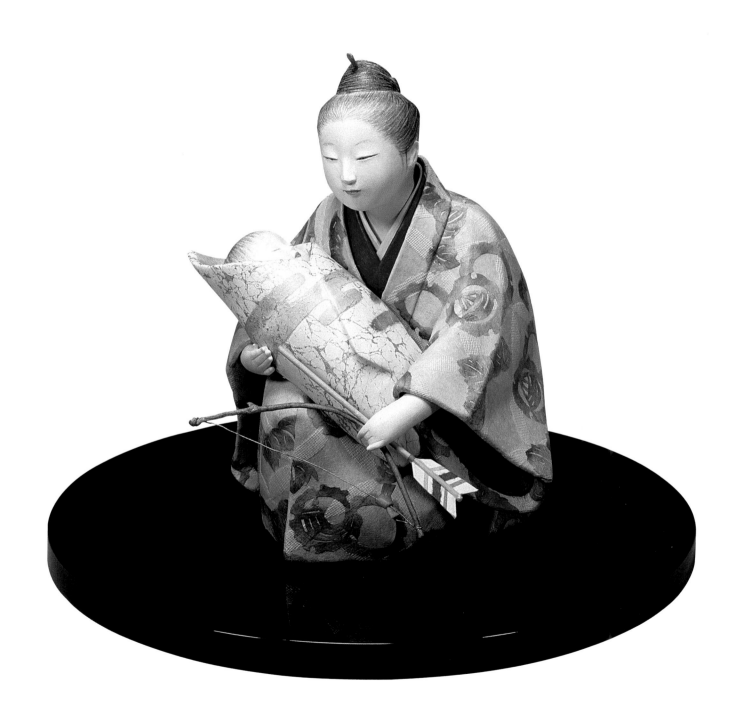

106
Doll, 'Eguchi', 1984
Hayashi Komao (b. 1936)
Paulownia wood, paulownia wood sawdust paste
(*tōso*), cloth, powdered shell (*gofun*)

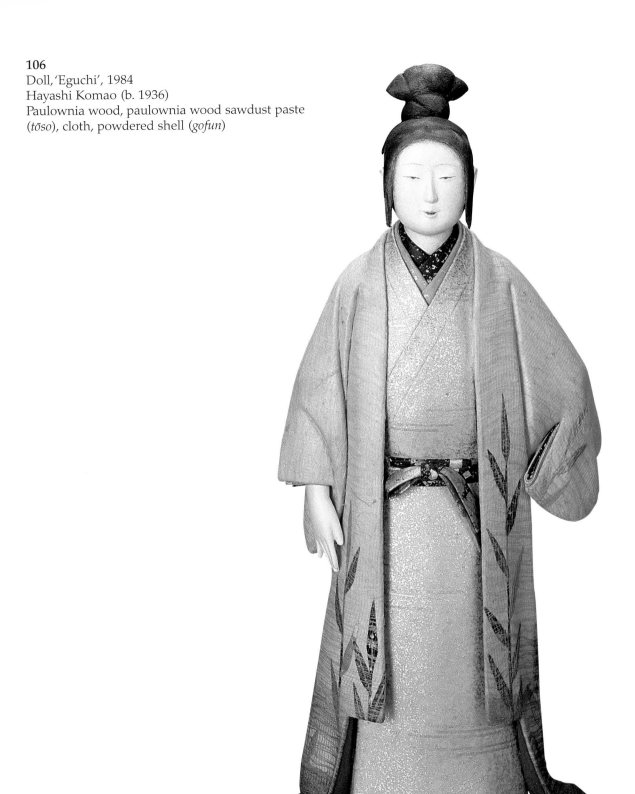

107
Doll, 'Turning Autumnal' (*Aki meku*)
Serikawa Eiko (b. 1928)
Paulownia wood, cloth

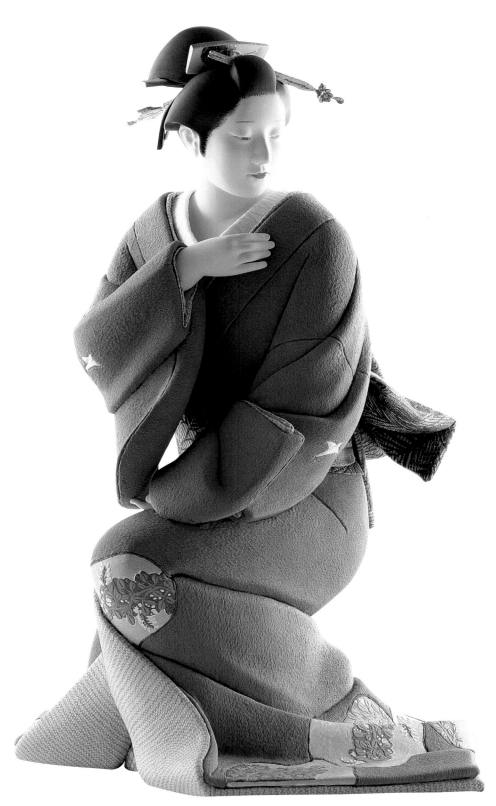

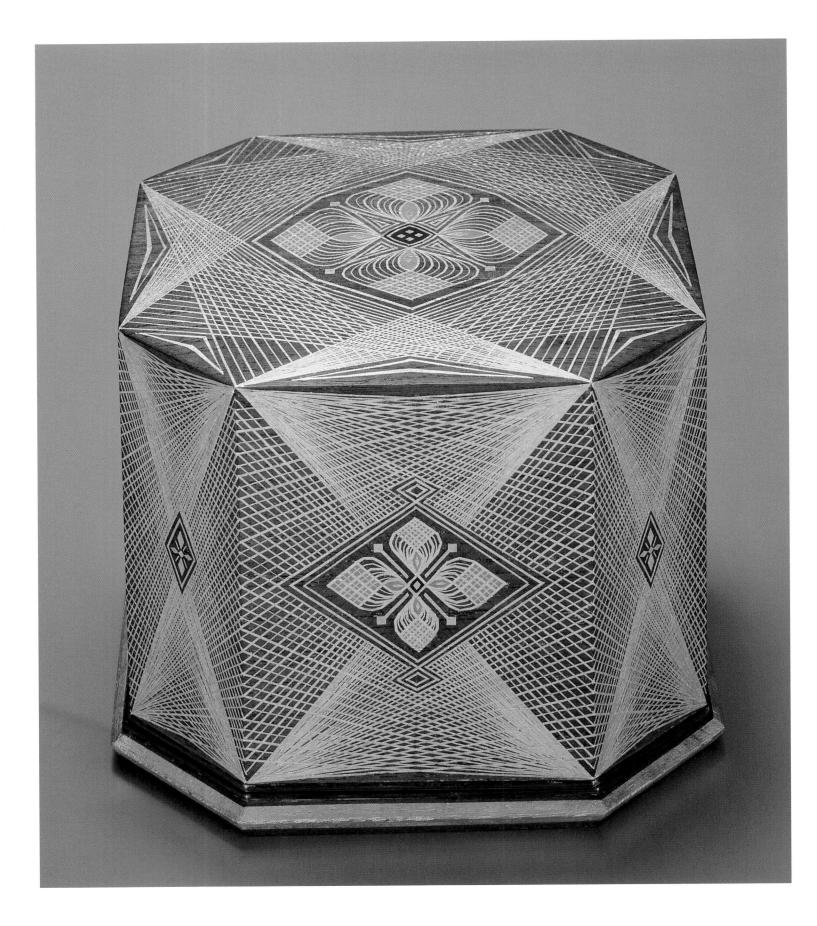

109
Ornamental box, 1991
Eri Sayoko (b. 1945)
Wood with cut metal-foil
decoration (*kirikane*)

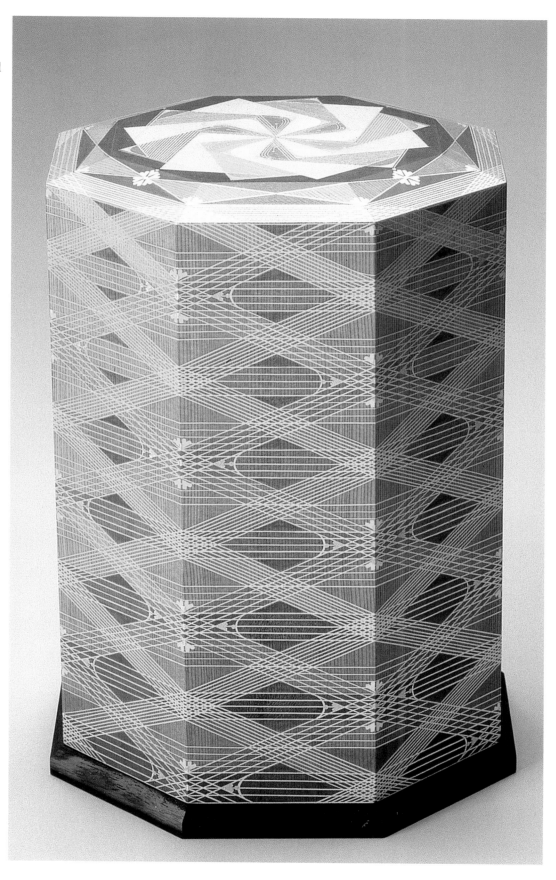

108
Small box with rape-flower design,
1963
Saida Baitei (1900–81)
Wood with cut metal-foil
decoration (*kirikane*)

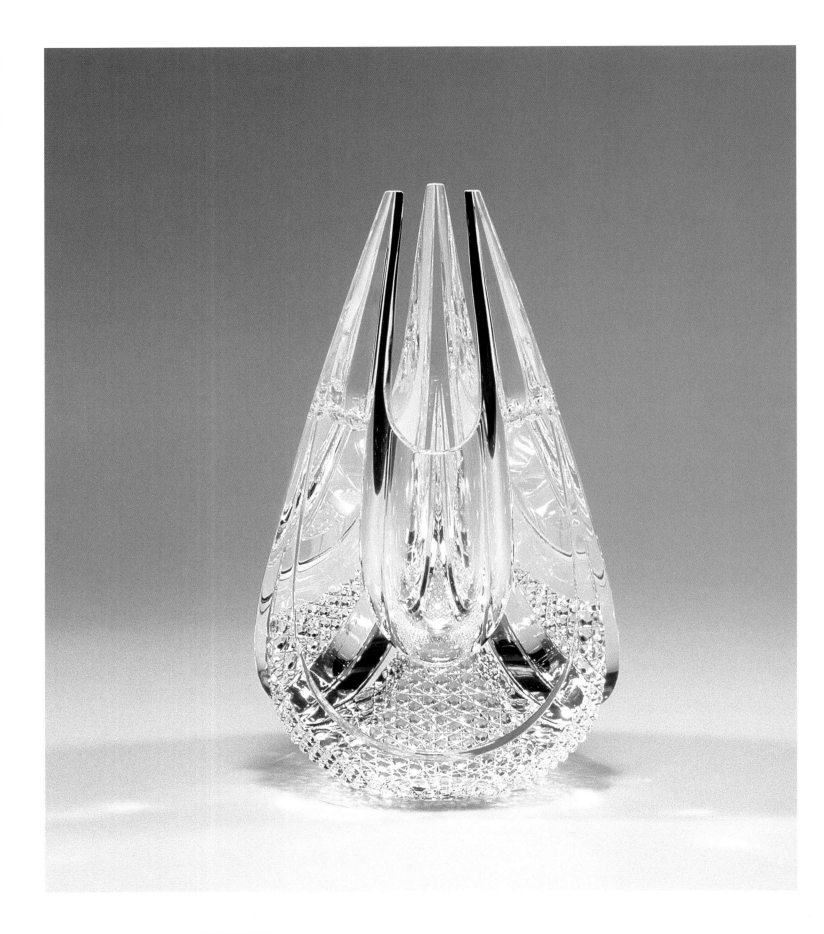

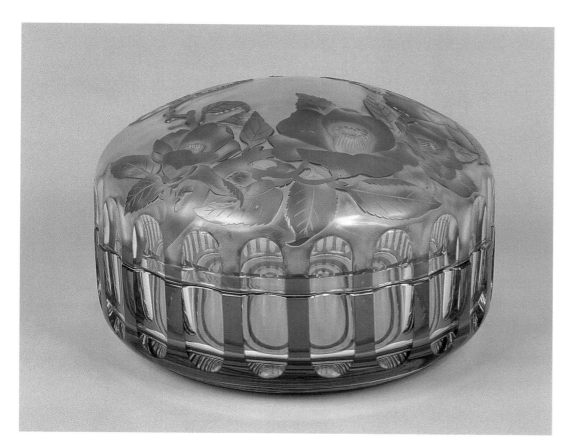

111
Covered container
with camellia design, 1993
Aono Takeichi (b. 1921)
Red cut overlay glass

112
Covered container, 'White Age
(Age 99)', 2000
Ishida Wataru (b. 1938)
Glass, *pate de verre*

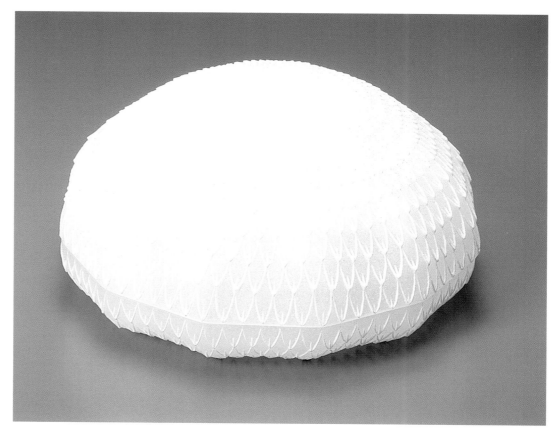

110
Vase with three points, 1988
Shirahata Akira (b. 1946)
Crystal glass

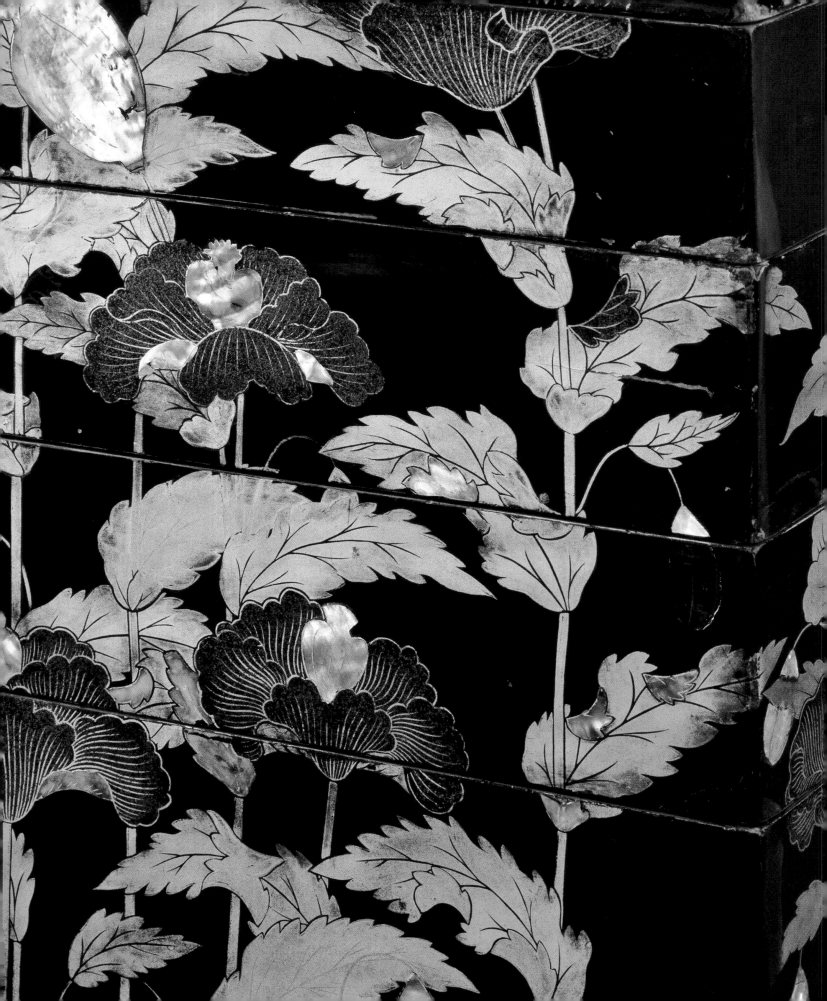

CRAFT HERITAGE

In Japan today the range of art-craft expression is particularly rich. If they so choose, artists are able to draw on an astonishingly wide variety of examples from all historical periods. However, contemporary Japanese craft artists are not hidebound by their country's past; rather, they can be set free by inspiration from such a diverse spectrum of materials, techniques and designs. In part, this reflects how Japanese material culture and artistic traditions have from prehistoric times been influenced from Korea, China, South and Southeast Asia and beyond. Since Japan reopened to sustained contact with a wider world in the mid-1800s, international cross-influences have proliferated. This has produced hybrid and fascinating developments in techniques, uses of material and patterns not otherwise possible. The constant international dialogue has proved a fertile laboratory from which different successive styles have emerged. Within Japan itself, the strong emphasis traditionally placed on material, texture, process, and sense and sensation during use, have all sustained the vigour of art crafts.

The British Museum's collections include some 30,000 objects that relate to Japan. The small selection illustrated in this section, which includes two loaned objects, has been carefully chosen to suggest historical resonances with the modern craft objects presented in the rest of the book. Interestingly, while many swordsmiths are designated Living National Treasures, swords are not included in the Japan Traditional Art Crafts Exhibition. Instead, sword makers have a separate association to support their craft, Nihon Bijutsu Tōken Hozon Kyōkai (Society for the Preservation of Japanese Art Swords). Swords are not collected or displayed at the Craft Gallery of the National Museum of Modern Art, Tokyo, but rather at the Tokyo National Museum. The sword included here was made in 1963 by the Living National Treasure swordsmith Miyairi Akihira (1913–77).

114
Dish with bull's-eye motif, early 1800s
Stoneware with slip and glaze, Seto ware

113
Flower vase, 1580–1620
Stoneware with natural ash-glaze, Iga ware

115
Lobed dish with design of birds and flowers, late 1600s
Porcelain with overglaze enamels, Hizen ware, Ko-Kutani style

116
Dish with design of maple
leaves and rushing stream,
*c.*1700–20
Porcelain with underglaze
cobalt and overglaze enamels,
Nabeshima ware

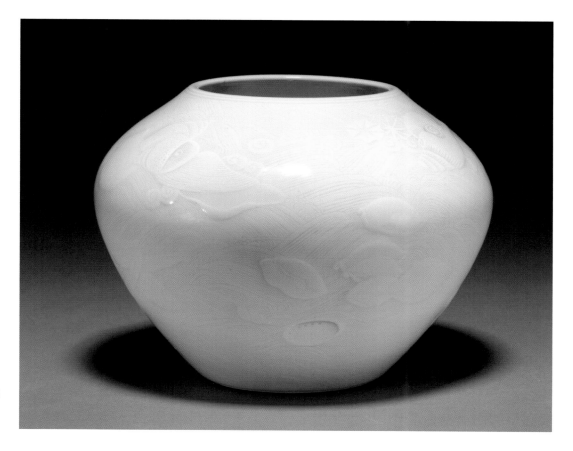

117
Vase with shell design, *c.*1900
Seifū Yohei III (1851–1914)
Porcelain with glaze

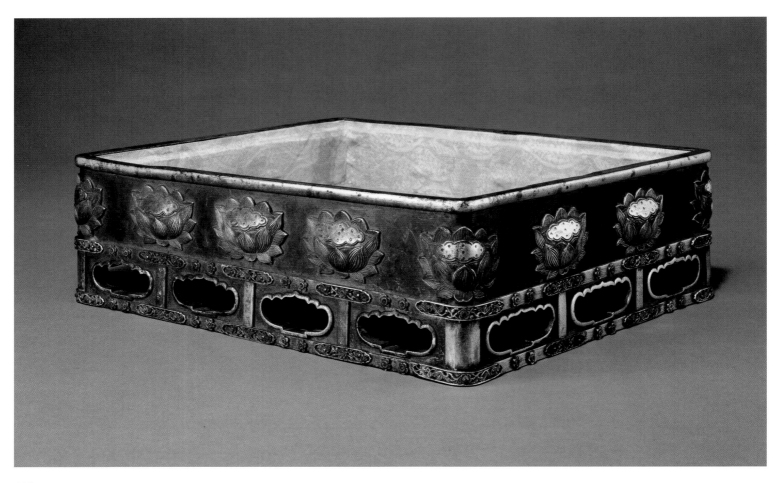

118
Rital tray (*suebako*), *c.*1400s
Wood, gilt-bronze, lacquer, silk

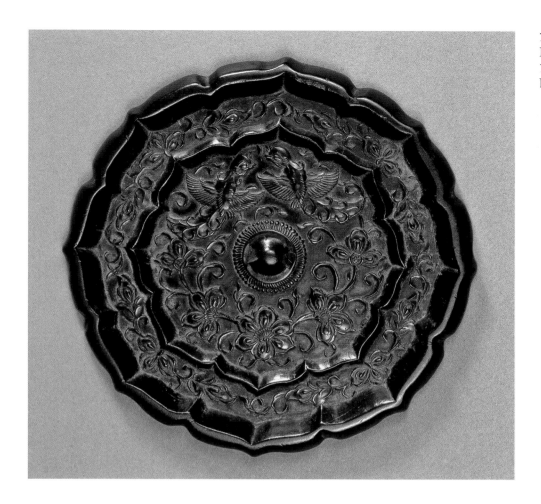

119
Mirror with birds and butterflies,
1400s–1500s
Bronze

120
Katana blade, 1963
Miyairi Akihira (1913–77)
Steel

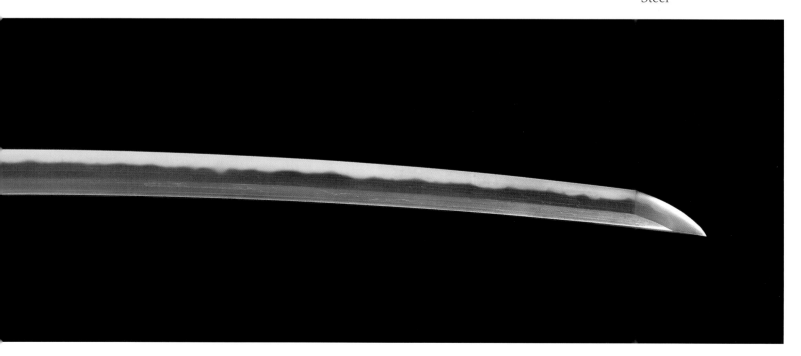

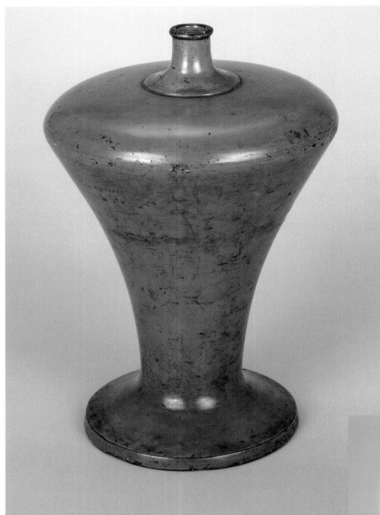

121
Saké pourer, 1400s
Wood, lacquer, Negoro style

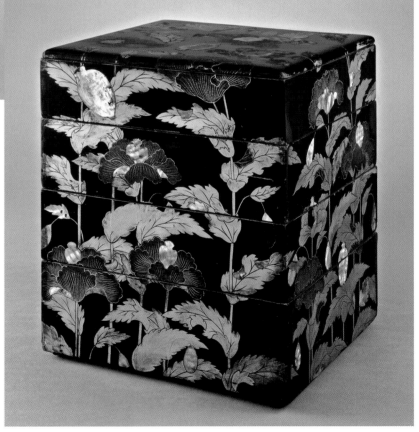

122
Tiered picnic box with design of poppies, late 1600s
Wood, lacquer, shell inlay

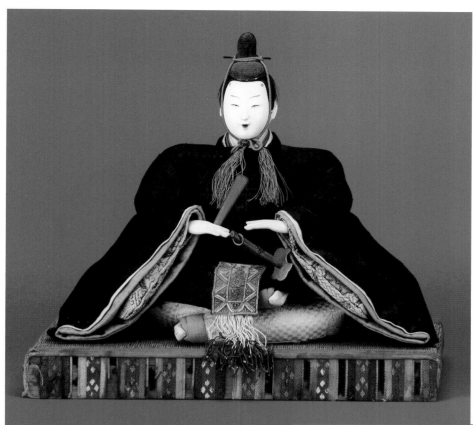

123
Emperor and empress dolls, *c.* early 1800s
Wood, powdered shell (*gofun*), textile

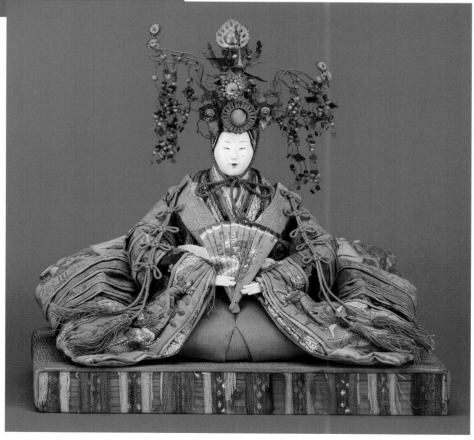

Craft Techniques

Ceramics

Bizen ware

Bizen ware is a high-fired unglazed stoneware produced in the Inbe area of Bizen, modern Okayama prefecture. Bizen production began in about the late AD 1000s and has continued uninterrupted to the present day. Everyday utensils such as jars and mortars were produced during the Kamakura (1185–1333) and Muromachi (1333–1573) periods. Since the Momoyama period (1573–1600), however, large quantities of specialty wares have been created for tea gatherings. Minute differences in the mineral content of the iron-rich clay and the variable temperature of the kiln give the unglazed wares their distinctive and unpredictable surface patterns, which have always been admired by tea masters. In the Edo period (1600–1868), glazed Bizen wares such as white Bizen (*shiro-Bizen*) and blue Bizen (*ao-Bizen*) were also produced. In the Meiji era (1868–1912), Bizen wares often had ornamental additions to the ceramic surface. It was not until the recent Shōwa era (1926–89) that there was a revival of the older, more austere Bizen ware production by Kaneshige Tōyō (q.v.), which has lead to its current popularity.

Hagi ware

The Hagi kilns are located in Hagi city in modern Yamaguchi prefecture. They began production in the Momoyama period (1573–1600) and developed into a substantial industry by the beginning of the 1600s, spreading to neighbouring Nagatoshi. Hagi wares are made from local soft *daidō* clay and are typically finished with clear ash glaze, or with a milky feldspathic white glaze called white Hagi glaze. In general, the wares are simple and subdued. The vessels are porous and vary somewhat in colour as a result of the highly refractory nature of the clay and the low firing temperatures of the kiln.

Hakuji (white porcelain)

Hakuji refers to undecorated white porcelain wares covered with transparent high-fired glaze. The Arita-area kilns started producing this type of ware in the first half of the 1600s in imitation of earlier Chinese examples.

Iro-e (overglaze enamels)

Iro-e refers to the technique of applying polychrome enamels to the surface of a ceramic vessel. Colours such as red, yellow and green are painted with a brush onto an already glazed and fired ceramic surface. The vessel is then re-fired in a muffle kiln at a lower temperature. This firing temperature is dependent on the chemical composition of the enamel colour, and ceramics decorated with many overglaze colours such as Kakiemon or Imaemon wares are fired multiple times. The overglaze-enamel technique was introduced to Japan from China, probably through Nagasaki, in the 1640s, and the first overglaze enamel porcelains were produced in the Arita-area kilns. Representative overglaze-enamel ceramics include Kakiemon-, Iro Nabeshima- and Ko-Kutani-style wares.

Kinrande (brocade style)

Kinrande refers to a method of decorating a surface by applying thick gold leaf and then firing the vessel. The name derives from brocade textiles where gold thread is woven into the fabric. The technique was first developed in Ming-period China (1368–1644). In a related method known as *kinsai,* gold enamel is substituted for gold leaf.

Kin'yō

Kin'yō refers to a silica-rich celadon glaze with a milky lavender colour, sometimes called *densei* glaze. It was famously produced in China during the Northern Song, Jin and Yuan periods (960–1368). The term *kin'yō* is the Japanese reading of the Chinese place-name Junzhou, the kiln group in Henan province where these wares were originally fired.

Neriage (marbled clay)

Neriage is a decorative method that uses the layering of different coloured clays to create a striped, patterned or marbleized effect. The method was originally developed in Tang-period China (618–907). The marbled-clay technique was first used in Japan from the late 1500s in the kilns in the Mino region.

Nigoshide

The term *nigoshide* is of local Arita-area origin and is used to refer to the milky white body typical of high-quality Kakiemon-style porcelains from the later 1600s. The name originally derives from the white cloudy colour of water used to rinse rice. Japanese porcelain produced in

the Arita-area kilns often has a blue sheen that derives from two factors: the use of the underglaze cobalt-blue colourant, and the iron content of the clear glaze. As a rule, the extreme milky whiteness of the *nigoshide* body is not used in combination with underglaze cobalt blue. It therefore retains its bright whiteness even after glazing, which helps to enhance the colour of the overglaze enamels. The use of *nigoshide* porcelain ended in the early 1700s when the classic Kakiemon style ceased to be produced. The style was revived in 1953 through the efforts of Sakaida Kakiemon XII (1878–1963) and Kakiemon XIII (1906–82)

Oribe
Oribe is a style of stoneware produced in the Mino region during the early 1600s. Oribe-type Mino-ware ceramics are considered to reflect the aesthetics of the famous Momoyama-period (1573–1600) tea master Furuta Oribe (1543–1615), although the exact origin of the name is still unclear. Oribe style generally refers to a stoneware vessel which is partially or completely covered with a greenish-blue glaze containing copper that is subsequently fired in an oxidizing kiln atmosphere. The vessel is also often ornamented with brown iron-oxide designs. Types of Oribe include *sō-Oribe*, where a vessel is completely covered with copper glaze; *e-Oribe*, where a ceramic is decorated with pictorial designs in iron oxide and copper glaze; and *aka-Oribe* and *narumi-Oribe*, where different coloured clays, glaze, slip and painted designs are combined to dramatic effect.

Sansai (tri-colour)
Sansai refers to coloured lead-based glazes which contain copper, iron and other colourants. The standard *sansai* glaze colours are green, yellow and blue, and although the name literally translates as 'tri-colour', occasionally only two colours are used. Prototypes include Chinese Tang-period (618–907) and Japanese Nara-period (710–794) tri-colour wares.

Seihakuji (blue-white porcelain)
A type of porcelain covered with a clear glaze that has a light bluish sheen. The blue sheen results from a very small amount of iron contained in the glaze mixture. Some *seihakuji* porcelains have incised or carved designs that allow the glaze to pool in the incised areas. When fired, the pooled glaze has a richer shade of pale blue,

an effect called *inchin*, or shadow blue.

Seiji (celadon)
Celadon's characteristic pale-green colour is created by a feldspathic glaze with 1–3 per cent ferric oxide that is fired in a kiln with a reduction atmosphere. Some of the finest examples of celadon wares were produced in China during the Song period (960–1279) at the Longquan-ware kilns in Fujian province. Korea, Thailand, Vietnam and Japan have also produced fine celadon wares, which are among the most prized of all ceramics.

Seto-guro (Black Seto)
Black Seto wares were originally produced during the late 1500s in the Mino area of modern Gifu prefecture. Momoyama-period (1573–1600) Black Seto wares are typically teabowls made specifically for tea gatherings. The lacquer-like black surface is achieved by removing the vessel from the kiln at the height of the firing and then cooling it in water. This process gives rise to another name, *hikidashi-guro*, literally 'pulled-out black'.

Shino
Shino is a style of stoneware produced in the Mino region during the late 1500s, in an area close to modern Tajimi city in Gifu prefecture. Shino-type Mino-ware ceramics are covered with a feldspar-rich glaze that upon firing produces a distinctive rich white colour with a pronounced surface texture. Designs are often painted onto the ceramic body before glazing in iron oxide, and these works are called *e-shino*, or 'picture shino'. Shino-style wares from the Momoyama period (1573–1600) are much coveted for use in traditional tea gatherings.

Sometsuke (underglaze cobalt-blue)
Sometsuke (literally 'dyed pattern'), or underglaze cobalt-blue decoration, is the application of cobalt oxide directly onto the unfired ceramic surface. The vessel is then covered with a clear glaze and fired to a high temperature of between 1200 and 1250 degrees centigrade. The underglaze cobalt-blue decorative technique was first developed in China at least by the Tang period (618–907). It was first used in Japan relatively late, with the development of porcelain in the early 1600s in the Arita area. Underglaze cobalt-blue decorated ceramics became increasingly popular and the technique was quickly transmitted to the Seto and Kyoto area kilns.

Tamba ware

Tamba ware has been produced from about the late AD 1000s in kilns located in present-day Imada-machi, Hyōgo prefecture. Throughout this long history, production has been focused on everyday utensils, such as storage jars and mortars. During the Momoyama period (1573–1600), however, certain kilns also produced teabowls and other specialized items. Medieval Tamba jars were typically constructed by the coil method and then high fired (*yakishime*) without applied glaze. In the Edo period (1600–1868), climbing kilns were used to fire ceramics covered with ash and other glazes. The kilns continue to operate today, albeit on a somewhat reduced scale.

Yūri kinsai

Yūri kinsai is a decorative technique whereby gold leaf or gold enamel is applied to a glazed ceramic surface, glazed again and then fired at a lower temperature – effectively locking the gold decoration between two layers of glaze. This has the twin effect of making the decoration more durable and enhancing its visual effect through the clear glaze. The technique should be distinguished from classic *kindeisai*, in which designs are applied using gold enamel in an overglaze process.

Textiles

Bashō-fu (abaca cloth)

Bashō fabric is traditionally woven from fibres of the banana plant (abaca) and made into textiles worn by all classes. Traditionally, kasori patterns were most often dyed in brown, but also occasionally in red and blue depending on the social status of the wearer. Abaca cloth was traditionally produced in the Okinawan island chain of southern Japan (the former Ryūkyūan kingdom) and the neighbouring Amami islands. In recent years, however, production has been primarily concentrated in the Kijoka district of Ōgimi village, where there is an active apprenticeship programme to help ensure the preservation of the technique.

Bingata

The *bingata* stencil technique employs a colour scheme and aesthetic particular to the Okinawan islands. The technique is distinguished by the brilliance of its colour, which derives from mineral pigments and not vegetable dyes. During the 1700s, the technique reached its peak when it was used exclusively for the garments of royalty and the high-ranking elite. The stencil process is time-consuming. First, sections of the fabric are masked using either a stencil or dye-resist paste (*nori*). Then, each area of the design is individually coloured. After the fabric is dry, the design is again masked with dye-resist paste and the ground colour is applied.

Edo komon (Edo 'fine pattern')

Edo komon is a stencil-resist dyeing technique that became popular during the Edo period (1600–1868). It was originally developed to dye formal costumes called *kamishimo* worn by the samurai elite. First, a liquid rice-paste resist is applied through stencils cut with very fine patterns onto a white cloth stretched taut over a board, then various dyes are painted over it with a brush. This technique was particularly common in Japan until the Taishō era (1912–26). By the 1920s, however, a simplified method of dyeing by the direct application of colour-resist liquid became widespread, signalling the end of the more labour-intensive *Edo* 'fine pattern' technique. Broadly similar to the 'middle size' stencil-dyeing (*nagaita chūgata*) technique (q.v.), the *Edo* 'fine pattern' process is able to depict smaller and more intricate patterns.

Kasuri-ori (Kasuri weave)

Karuri-ori is a thread-resist technique that uses tightly bound yarn prior to dyeing. When the skein is dipped into the dye, the colour does not penetrate the areas that are bound, which results in a partially white design on dyed ground. The designs on the textiles created from using this yarn, from simple to pictorially complex, are a result of the configuration of the yarn used for the warp and the weft during the weaving process. This method of textile production was introduced to Japan during the Edo period (1600–1868) from Southeast Asia, called Ikat). Ikat fabrics from Southeast Asia are only dyed in the warp, whereas the Japanese Kasuri also employs dyed yarns in the weft, resulting in the ability to produce more pictorial motifs. The Kasuri weave became popular in the mid-Edo period (during the 1700s), and again in the late 1800s to early 1900s. Recently pongee (*tsumugi*) has been substituted for the more traditional cotton, lending the garment a contemporary feel.

Kata-e-zome (stencil picture dyeing)

Kata-e-zome is a general term used to refer to the stencil-dyeing technique. Stencils can be made from wood, Japanese paper (*washi*) or metal. The term was first coined to describe the work of Serizawa Keisuke (1895–1984), when he was designated a Living National Treasure in 1956. Unlike other stencil-dyeing methods, *kata-e-zome* requires that the artist oversee the entire production process: conceptualizing the design, transferring it into stencil form, and dyeing the patterns the appropriate colours. The technique offers great expressive freedom to create unique designs, but is labour intensive.

Nagaita-chūgata ('middle size' stencil-dyeing)

Nagata-chūgata is a stencil-dyeing technique. The stencils employed are of a larger size than the *Edo komon* ones. It is generally used for summer *yukata* or kimono. Cotton textile is stretched taut along a long, narrow board. A stencil is placed on top of the textile and resist paste (*nori*) is carefully applied onto the surface before dip-dyeing. When the cloth is dyed, the colour does not penetrate areas covered with resist paste. The same process is carefully repeated for the reverse side. After the cloth has dried, the resist paste is washed away. The *nagaita chūgata* dyeing method is believed to have developed during the 1700s, coinciding with the widening use of cotton fabrics.

Ra

Ra is a delicate gauze woven fabric made in Japan since ancient times. It was popular in the Nara period (710–94), but its use declined during the subsequent Heian period (794–1185) due to the complexity of its manufacturing process. In recent times, however, refined *ra* has reappeared and there is renewed interest in preserving production techniques and creating modern versions. The process involves threading weft through warps that have been intertwined around adjacent warps. The technique is time-consuming and demands great concentration, which limits the amount that can be woven in a single day.

Saga-nishiki (Saga brocade)

Saga-nishiki became widespread in the early 1900s. It was first introduced in the early 1800s in Kashima, Saga domain in Kyushu as a craft practised by women in their homes. Saga brocades are made by weaving colourful silk weft through a warp made of finely cut strips of mulberry paper (*washi*), which is sometimes ornamented with lacquer, or gold and silver leaf. Great skill is required in order to weave Saga brocades, especially when using traditional bamboo combs. Lozenges and *sayagata* (interlocking swastikas) are among the most typical patterns employed.

Tate-nishiki (vertical brocade)

Tate-nishiki is a type of woven brocade. This textile technique was used in Japan from an early historical period. However, because of the difficulty involved in using a multiple-colour warp to create the patterns, the *tate nishiki* technique was not easily transferred. Production was limited until its revival by the artist Kitamura Takeshi (q.v.). The term *nishiki* refers to a wide range of woven silk fabrics with supplementary patterning warps, or wefts of polychrome silk or metallic threads.

Tsumugi-ori (woven pongee)

Tsumugi-ori, or woven pongee, is a durable hand-woven textile made from handspun floss silk. Traditionally, silk cultivators would use the agricultural off-season to make their own clothes made of *tsumugi* from discarded cocoons. The fabric is traditionally plain or striped, and dyed with indigo blue.

Tsuzure-ori (Tsuzure weave)

The *tsuzure* weave is one of the oldest methods for making tapestries, found in such diverse places and periods as Coptic Egypt from the 400s onwards and the Gobelins textile factories of France in the later 1400s–1600s. The technique was originally introduced to Japan from China during the Nara period (710–94). Production declined during the medieval period, but was revived in the 1800s with a new wave of influence from China, becoming a specialty of the Nishijin textile district of Kyoto. To create *tsuzure*-woven fabric, a full-size preparatory drawing of the design is placed beneath the warp and specific coloured yarns are woven back and forth in their own pattern area rather than passing through the entire width of the fabric. The large floats of the famous annual Gion festival in Kyoto are often decorated with textiles of this kind, some of them European in origin.

Yūzen

Yūzen is probably Japan's most celebrated textile art. It is a freehand paste-resist method of dyeing technique named after Miyazaki *Yūzen*sai, who first perfected the method during the Genroku era (1688–1704). This new type of dyeing radically transformed the previous vocabulary of textile design by overcoming the limitations of earlier techniques such as tie-dyeing. Patterns are drawn onto the cloth with dye-resist rice paste extruded through the brass nozzle of a paper-cloth bag, in a variety of techniques known as *itome* (thread-like lines), *sekidashi*, *musen* and *fuki*. There is also a form of stencil-dyed *yūzen* (*kata yūzen*) that was developed in the Meiji era (1868–1912). In general, a combination of techniques is employed to create *yūzen* textiles, including hand-stitching, *surihaku* (rubbed metal foil), tie-dye and embroidery.

Lacquer

Chōshitsu (carved lacquer)

In the *chōshitsu* technique a design is carved into a lacquer coating made up of as many as 100 layers, some of different colours. The average thickness of an individual layer is around 3 mm. The design is incised to varying depths to expose the different colours desired. The traditional colours employed are red, black, green and vermillion, and these are used in combination to create well-known patterns such as *kōka ryōyō* (literally 'red flowers, green leaves'). The technique was first developed in China during the Song and Yuan periods (960–1368) and became increasingly popular during the Ming period (1368–1644). In Japan, during the 1800s, Tamakaji Zōkoku (1807–69) is thought to have adapted the Chinese technique to suit Japanese tastes and made it popular. While traditional lacquer was limited to the five colours of yellow, green, vermillion, dark brown and black, scientific advances in the early Shōwa era (1926–89) led to the development of a titanium-based white lacquer. This new colour brought with it a wide range of new possibilities: mixing pigments to create secondary colours, such as purple; and permitting different shades of colours, such as pale blue. Contemporary works using the *chōshitsu* lacquer technique exploit this expanded palette. Since designs are carved so as to expose the different coloured striations,

the technique requires careful calculation to ensure that the chisel strips away the lacquer to precisely the desired levels.

Chinkin (incised and gold-filled decoration)

The *chinkin* technique involves engraving a lacquer surface with special blades using shallow strokes. Wet lacquer is then rubbed into these incised lines to act as an adhesive for the gold leaf or gold powder that is then applied. Any excess gold leaf and powder is removed and gold lines and detailing are painted onto the surface to finish the design. The name of the technique in Japanese translates as 'sunken gold', as the gold is literally pressed into the incised grooves – a kind of gold inlay. Variations on this technique include the use of coloured pigments instead of the gold leaf or powder, and engraving without any in-filling (*subori*). In China the method was popular in the Song, Yuan and early Ming periods (960–1400s). It was transmitted to Japan during this time in the form of decorated sutra boxes. *Chinkin* lacquer ware was mostly produced in Wajima (in modern Ishikawa prefecture) from the late 1800s and it continues to be associated with the area today.

Hyōmon (metal sheet inlay)

The *hyōmon* technique involves the cutting of thin sheets of metal made from gold, silver or tin into shapes that are then fixed to a lacquered surface. A coat of lacquer is then applied over the decorated surface and allowed to dry before excess lacquer covering the metal inlay is removed and the entire work polished. Depending on the design, lines may be incised into the metal inlay as well. The technique is often used in conjunction with *maki-e* (sprinkled picture decoration) and was introduced from China in the AD 700s.

Kanshitsu (dry-lacquer technique)

Kanshitsu is the Japanese term for the 'dry lacquer' technique. This technique involves pasting successive sheets of hemp cloth mixed with lacquer over a mould made from wood, clay or plaster to build up the desired form. Once the hemp cloth has dried into place, the hardened fabric form is separated from the mould and multiple thin coats of lacquer are applied to finish the work. The dry-lacquer method was originally developed in China during the Tang period (618–907) and transmitted to Japan in the Nara period (710–794).

In Japan the technique was commonly used for creating Buddhist sculpture, especially during the early Heian period (c.800–1000). Today, dry lacquer is used regularly with plaster moulds, which lend a high degree of plasticity to the finished work.

Kinma (incision and colour-filled decoration)
The *kinma* technique is similar to *chinkin* (incised and gold-filled decoration), only with coloured lacquer used instead of gold. It is equivalent to the Chinese technique of *tenshitsu* (literally, to fill-in with lacquer). The method originated in South China, Thailand and Myanmar. The word itself derives from the Thai term *kin maak*, or 'chewing areca palm fruit', the practice of people chewing rolled betel leaf with limestone ash and areca palm fruit to keep cool. In Southeast Asian households these ingredients would be placed in bowls with incised colour-filled line designs, and this design pattern itself later became known as *kinma*. In Muromachi-period (1392–1573) Japan, vessels with this type of decoration were referred to as '*kinma te*' and were highly prized by tea practitioners. In the late Edo period, during the 1800s, Tamakaji Zōkoku (1807–69) from the Takamatsu domain (modern Kagawa prefecture in Shikoku) perfected the technique and the area became famous for *kinma* production. Woven bamboo is the most traditional substrate. A chisel (*ken*) specifically made for *kinma* engraving is used to incise the design into the lacquered surface. The resulting grooves are then filled with coloured lacquer, which is polished flush with the surface.

Kintai (metal substrate)
The term *kintai* refers to the metal substrate over which lacquer is applied. In China during the Song period (960–1279), metal substrates were used to make the famous cinnabar lacquer-covered boxes. In Japan *kintai* is a general term that encompasses a variety of metal substrates such as copper, brass and aluminum. Silver is also used as a substrate and referred to specifically as *gintai*. The plasticity and durability of metal combined with its ability to withstand heat without warping continue to make it a popular type of substrate.

Kirigai (cut shell)
The *kirigai* decorative technique employs thin sections of iridescent shell cut into various shapes and inlaid into a lacquered surface using lacquer as a fixative. Turban shells, mother-of-pearl and abalone are among the seashells used, and these are occasionally backed with gold leaf, silver leaf, *aokin* (gold or silver alloy) or coloured pigments. The backing adds an extra iridescence to the lacquer surface where it shines through the semi-transparent shell body.

Magewa-zukuri (hoop-built core)
Substrates made of thin strips of wood such as white cedar (*hinoki*), *hiba* and Japanese cypress (*sugi*) form the basis of this technique. The strips are first softened by soaking in hot water. They are then bent into circular or oval rings and nestled together and attached to a base to form a vessel called a *magemono* (literally 'bent object'). In the *magewa* technique, first devised by Akaji Yūsai (1906–84), several dozen of the rings are piled up or spread sideways to form a dish-like vessel core that is then lacquered.

Maki-e (sprinkled-picture decoration)
Maki-e is the most characteristic form of Japanese lacquer decoration. The technique involves drawing a design onto wet lacquer and then sprinkling metallic powder – gold, silver and tin – or coloured pigments onto the wet surface. The *maki-e* method dates back to the Heian period (794–1185) and was then adapted to reflect the taste and styles of each subsequent period. Types of *maki-e* include flat (*hira*) *maki-e*, polished (*togidashi*) *maki-e* and raised (*taka*) *maki-e*. With flat *maki-e* the design is painted directly onto the vessel with a brush and metallic powder sprinkled over the design while still wet. With polished *maki-e* the flat *maki-e* surface is then covered with lacquer, and once the surface is hardened, charcoal is used to rub off excess lacquer in order to make the design flush with the lacquer ground. Afterwards the work is completely polished. Raised *maki-e* uses lacquer or lacquer paste to create the design in relief before the metallic powder is applied. It is quite common to find these techniques used in combination on a single work, in addition to other decorative methods such as mother-of-pearl inlay (*raden*), metal sheet inlay (*hyōmon*) and cut metal foil (*kirikane*).

Raden (mother-of-pearl inlay)
The term *raden* literally means 'triton shell' (*ra*) plus 'to decorate' (*den*). Green turban, abalone, mother-of-pearl and pearly nautilus shells are ground down to an

appropriate thickness, cut into the desired shapes and applied onto – or inlaid into – wood or lacquer surfaces. In Tang-period China (618–907) as in Nara-period Japan (710–94), thickly ground shells were commonly used as a material for inlay. In the Heian period (794–1185), mother-of-pearl inlay was used in combination with the *maki-e* technique. Thin shell inlay, which became popular in Yuan- and Ming-period China (1279–1644), was introduced to Japan in the Muromachi period (1392–1573) and referred to as *aogai* ('blue shell').

Rantai (basket body)

Rantai wares are created by weaving bamboo strips into baskets, which are then coated with lacquer. Archaeological excavations have shown that the technique began as early as the Jōmon period (12,500–300 BC). Bamboo is both lightweight and elastic. It can withstand heat and humidity and grows quickly, making it a sustainable resource. *Rantai* wares are also found in Thailand and Myanmar. In Japan Tamakaji Zōkoku (1807–69) of the Takamatsu domain (modern Kagawa prefecture) is believed to have developed the technique in the early 1800s. Bent bamboo substrates have been widely used since that time.

Tsuikin

Tsuikin is a lacquer technique first developed in Okinawa and that is still practised today. Higa Raishō (Bōkōtō) introduced the technique to mainland Honshu in 1715. It uses black lacquer and coloured pigments, which are kneaded together and then rolled into a sheet. Designs and shapes are then cut out and these cut-outs are attached to lacquer wares. Detailing can be engraved onto the lacquer and the sheets are sometimes layered to give added volume to the designs.

Metal

Fukiwake

Fukiwake is a casting technique in which two or more different alloys are melted in separate crucibles and then either poured together, or alternately, into a mould to create a vessel. This method results in an unusual pattern, which highlights the different alloys used to form the vessel.

Hagi-awase (soldering)

Hagi-awase is a hammering technique that involves soldering together sheets of copper, copper alloy, silver or iron and hammering them out to form dishes, flower vases and other vessels. As each metal has a different melting point and rate of expansion and contraction, the technique requires great skill and understanding of these different properties.

Hira-zōgan (flat inlay)

With the *hira-zōgan* technique, a design is engraved into the surface of a metal to a certain depth, then sheet metal cut to the same shape is inlaid and the surface carefully polished. The cuts that take the inlay are made so that they flare out wider at the bottom than on the surface. The technique is considerably more difficult than line engraving (*sen-zōgan*) and requires great skill.

Ko-kanagu ('small metal fittings')

Ko-kanagu is a method of creating elaborate, miniature designs in relief on a surface several centimetres square, using various chasing techniques. The *ko-kanagu* technique was originally developed for decorating sword guards (*tsuba*) and hilt ornaments (*menuki*). After the wearing of swords as part of samurai clothing was abolished in 1876, *ko-kanagu* craftsmen turned to producing ornamental objects and decorative metal fittings.

Nunome zōgan (textile imprint inlay)

Nunome zōgan is a technique in which narrow horizontal, perpendicular and diagonal lines are engraved into a surface to resemble the texture of a textile, using a special chisel (*megiri*). Gold or silver wire, or thin sheets of gold or silver leaf are then positioned on top of the engraved surface and hammered to force them into the incisions. The technique is said to have been introduced by the Portuguese and Spanish, who arrived in Japan during the late 1500s.

Oborogin (*rōgin*, or *shibuichi*)

Oborogin is an alloy made up of 75% copper and 25% silver. For this reason it is often called *shibuichi*, meaning 'four to one ratio'. The silver content lends to the metal a subdued colour with a distinctive crystalline surface, which accounts for the name *oborogin*, 'hazy moon silver'. Often alloyed with bronze or copper, this metal is quite hard and requires special skill to handle it well.

Ōdō (brass)

Ōdō or brass is a copper and zinc alloy. When polished, it resembles gold and can be cast and hammered.

Rōgata chūdō (lost-wax casting)

Rōgata chūdō is a casting technique in which a mould is made from pinesap and/or wax. Clay or some other material is placed over the mould and then heated. The pinesap or wax liquefies or melts and a molten metal can then be poured into the mould in place of the wax. When the molten metal hardens it forms an identical shape to the wax mould. In the Asuka period (late AD 500s–710), lost-wax casting was used to make small gilt-bronze Buddhist statues. While the method is ideal to replicate complex shapes with fine texture and definition, only one cast can be produced from an individual mould and so the technique is not suitable for mass-production.

Sahari

Sahari is an alloy made mostly of copper, with small amounts of tin, lead and silver. It is frequently used in the casting of bells and gongs as the alloy emits a beautiful sound when struck. Utensils for tea gatherings are also occasionally made of sahari.

Sen-zōgan (line inlay)

Sen-zōgan is an inlay technique in which a thin wire made of gold or silver is hammered into a groove on an iron or bronze surface. The term 'thread inlay' (ito-zōgan) refers to a very fine wire inlay. Use of the technique dates back to the AD 400s, during the Kofun ('mounded tomb') period, on objects such as horse fittings, sword blades, hilt ends and sword guards.

Uchidashi (hammering out)

Uchidashi involves hammering out a solid metal sheet of gold, silver, copper or iron and forming it into the shape of a vessel.

Zōgan (inlay)

Zōgan is a general term for inlay, embedding one material into the surface of another, and it is used to describe many different techniques of decoration. In metalwork, chisels are used to make incisions in a metal surface and then the groove is filled with different types of metal. The most common ground metal is copper or iron, which is then inlaid with gold, silver or brass.

Wood and Bamboo

Fuki-urushi (wiped lacquer)

Fuki-urushi is a technique where lacquer is applied to the body of a vessel using a cloth or cotton, and then removed using Japanese mulberry paper (washi) or a cloth before it can harden. These steps are assiduously repeated to produce a surface glow and to highlight wood-grain patterns. Rubbed lacquer (suri-urushi) is a similar technique that employs fewer coats of lacquer. Kuroda Tatsuaki (q.v.) was particularly famous for this technique, and he applied at least ten layers, sometimes several dozen, to enhance the natural beauty of the wood.

Moku-zōgan (wood inlay)

Moku-zōgan is a technique of inlaying one wood into another to form a pattern or decorative effect. Metals, shells, or semi-precious stones can also be used for the inlay. The technique is occasionally referred to as 'wood picture' (mokuga). Some of the most outstanding examples are found in the Shōsōin treasure house, dating to the mid-AD 700s. The technique retains clearly the particular characteristics of the inlay and its colour and shape, permitting a wide range of personal artistic expression.

Shirasabi ('rusty white' bamboo)

Bamboo used for basketry is often subjected to a special treatment to remove the oil. This speeds up the drying process and generally strengthens the stalk. Bamboo thus treated is referred to as shirasabi or 'rusty white', and objects made from it are called shiratake or 'white bamboo'.

Susudake (smoked bamboo)

Smoked bamboo refers to bamboo blackened by soot. Bamboo left stacked under roofs or ceilings of traditional buildings for several hundred years slowly acquires a deep patina of soot and turns a yellowish-brown colour. The area beneath the rope that has secured the bamboo in place under the roof turns a lighter brown than the rest of the stalk. Smoked bamboo, when polished, exhibits a beautiful shine and lustre, but becomes brittle due to a loss of elasticity through age and storage conditions. It is often used as a material for wood objects that incorporate bamboo, and stalks that still retain their elasticity can be woven, the finished product having an elegant beauty. In recent years artificially treated bamboo with similar qualities has become available.

Dolls

Gofun

Gofun is a paste made from powdered seashell and animal glue. It is applied in liquid form and both seals and gives a subtle sheen to the surface, helping to preserve the doll. The paste is commonly used as a base coat, and can also be employed in successive layers to build up a surface in a specific area such as facial details and fingers – a technique called *okiage*. A fine grade of *gofun* is used for the final coat, occasionally mixed with pigment to give certain areas a desired colour. Once dry, the surface is then polished to give lustre to the doll's skin.

Ishō ningyō (costume dolls)

Ishō ningyō are handmade dolls dressed in tailored costumes made from dyed and woven textiles, similar to those worn in daily life. The exposed areas of the dolls such as hands and feet are covered with a thick white paste made from powdered seashell and animal glue (*gofun*) and painted in various colours. All other areas are covered either with several layers of cloth or with pasted fabric (*kimekomi*) decoration.

Kimekomi

In the *kimekomi* technique, a doll's body is first sculpted using wood-carving tools and a modelling compound (*tōso*). Grooves are carved into the doll's body where the edge of a garment fabric is to be inserted. The body is then prepared by lightly sanding the surface. After sanding, a lacquer and *gofun* paste is applied and allowed to dry. This process strengthens the surface of the doll. The final step involves pasting textiles onto the doll with edges inserted into the grooves carved into the body.

Shiso

Shiso is made from mulberry fibre mixed with sawdust, *gofun* and adhesive. The mixture is pounded in a mortar for many hours to create a plastic substance that is both strong and elastic. The mixture is either pressed into a mould or sculpted by building it up to achieve the desired form. Pieces of dyed handmade paper (*washi*) are then pasted onto the doll in successive layers; alternatively the paper is painted with colour and decorated in detail by hand. The technique is adapted from the *tōso* method and was devised by Kagoshima Juzō.

Tōso

Tōso is a traditional method of doll-making that was originally used to cast mass-produced heads, hands and feet. Paulownia sawdust is mixed with wheat starch and ground winter plum paste to make a viscous clay-like plaster that is used to form the base of the doll. *Tōso*'s plasticity allows for innovative shaping, and once dry the substance is extremely hard, which allows it to be sculpted like wood. Pasted fabric, paper and painted *gofun* are then added to decorate the doll's surface. This technique is favoured by many contemporary doll-makers for its versatility, which enables them to create new forms. *Mokushin tōso*, or 'wooden core *tōso*' dolls are figures with a cast *tōso* head that is attached to a roughly carved paulownia body that is then covered with a *tōso* modelling compound and sculpted.

Other Crafts

Kirikane (cut metal foil)

A decorative technique whereby gold or silver foil is hammered out to a thickness of less than 1 micron (1/1000 mm). Lines, rectangles and other shapes are cut out from the fine foil and applied to surfaces. The method flourished particularly in the Heian period (794–1185) and was used in the making of Buddhist paintings, implements and sculptures. Although its use declined in the later periods – with the exception of production at Higashi Honganji and Nishi Honganji temples – there has been a surge of interest in modern times in its use as a decorative method for ornamenting craft items, such as decorative boxes. The fine foil retains its opulence and lustre for years and gives the surface an even tone and neat appearance. The technique is particularly appreciated for the harmony between the colours of the wood base and the colours of the foils.

Kiriko (cut glass)

In the *kiriko*, or cut-glass, technique a rotating stone or metal grinder is used both to incise and polish the surface of the glassware. Glass-making dates back to prehistoric times in Japan. However, the industry has rapidly developed since the Meiji era (1868–1912) through contact with Europe and the introduction of new techniques. Glass-making became generally known from the mid-1700s due to production in Edo (modern Tokyo)

and in the Satsuma domain (modern Kagoshima prefecture). Other surface treatments include sandblasting, etching and engraving. Engraving allows for closer control over the inscisions in the glass surface and a wider range of effects than the traditional *kiriko* technique, where incisions are limited to v-shaped grooves, straight lines, curved lines or circular patterns.

Pate-de-verre

Pate-de-verre is a method of forming glass vessels. The term derives from the French for 'glass paste'. The technique involves mixing into a paste glass powder and a metal-oxide binding agent, also used as the colourant. The mixture is heated until is becomes liquefied and is then poured into a fire-resistant mould, taking on its shape. The technique was quite popular in Europe during the late 1800s and has rapidly gained admirers in Japan in recent years. Similar to casting, *pate-de-verre* produces vessels of innovative and varied forms. The semi-transparency or cloudiness of the glass are all part of its appeal to a Japanese audience. When mixing the paste, different colours can be added and combined to produce a marble-like appearance, an effect that cannot be replicated with other glass-making techniques.

Zōgan (inlay)

With the *zōgan* technique, surfaces made of wood or metal are carved or incised and various materials are inserted into these lines, shapes or grooves. The imbedded materials are normally flush with the object's surface, creating a clear two-dimensional contrast in the surface pattern. Sometimes, however, thick pieces of inlay are imbedded into an object's surface, giving a three-dimensional effect. Metal inlay in Japan dates back to the Kofun period (AD 250–600) and was used on swords and other objects. Wood inlay shares a similarly long history, with exquisite examples housed in the Shōsōin treasure house of Tōdaiji temple in Nara, dating from the AD 750s.

Artist Biographies

Ceramics

Arakawa Toyozō (1894–1985)

Arakawa was born in Gifu prefecture. Having worked in Kyoto kilns, he moved to Kamakura in 1927 to assist at the Hoshigaoka kiln established by Kitaōji Rosanjin (1883–1959), a renowned artist, potter and food connoisseur. During this time, Arakawa developed an interest in ceramics for tea gatherings of the late 1500s and early 1600s and conducted excavations of old kiln sites and studied their sherds. His pioneering discovery in 1930 of the old kiln at Mino Ōgaya helped to reattribute the origin of Shino wares and led to similar excavations and study of sherds at kiln sites throughout Japan. He set out to reconstruct Mino wares based on his study of the original materials, techniques and kiln construction, creating new-style tea wares imbued with classical tradition. Arakawa was designated a Living National Treasure in 1955 for his 'Shino' style and 'Black Seto style Mino ware' (*Seto-guro*) techniques. (Cat. no. 7)

Fujimoto Yoshimichi (1919–92)

Fujimoto was born in Tokyo. After graduating from the Tokyo School of Fine Arts, he trained under Katō Hajime (q.v.) and Tomimoto Kenkichi (q.v.) at the Monbushō Kōgei Gijutsu Kōshūjo. In 1946 he moved to Kyoto and participated in the Shinshō Bijutsu Kōgeikai. Later he joined the Modern Art Association and Sōdeisha and produced avant-garde works. In 1962 he was appointed to a teaching position at the Tokyo National University of Fine Arts and Music and this coincided with a change of direction in his art. He began to work in porcelain with overglaze enamels and to exhibit in the Japan Traditional Art Crafts Exhibition. His decoration is extremely painterly: enamels are applied in a wide range of colours to create lyrical works with motifs from nature, such as birds, plants and flowers. Fujimoto was designated a Living National Treasure in 1986 for his 'porcelain with overglaze enamel' (*iro-e jiki*) technique. (Cat. no. 16)

Fujiwara Kei (1899–1983)

Fujiwara was born in Bizen city, Okayama prefecture. He attended Waseda University in Tokyo as an auditing student in the literature department. He became very active, editing literary magazines and composing poetry, and also wrote novels, performed in theatre and participated in the Socialist movement. In 1937 he abandoned this literary life to return to his hometown and pursue a career as a potter. He learned the Bizen-style firing technique from Kaneshige Tōyō (q.v.) and went on to develop his own natural yet dignified style. Fujiwara was designated a Living National Treasure in 1970 for his 'Bizen ware'. In 1977 he established the Kei Fujiwara Art Museum on the site of his former residence. (Cat. no. 9)

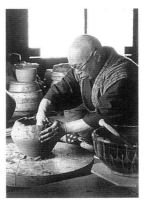

Hamada Shōji (1894–1978)

Hamada was born in Kawasaki city, Kanagawa prefecture. He began to study pottery at the age of sixteen, and after graduating from the Tokyo Institute of Technology he joined the Kyoto Municipal Ceramics Laboratory. While studying glazes he also worked to master the wheel. Later he met Bernard Leach (1887–1979) and together they travelled to England in 1920, where Hamada began his career as a working potter. After his return to Japan in 1924, he opened a studio at Mashiko in Tochigi prefecture. Together with Yanagi Muneyoshi (1889–1961), Kawai Kanjirō (1890–1966) and others, he promoted the Mingei, or Folk Crafts movement, creating simple and rugged stoneware works from his base in Mashiko. Hamada was designated a Living National Treasure in 1955 for his 'Folk Crafts stoneware' (*Mingei tōki*). He was awarded an Order of Cultural Merit in 1968. (Cat. no. 2)

Hara Kiyoshi (b. 1936)

Hara was born in Shimane prefecture. In 1954 he became a close apprentice of Ishiguro Munemaro (q.v.) and later studied under Shimizu Uichi (q.v.) to become a professional potter. In 1965 he established an independent kiln in Setagaya ward, Tokyo, where he adopted the iron-oxide glaze techniques of his two teachers, forging his own style. He has participated in the Japan Traditional Art Crafts Exhibition since first being selected in 1958, and has continued to win awards at this exhibition. In 1980 he moved from Tokyo to Yoriimachi in Saitama prefecture, where he set up a new kiln and studio. There he produces works with a bluish-white glaze derived from ferric colouring agents. His ceramics are characterized by their symmetry of form and the refined harmony of their glazes. Hara was designated a Living National Treasure in 2005 for his 'stoneware with iron-oxide glaze' (*tetsuyū tōki*) technique. (Cat. no. 27)

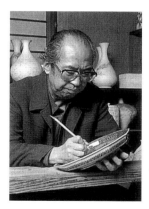

Imaizumi Imaemon XIII (1926–2001)

Imaizumi was born in Arita, Saga prefecture. After graduating in design from the craft department of the Tokyo School of Fine Arts, he learned the techniques of porcelain with overglaze enamel in Nabeshima style from his father Imaizumi Imaemon XII (1897–1975). He also researched historical documents for traditional Nabeshima overglaze-enamel techniques and styles. From 1962 he began to exhibit at the Japan Traditional Art Crafts Exhibition using his birth name Yoshinori. His innovative works, with their unique design compositions, received much attention. In 1970 he succeeded to the name Imaemon XIII. Imaizumi was designated a Living National Treasure in 1989 for his 'porcelain with overglaze enamel' (*iro-e jiki*) technique. In addition to traditional decorative techniques, he also incorporated new glaze techniques that were the result of personal experimentation. These included a 'blown ink' (*fukizumi*) technique that used uranium oxide as a colourant, sometimes in combination with a blown cobalt-blue oxide. (Cat. no. 14)

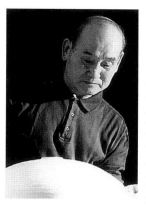

Inoue Manji (b. 1929)

Inoue was born in Arita, Saga prefecture. From 1945 he undertook an apprenticeship with Sakaida Kakiemon XII (1878–1963), during which he learned the use of the potter's wheel and other techniques of porcelain production. From 1958, while training younger students at the Saga Prefectural Ceramic Research Institute, he also pursued further independent study of white porcelain techniques. His works range from amply formed globe jars and pale-blue tinted carved designs to irregular and graceful flower-shaped white porcelain wares. All share the same clean and refreshing sense of form and outstanding technique. Inoue was designated a Living National Treasure in 1995 for his 'white porcelain' (*hakuji*) technique. (Cat. no. 24)

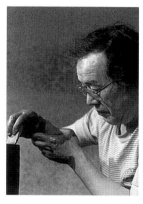

Isezaki Jun (b. 1936)

Isezaki was born in Bizen city, Okayama prefecture, the second son of the potter Isezaki Yōzan (1902–61). He learned the Bizen technique from his father before establishing his independence. From the nineteenth century, Bizen wares were mainly fired in climbing kilns (*nobori-gama*). However, Isezaki and his elder brother Mitsuru experimented with ways to revive the tunnel kiln and achieved success in 1961. In the same year he exhibited for the first time at the Japan Traditional Art Crafts Exhibition. Not limited to copying the works of the past, he freely mixes Bizen with non-Bizen clay, achieving a distinctive, brighter surface tone. He has actively pioneered new directions for Bizen-style ceramics, such as the production of ceramic walls. Isezaki was designated a Living National Treasure in 2004 for his 'Bizen ware'. (Cat. no. 28)

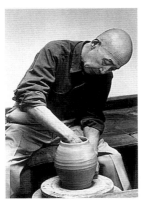

Ishiguro Munemaro (1893–1968)

Ishiguro was born in Shinminato city, Toyama prefecture. It is said he decided to become a ceramic artist after he was struck by the beauty of an 'oilspot' (*yōhen*) tenmoku teabowl which he saw in 1918. After establishing his studio in Jagatani, Kyoto in 1927, he developed a lifelong friendship with Koyama Fujio (1900–75), a potter and a leading scholar of ceramics who lived nearby. In 1935 he moved his residence and studio to Yase, Kyoto. Self-taught, Ishiguro developed a variety of pottery techniques and had a particular affinity for Chinese Tang- and Song-period ceramics and for Karatsu wares. Having mastered classical pottery techniques, he established an independent style appreciated for its elegance. He particularly excelled in the use of iron-oxide glazes, such as 'persimmon coloured glaze' (*kakiyū*) and tenmoku. Ishiguro was designated a Living National Treasure in 1955 for his 'stoneware with iron-oxide glaze' (*tetsuyū tōki*) technique. (Cat. no. 4)

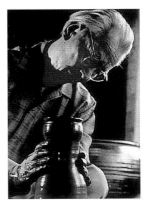

Kaneshige Tōyō (1896–1967)

Kaneshige was born into a family of potters in Bizen city, Okayama prefecture. He first studied with his father Baiyō, and was soon receiving praise for technically accomplished and intricate works such as incense burners and ornaments that continued Edo-period traditions. Around 1930, however, Kaneshige's interest shifted to old Bizen wares of the Momoyama period (1573–1600) and he worked towards their reconstruction. He revived lapsed practices such as proper attention to clay selection, blending and forming, and techniques such as *hi-dasuki* ('fire strands'), in which leaves were placed on the surface of the vessel during firing, producing an effect of red strands. Kaneshige was designated a Living National Treasure in 1956 for his 'Bizen ware'. Celebrated as the father of the Bizen revival, he also enjoyed close friendships with the sculptor Isamu Noguchi (1904–88) and the artist, potter and food connoisseur Kitaōji Rosanjin (1883–1959). (Cat. no. 3)

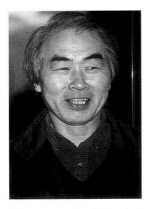

Itō Sekisui V (b. 1941)

Itō was born on Sado island, Niigata prefecture. His family ran the Mumyō i ware kiln, where he succeeded as Sekisui V in 1977. Mumyōi ware uses clay rich in iron that turns crimson when fired and has been a special product of Sado island since the early nineteenth century. Itō has revitalized Mumyōi ware through his creativity. By exploiting the glaze transformations that occur during firing as part of the design and also using a marbling (*neriagede*) technique, he has achieved a new style while retaining the core qualities of the ware. Itō was designated a Living National Treasure in 2003 for his 'Mumyōi ware'. (Cat. no. 19)

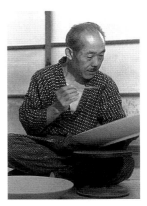

Katō Hajime (1900–68)

Katō was born in Seto, Aichi prefecture. From 1926 he taught design and pottery technique at the Gifu Prefectural Ceramics Research Institute in Tajimi. In 1940 he decided to pursue an independent career and established a studio at Hiyoshi in Yokohama. He mastered a broad range of techniques, but developed a particular interest in Chinese Ming-period polychrome enamelled porcelains. He succeeded in reconstructing some of the most difficult polychrome techniques such as yellow- and red-enamelled porcelain (*kōchi kōsai*) and gold leaf on overglaze yellow-green enamel (*moegi kinrande*). Katō was designated a Living National Treasure in 1961 for his 'porcelain with overglaze enamel' (*iro-e jiki*) technique. He was one of the first professors of ceramics at the Tokyo National University of Fine Arts and Music. (Cat. no. 5)

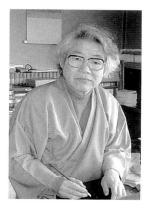

Ōta Hitoshi (b. 1931)

Ōta was born in Okayama city. He became a pupil of Isoi Joshin (1883–1964), who was then working as a visiting lecturer in arts at Okayama University. Isoi showed him a writing equipment box in the 'incised and colour-filled' (*kinma*) technique by Tamakaji Zōkoku (1807–69) and he decided to make it his life's work to study the 'basket body' (*rantai*) and *kinma* techniques. In *rantai* lacquer he has developed a 'double-layer weave' (*nijū-ami*) technique, in which a wooden body is coated with lacquer on the inner side, and then woven over with strips of shaved bamboo (*higo*) so that it has a double-layer woven construction, creating a more solid and precise base. In *kinma* he has devised a 'textile imprint carving' (*nunome-bori*) technique, in which he carves vertical, horizontal and diagonal lines that are then filled with coloured lacquer. This produces more delicate effects of shading and volume, thereby expanding the painterly expression available to *kinma* designs. He uses familiar motifs from nature: plants and flowers, fish, birds and insects. Ōta was designated a Living National Treasure in 1994 for his 'incised and colour-filled' (*kinma*) technique. (Cat. no. 69)

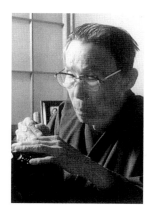

Otomaru Kōdō (1898–1997)

Otomaru was born in Takamatsu city. From the age of thirteen, he worked as a live-in pupil of Ishii Keidō, a master wood-carver in the local Sanuki style (*Sanuki-bori*). He saw the so-called 'Ikkaku *inrō*', a lacquered medicine case that was a test-piece made by the famous Tamakaji Zōkoku (1807–69) and this spurred his determination to teach himself the art of carved lacquer. In 1937 Otomaru moved to Tokyo. His use of lake pigments to create secondary colours and vibrant new tones of lacquer led to the creation of highly innovative and expressive works. Using his favourite motifs such as the water hollyhock (*mizu-aoi*), trillium (*enrei-sō*) and orchids in realistic yet deliberately distorted designs, he devised his own unique style. He also experimented with various other techniques, such as mixing gold and silver powder with coloured lacquer to create *hanmon*, and incising multicoloured layers of lacquer so as to expose the cross-section for dramatic contrast. Otomaru was designated a Living National Treasure in 1955 for his 'carved lacquer' (*chōshitsu*) technique. (Cat. no. 62)

Sasaki Ei (1934–84)

Sasaki was born in Akita city. He studied 'sprinkled picture' (*maki-e*) lacquer techniques at Tokyo National University of Fine Arts and Music under Matsuda Gonroku (q.v.), Niimura Senkichi (1907–83) and Rokkaku Daijō (1913–73). At an early age he travelled around the country studying the translucent *shunkei* lacquer-coating technique, and discovered its origins at Awano in Tochigi prefecture. Thereafter he devoted himself to producing lacquers of this type. Sasaki would draw inspiration from sketching trips to Oze and Nagano prefecture. He depicted the watery Oze marshlands using cut shell, expanding the repertoire of lacquer techniques. Finely cut pieces of limpet shell were placed tightly alongside one another and stuck to the surface. He then created further rich and complex expressive effects by applying gold or silver leaf to the background and coating it with coloured lacquers. This method is known as 'coloured cut-shell' (*iro-kirigai*). (Cat. no. 68)

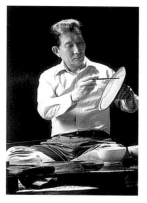

Shioda Keishirō (b. 1926)

Shioda was born in Wajima city, Ishikawa prefecture. His family had for generations worked in lacquer coating, and he learned Wajima lacquer from his father Masa. After the war he studied the 'sprinkled picture' (*maki-e*) technique under Katsuda Seishō (d. 1975). However, Matsuda Genroku (q.v.) advised him, 'if the base form and coating are good enough you don't need to add more decoration,' and so he decided to pursue the beauty of just the lacquer coating itself. First he freely forms the shape of the vessel using 'dry lacquer' (*kanshitsu*) technique. He also then adds to the lacquer a powder particular to the Wajima area, in which four or five layers of hemp cloth are imbedded for a more solid result. For the lacquer coating he mainly uses a vermillion or pomegranate coating in the so-called *hana-nuri* style. He has expanded the range of expression with techniques such as 'highly viscous lacquer' (*shibori-urushi*) that creates a pattern in the coating, also with unusual coatings that use sprinkled gold powder. Shioda was designated a Living National Treasure in 1995 for his 'lacquer coating' (*kyūshitsu*) technique. (Cat. no. 66)

Taguchi Yoshikuni (1923–98)

Taguchi was born in Tokyo. He received special training in 'sprinkled picture' (*maki-e*) lacquer decoration from Matsuda Gonroku (q.v.) and traditional Japanese-style painting (*Nihonga*) from Okumura Togyū (1889–1990). He participated in restoration work at the Tōshōgū shrine, Nikkō and the Konjikidō hall at Chūsonji temple. He created his own style of 'raised sprinkled picture' (*takamaki-e*) decoration in relief, using coatings of black lacquer instead of the normal sprinkled gold. He left the main motifs in black silhouette, creating novel works with a contemporary sensibility. The techniques he devised have expanded the boundaries of traditional *maki-e* in both decorative and expressive terms. These include cut-shell work (*kirigai*), where fine pieces of limpet shell (*aogai*) are applied; a 'cracked shell' (*wari-gai*) technique in which the cracks are artificially induced; and a *hikkaki* technique of directly scratching the surface. Taguchi was designated a Living National Treasure in 1989 for his 'sprinkled picture decoration' (*maki-e*) technique. (Cat. no. 60)

Terai Naoji (1912–98)

Terai was born in Kanazawa city, the fourth son of the owner of a metal goods store. While studying at the Tokyo School of Fine Arts, he was taken by Matsuda Gonroku (q.v.) to inspect the lounges of luxury cruise liners, and he realized the new possibilities of using lacquer in interior design. He then studied the base materials used for export lacquer wares. Observing that lacquer tends to peel off when applied to non-porous surfaces such as metal, he joined a physics and chemistry research institute to create lacquer-compatible metal. He experimented by electrolyzing the surface of aluminum to create tiny perforations in its oxidized film into which the lacquer could penetrate and adhere. After the war he established an independent business in Kanazawa, where he decorated fountain-pen casings. He created new contrast and perspective in his designs by arranging white eggshell fragments of different sizes and coarseness on the surfaces. Terai was designated a Living National Treasure in 1985 for his 'sprinkled picture decoration' (*maki-e*) technique. (Cat. no. 65)

Yamaguchi Matsuta (b. 1940)

Yamaguchi was born in Okayama city. He was inspired to become a lacquer maker at the age of twenty-five after seeing a work by Nanba Jinsai (1903–76) done in 'incised and colour-filled, with painting' (*kaki-kinma*) technique. This is a method whereby red lacquer is painted onto a black lacquer surface. Learning the basic techniques of lacquer at Kagawa Prefectural Lacquer Art Research Centre, he also apprenticed under Nanba. He not only studied the whole range of traditional lacquer techniques, but also in Okinawa the *tsuikin* (q.v.) technique, which expanded his expressive potential. Back in Okayama he experienced problems in working with the pigment and lacquer mixture because it would not harden. He resolved this by using local Bitchū lacquer. Yamaguchi has perfected his own original style of using a black 'dry lacquer' (*kanshitsu*) ground, which is then decorated with sprinkled gold and rhythmically applied arrangements of countless multicoloured *tsuikin* roundels. (Cat. no. 72)

Metal

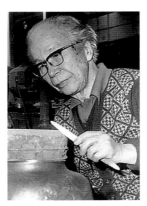

Kakutani Ikkei (1904–99)

Kakutani was born in Osaka. After learning kettle-making from his father, he studied under Katori Hozuma (1874–1954). He was also influenced by a leading researcher into the history of tea gatherings, Hosomi Kokōan (1901–79). Immediately after the war, he became involved in the repair of famous historic tea kettles, thereby learning their construction, surface pattern, texture and colour. His work was first accepted at the Nitten in 1952, and he won the President's Prize at the Japan Traditional Art Crafts Exhibition in 1958. In 1973 and again in 1993 he produced sacred mirrors for the rituals of the periodic rebuilding of Ise shrine. His signature technique was pressing with a sharp spatula to make the body patterns before casting, and he was celebrated as the maker of bold 'tea kettles for the Shōwa era' (1926-89). Kakutani was designated a Living National Treasure in 1978 for his 'kettles for tea gatherings' (*chanoyu-gama*) technique. (Cat. no. 77)

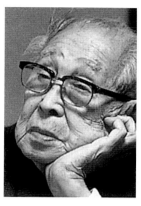

Kashima Ikkoku (1898–1996)

Kashima was born in Shitaya, Tokyo. For generations the family had worked as metal chasers, primarily in the technique of 'textile imprint inlay' (*nunome zōgan*). From around 1912 he studied metal chasing from a pupil of the school of Gotō Ichijō (1791–1876) and later apprenticed under his grandfather Ikkokusai Kōkei. He also learned new forms of craft expression from Unno Kiyoshi (1884–1956) and Kitahara Senroku (1887–1951). His work was first accepted at the Teiten exhibition in 1929, and he went on to show at the Shin-Bunten and Nitten. He helped to found the Japan Art Crafts Association in 1955. In 1957 he was designated a national affiliated craftsman for the Important Intangible Cultural Property of the 'textile imprint inlay' technique. His works are known for the grace and refinement of their pictorial design and feature the 'textile imprint inlay' technique, sometimes in conjunction with 'polished-out inlay' (*togidashi zōgan*). Kashima was designated a Living National Treasure in 1979 for his 'metal chasing' (*chōkin*) technique. (Cat. no. 83)

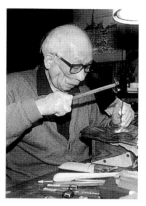

Masuda Mitsuo (b. 1909)

Masuda was born in Saitama prefecture. He graduated from the research department (metal chasing) of the Tokyo School of Fine Arts in 1936. While still a student in 1933, his work was accepted for the first time at the Nitten exhibition. He developed an interest in the Mingei (Folk Crafts) movement, and received instruction in the formal aspects of his work from Tomimoto Kenkichi (q.v.). After the war he exhibited for a period at the Shinshō Bijutsu Kōgeikai and became a member. In 1962 he presented his work for the first time at the Japan Traditional Art Crafts Exhibition and was awarded a prize. His technique involves hammering out silver, copper or iron to form a jar or box and decorating the surface with various types of inlay. Drawing inspiration from the collections of the Shōsōin treasure house and other ancient works, Masuda creates his own personal interpretation of the seasons in Japan, using classical motifs of animals, plants and landscapes. Masuda was designated a Living National Treasure in 1991 for his 'metal chasing' (*chōkin*) technique. (Cat. no. 82)

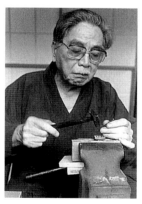

Katori Masahiko (1899–1988)

Katori was born in Tokyo, the eldest son of Katori Hozuma (1874–1954), a pioneer in modern Japanese metal work. From 1916 he studied oil painting at the Pacific Painting Society Institute (Taiheiyō Gakai Kenkyūjo), and in 1920 he entered the metal-casting department of the Tokyo School of Fine Arts. He won special awards at the Teiten exhibition three years consecutively, from 1930 to 1932, and went on to show at the Shin-Bunten, Nitten and Japan Traditional Art Crafts Exhibition. His work reflects great knowledge of classical techniques and historical periods, and his output is diverse, comprising jars, ornamental objects, Buddhist statues and Buddhist altar fittings. In 1953 he won the Japan Art Academy Prize. In 1969 he constructed the Great Peace Bell (*Heiwa daibonshō*) on the summit of Mt Futakamiyama near Takaoka city. Katori was designated a Living National Treasure in 1977 for his 'temple bell' (*bonshō*) technique. In commemoration of his 100th temple bell in 1981 he published the book *Hyakuroku no kane* (*One Hundred Happy Bells*). In 1987 he was elected a member of the Japan Art Academy. (Cat. no. 79)

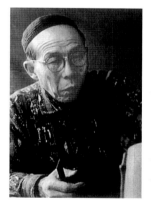

Nagano Tesshi I (1900–77)

Nagano was born in Nagoya. He first intended to become a Western-style (*yōga*) painter but in 1923 switched to metal-casting, studying with Yamamoto Azumi (1885–1945). From 1928 he learned the history of antiquities and metal work from Katori Hozuma (1874–1954) and became interested in the iron kettles used at tea gatherings. He won a special award at the Teiten exhibition in 1933 and became a jury member. After the war he left the Nitten and began exhibiting at the Japan Traditional Art Crafts Exhibition. Nagano was the leading maker of kettles for tea gatherings of his generation. He revived the ancient Japanese *wazuku* casting method, which he used to create original and contemporary works. This involves refining with iron sand to prevent the tea kettle from rusting. Nagano was designated a Living National Treasure in 1963 for his 'kettles for tea gatherings' (*chanoyu-gama*) technique. (Cat. no. 80)

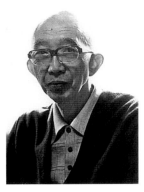

Naitō Shirō (1907–88)

Naitō was born in Tokyo. He learned metal chasing from Shimizu Kamezō (1875–1948) and Unno Kiyoshi (1884–1956) at the Tokyo School of Fine Arts. His work was first accepted at the Teiten exhibition in 1929, and after that he showed at the Shin-Bunten and Nitten. After the war he met Tomimoto Kenkichi (q.v.) and became a member of the craft section of the Kokugakai society. For a period he joined the 'Craft Movement'. In 1960 he became a professor at the Tokyo National University of Fine Arts and Music. He took part in the 1963 and 1970 surveys of metal work at the Shōsōin treasure house, and made a special study of Chinese Han-period metal sash hooks (daigou) and ancient Egyptian craft items. His own original works featured the novel use of inlaid calcite powder and natural mineral pigments. He made metal fittings that were used on the architecture of the Crown Prince's Palace. For the Japan Traditional Art Crafts Exhibition he mainly submitted jars and containers that were engraved with geometric designs or classical motifs and his work represented an amalgam of traditional and modern aesthetics. Naitō was designated a Living National Treasure in 1978 for his 'metal chasing' (chōkin) technique. (Cat. no. 78)

Okuyama Hōseki (b. 1937)

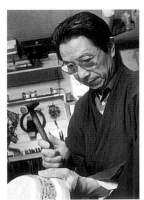

Okuyama was born in Shinjō city, Yamagata prefecture. From 1952 he apprenticed with Kasahara Sōhō and from 1977 he studied under Tanaka Mitsuteru. He hammers outstanding works that are lightweight but sturdy, with typically clean and refined designs. He is particularly celebrated for his skill at manipulating into graceful forms the copper and silver alloy oborogin ('dusky silver'), which is hard and difficult to hammer. Highly regarded, too, are his brazing and soldering techniques, whereby he brazes individual silver, copper and gold-copper alloy sheets together and then painstakingly hammers them into the finished shape. He is also accomplished at other decorative techniques, such as 'openwork inlay' (kiribame), 'hammered inlay' (uchikomi zōgan), 'lost wax' (rō-nagashi) and 'gold gilding' (kin-keshi). Drawing inspiration from forms found in nature, he creates works with harmonious colour schemes in an ample and modern style. Okuyama was designated a Living National Treasure in 1995 for his 'metal hammering' (tankin) technique. (Cat. no. 87)

Nakagawa Mamoru (b. 1947)

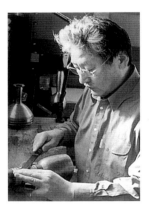

Nakagawa was born in Kanazawa city. He graduated from Kanazawa College of Arts with a degree in industrial art in 1971. From 1974 he studied the local 'Kaga inlay' (Kaga zōgan) technique under Takahashi Kaishū (1909–2005), and has gone on to teach at Kanazawa College of Arts. Kaga inlay was developed in the Edo period and features fine lines of inlay and layers of coloured metals. The most lavish examples of the technique are found on decorated stirrups. Nakagawa uses it to inlay copper and silver alloy (oborogin) into cast-copper flower vases, imbuing them with a calm and restrained colour scheme. The decoration generally consists of geometric designs of perpendicular lines, or stylized motifs from nature which are expressed in a modern style. Nakagawa uses precision inlay techniques to great effect. He carves 1 mm and 0.6 mm grooves alternately on the surface, which he then inlays with different metals. (Cat. no. 85)

Ōsumi Yukie (b. 1945)

Ōsumi was born in Shizuoka prefecture. After graduating from Tokyo University of Fine Arts and Music in 1969 she learned the metal techniques of inlay, hammering and chasing from Kashima Ikkoku (q.v.), Sekiya Shirō (1907–94) and Katsura Moriyuki (1914–96). In 1987 she won the President's Prize of the Japan Art Crafts Association, and from 1988–9 studied in England on a scholarship provided by the Agency of Cultural Affairs for artists to work overseas. Influenced by traditional European metalwork techniques and silver vessels, she combined these newly acquired methods with traditional Japanese techniques. She has worked hard to introduce Japanese metalworking techniques to London, where she held solo exhibitions during the Japan Festivals of both 1991 and 2001. She creates vessels by hammering metal sheets into the required form and then decorating these with 'textile imprint inlay' (nunome zōgan). Her works achieve an overall grand and powerful effect, combining exquisite handling of the metal body with a delicately hammered texture on the finished surface. (Cat. no. 84)

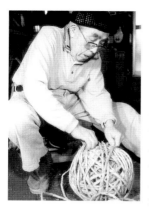

Saitō Akira (b. 1920)

Saitō was born in Tokyo, and from 1935 received instruction from his father Saitō Kyōmei (1890–1938) in lost-wax and other traditional metal-casting techniques. He also studied under Takamura Toyochika (q.v.) in both technique and form, mastering these to the highest levels and working determinedly to preserve and transmit them. He draws on a rich knowledge and a wide range of skills that are the result of assiduous research, and specializes in technically demanding 'mixed casting' (*iwake*). Exhibiting at the Japan Traditional Art Crafts Exhibition and the exhibition of new works by Living National Treasures, he applies the full range of traditional casting techniques to create pieces that are filled with a simple and fresh, contemporary beauty. These steps include constructing the mould, determining the mixture for the alloy, pouring into the mould, exposing the form and finishing with colour. His work was first accepted at the Nitten exhibition in 1950. Since 1975 he has exhibited regularly at the Japan Traditional Art Crafts Exhibition. In 1987 he was awarded the Tokyo Board of Education Prize at the Japan Traditional Art Crafts Metals Exhibition. He has continued to develop his skills and be active as a teacher. Saitō was designated a Living National Treasure in 1993 for his 'metal casting' (*chūkin*) technique. (Cat. no. 86)

Takamura Toyochika (1890–1972)

Takamura was born in Tokyo, the third son of the metal artist Takamura Kōun (1852–1934). He graduated in metal casting (*chūkin*) from the Tokyo School of Fine Arts in 1915 and taught there from 1926. In 1950 he became a Professor at the Kanazawa College of Arts. He has taught many pupils in addition to his creative activities as a metal caster. He won special awards at the eighth, ninth and tenth Teiten exhibitions, becoming the central figure in metal casting and a leader in the craft world. He commanded the various techniques of general moulds, wax moulds and stuffed moulds and used classical themes in his works in a simple, fresh and modern manner, working hard to create a new style full of artistic merit. In the field of metal casting he brought to life classic and traditional styles for the modern era. Takamura was designated a Living National Treasure in 1964 for his 'metal casting' (*chūkin*) technique. (Cat. no. 81)

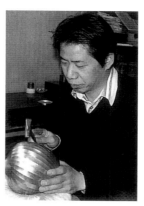

Tanaka Masayuki (1947–2005)

Tanaka was born in Tokyo. He learned hammering techniques from his father Tanaka Mitsuteru. In 1973 he won the Chairman's Prize and in 1999 an Outstanding Award at the Japan Traditional Art Crafts Exhibition. He taught at Utatsuyama Craft Workshop in Kanazawa. He was known for excellent hammering, beating and brazing techniques, which he used to make water jars for tea gatherings, flower vases and bowls. He devised a technique of applying gold and silver linework onto a pure silver hammered surface, creating warm designs that brought out the natural qualities of the metal. He skilfully handled the hammer to leave beautiful and sophisticated marks on the surface. Tanaka concentrated in the later part of his career on creating pieces with 'light and shadow' as their theme. He did this with faceting (*shinogi*) to express the light areas and hairline inlays of gold for the shadow areas. (Cat. no. 89)

Uozumi Iraku III (b. 1937)

Uozumi was born in Kanazawa city. He learned casting of copper and tin alloy (*sahari*) from his grandfather Iraku I (1886–1964), who was designated a Living National Treasure for his 'gong-making' (*dora*) technique. In 1959 his work was first selected for the Japan Traditional Art Crafts Exhibition, and in 1962 he was awarded the Chairman's Prize of the Committee for the Preservation of Cultural Properties. In 1980 he completed a bell known as 'Myōhachi' for Shitennōji temple, Osaka in 1980, and from 1983 began lecturing at Kanazawa College of Arts. Since 1989 he has taught at Utatsuyama Craft Workshop in Kanazawa. Enhancing the restrained colour and lustre typical of the copper and tin alloy (*sahari*), he specializes in utensils for tea gatherings and bowls. Their apparently simple forms are the product of his high level of technical skill. Iraku was designated a Living National Treasure in 2002 for his 'gong-making' (*dora*) technique. (Cat. no. 88)

Wood and Bamboo

Akiyama Issei (1901–88)

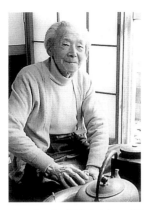

Akiyama was born in Tokyo. From 1918 he studied with Shimada Itsuzan and mastered the techniques of the so-called Shibayama style of inlay in shell, tortoiseshell, coral and precious stones. He also mastered the techniques of 'wood picture' (*mokuga*) inlay and metal chasing. In 1942 his work was first accepted at the Bunten exhibition. After the war he exhibited at the Nitten and Japan Traditional Art Crafts Exhibition. He was deeply impressed by the richness of the implements used in Buddhism ritual and this had a strong influence on his own creative activities from the late 1970s. His works were characterized by the purity of their forms, typically with patterns in inlay that contrasted strongly with the ebony (*kokutan*) or rosewood (*shitan*) body. Akiyama was designated a Living National Treasure in 1987 for his 'wood inlay' (*moku zōgan*) technique. (Cat. no. 94)

Hayakawa Shōkosai V (b. 1932)

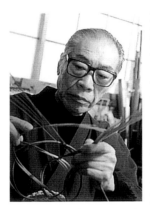

Hayakawa was born in Osaka. He learned bamboo craft from his father Shōkosai IV. He has exhibited his works at the Japan Traditional Art Crafts Exhibition each year since 1966, and succeeded his father as Shōkosai V in 1977. Building on the foundation of his apprenticeship, he creates works that preserve the traditions and techniques of the Hayakawa family while also expressing the strength, vitality and linear beauty of bamboo in a clean-cut and modern style. Hayakawa was designated a Living National Treasure in 2003 for his 'bamboo craft' (*chiku kōgei*) technique. (Cat. no. 99)

Himi Kōdō (1906–75)

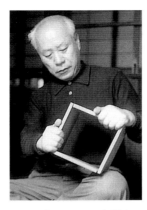

Himi was born in Kanazawa, Ishikawa prefecture. At the age of fifteen, he apprenticed with Kitajima Isaburō to learn joinery (*sashimono*) techniques. Then from the age of eighteen he studied 'Chinese-style decoration' (*karamono saiku*) techniques and wood-joinery design with the wood artist Ikeda Sakumi I (1886–1995). At the age of twenty, he established his independence. Based on techniques of Chinese-style decoration, he created practical objects with an appealing purity, such as tables, shelves and boxes. From 1951 he developed his signature gold- and silver-inlay technique, which successfully harmonized the natural beauty of the wood grain with the artificial beauty of the geometric inlay designs. Himi was designated a Living National Treasure in 1970 for his 'wood craft' (*moku kōgei*) technique. (Cat. no. 90)

Iizuka Shōkansai (1919–2004)

Iizuka was born in Hongō, Tokyo, the second son of Iizuka Rōkansai (1890–1958), a bamboo craftsman. He entered the Tokyo School of Fine Arts to study oil painting but was forced to graduate early, in 1942, because of the war. After demobilization he re-learned each of the bamboo-weaving techniques from his father. Early in his career he showed his works mainly at the Nitten exhibition, and then from 1974 he began to exhibit and win awards at the Japan Traditional Art Crafts Exhibition. Inheriting his father's signature weaving techniques such as 'layering and weaving' (*tabane-ami*) and 'pattern weaving over bamboo' (*takesashi-ami*), he created graceful works steeped in tradition that brought out the natural suppleness and elasticity of bamboo, while also paying due attention to their practicality. Iizuka was designated a Living National Treasure in 1982 for his 'bamboo craft' (*chiku kōgei*) technique. (Cat. no. 100)

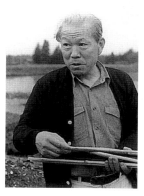

Katsushiro Sōhō (b. 1934)

Katsushiro was born in Kuroiso city, Tochigi prefecture. He studied the basic techniques of bamboo from the age of fifteen with Kikuchi Yoshii, a bamboo craftsman. In 1955 he established himself as an independent basket maker. Due to dwindling demand, however, in 1965 he joined the studio of the bamboo artist Yagisawa Keizō (1927–2006) and turned to more creative activities. In 1968 one of Iizuka Rōkansai's students, Saitō Bunseki, advised him on the direction that his artistic career should take. The basket entitled 'Shallow Stream' in the present exhibition features quite thick strips of bamboo arranged in curves using a technique called 'one thousand strands' (*sensuji*). This traditional technique aligns thin bamboo strips in a row that resemble the teeth of a comb. However, Katsushiro takes the technique further by curving the strips to evoke the sounds and reverberations of nature, expressing powerful rhythms in his bamboo works. Katsushiro was designated a Living National Treasure in 2005 for his 'bamboo craft' (*chiku kōgei*) technique. (Cat. no. 97)

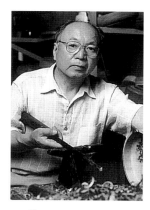

Kawagita Ryōzō (b. 1934)

Kawagita was born in Yamanaka town, Enuma district, Ishikawa prefecture. He learned woodcraft techniques from a young age from his father Kawagita Kōichi (1902–77), who was a maker of turned wood bodies for lacquer wares. He then studied under Himi Kōdō (q.v.), pursuing the traditional techniques of wood-turning to a high technical level. He works mainly in zelkova, mulberry, maple, black persimmon and horse chestnut (*tochi*), bringing out the natural qualities of each wood. He also uses the traditional technique particular to the Yamanaka area of wrinkled gold line inlay, producing works with a modern sensibility. Kawagita was designated a Living National Treasure in 1994 for his 'wood craft' (*moku kōgei*) technique. (Cat. no. 91)

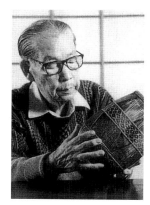

Maeda Chikubōsai II (1917–2003)

Maeda was born in Sakai city, Osaka prefecture. He learned traditional bamboo-craft techniques from his father Chikubōsai I, whom he succeeded as Chikubōsai II at the age of eighteen. Bamboo weaving was a thriving craft in Osaka during the Edo period (1600–1868), in the context of that city's enthusiasm for Chinese literati culture, and detailed Chinese-style weaving techniques evolved there. Chikubōsai II continued these traditions of his native city, weaving thin strips of bamboo into fine, delicate patterns. His works are also filled with a refined modern sensibility, with their layered weaves, transparency to suggest depth and geometric designs. Maeda was designated a Living National Treasure in 1995 for his 'bamboo craft' (*chiku kōgei*) technique. (Cat. no. 93)

Murayama Akira (b. 1944)

Murayama was born in Amagasaki city, Hyōgo prefecture. He graduated in sculpture from Kyoto City University of Arts and studied woodcraft with Kuroda Tatsuaki (q.v.). He has shown his works regularly since 1970 at the Japan Traditional Art Crafts Exhibition, when he immediately won the Asahi Shimbun Prize in the first year that he was accepted. He works mainly in zelkova (*keyaki*), which he finishes with the 'wiped lacquer' (*fuki-urushi*) technique. Building on Kuroda's style, he produces impressive works with powerfully curving surfaces that exploit the beautiful natural grain of the zelkova. Murayama was designated a Living National Treasure in 2003 for his 'wood craft' (*moku kōgei*) technique. (Cat. no. 98)

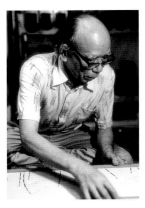

Nakadai Zuishin (1912–2002)

Nakadai was born in Chiba prefecture. At the age of fourteen he went to Tokyo and studied with the joiner Takeuchi Fuzan. Under Fuzan he began to make vessels for tea gatherings, using a wide range of woodworking skills, including joinery and 'pierced carving' (sukashi-bori). In 1933 he established his independence and from around the same time studied tea practices with Tanaka Senshō (1875–1960) and made tea utensils. He pursued further independent study of 'carving from the block' (kurimono) and mastered a wide range of traditional woodworking skills. He made many works of joinery such as small shelves, boxes and other tea utensils, but his most characteristic pieces are made of paulownia in the carving-from-the block technique. As the names suggests, this technique involves carving a block of wood by hand to make a form, using chisels, planes and small knives. Normally the material of choice is a hard wood such as zelkova (keyaki). Because paulownia is soft, it is relatively easy to carve the basic shape; however, it then requires a very high level of skill to finish off the surface in a beautiful way. Nakadai exploited the natural qualities of his woods very cleverly: the silver lustre given off by paulownia from the Aizu region, or the fine, straight grain of paulownia from the Nanbu region. He developed a personal style of carving that featured special curving planes and brought out the pure beauty of the surface of the wood. Nakadai was designated a Living National Treasure in 1984 for his 'wood craft' (moku kōgei) technique. (Cat. no. 95)

Nakagawa Kiyotsugu (b. 1942)

Nakagawa was born in Kyoto. He studied with his father Nakagawa Kameichi and Takeuchi Hekigai (1896–1986), mastering a wide range of wood-crafting techniques. He specializes in joinery, using soft woods such as Japanese cedar and sawara cypress. He is particularly skilled at the 'wood picture' (mokuga) technique – detailed arrangements of rectangular and triangular pieces of various special woods such as aged cedar (jindai sugi), Yoshino cedar and Kasuga cedar – and also at combining natural grain patterns to form decorative geometric designs. Nakagawa was designated a Living National Treasure in 2001 for his 'wood craft' (moku kōgei) technique. (Cat. no. 101)

Ōno Shōwasai (1912–96)

Ōno was born in Sōja city, Okayama prefecture. He learned the basics of woodcraft from his father Saizaburō, a joiner, and went on to study independently. From the age of twenty-three, he studied in Kurashiki with the literati painter Yunoki Gyokuson (1865–1943), who encouraged him to develop an interest in Chinese painting and calligraphy. He worked in a variety of formats, such as tables, shelves, boxes and small folding screens for tea gatherings (furosaki byōbu), tastefully bringing out the full beauty of the wood grain. He was highly skilled at strong and neatly fitting joinery, as well as in the wood inlay and 'incised and gold-filled wood grain' (mokume chinkin) techniques. Ōno was designated a Living National Treasure in 1984 for his 'wood craft' (moku kōgei) technique. (Cat. no. 96)

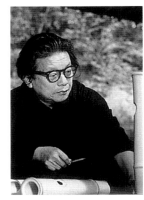

Shōno Shōunsai (1904–74)

Shōno was born in Beppu city, Ōita prefecture. From the age of nineteen he apprenticed under Satō Chikuyūsai, a local bamboo craftsman and learned traditional bamboo-crafting techniques. At the age of twenty-one he established his independence. His work was accepted at the Exhibition to Celebrate 2,600 years of the Imperial Dynasty in 1940, and he won a special recognition award and automatic acceptance status at the Bunten exhibition in 1943. After the war he extended his activities to the Nitten and the Japan Traditional Art Crafts Exhibition. While his earlier works focused on fine precision weaving, his later, highly skilled pieces demonstrated the natural beauty and elasticity of bamboo. Shōno was designated a Living National Treasure in 1967 for his 'bamboo craft' (chikugei) technique, the first bamboo artist to be so honoured. (Cat. no. 92)

Dolls

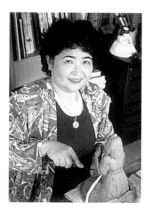

Akiyama Nobuko (b. 1928)

Akiyama was born in Osaka. From 1956 she apprenticed with Ōbayashi Sono (1910–71) to learn various doll-making techniques, including *tōso,* the application of handmade Japanese papers, and *kimekomi* fabric decoration. She also studied traditional Japanese-style painting (*Nihonga*) with Ikuta Kachō (1889–1978), lacquer with Takeishi Isamu (b. 1920) and sculpture with Itō Tetsugai. She creates dolls rich in expression using a wide variety of techniques. Onto a base of wood-core *tōso,* stripped dry lacquer or wood-core dry lacquer, she applies handmade Japanese paper or fabric, and then handpaints in colours or lacquer. Her subjects range over the customs and traditional performing arts of Okinawa, Korea and China, as well as Japanese traditional festivals. Akiyama was designated a Living National Treasure in 1996 for her 'costume doll' (*ishō ningyō*) technique. (Cat. no. 105)

Hayashi Komao (b. 1936)

Hayashi was born in Kyoto. He learned the traditional Kyoto technique and style of doll-making with Okamoto Shōzō (1910–94, Menshō XIII). He also studied Noh mask-making with Kitazawa Nyoi (1911–81) and 'Creative Doll'- (*Sōsaku ningyō*) making with Hiranaka Toshiko (1910–88), using the *tōso* technique. From his student days he has embraced an interest in Bunraku, Noh, Kyōgen and other traditional performing arts. Such influences are undoubtedly present in his work, when he creates dolls that convey an intense impression from within a still and confined pose. Traditional doll-making, particularly in the Kyoto style, fuses the opposing elements of the 'extraordinary' (*hare*) and the 'mundane' (*ke*) within a single entity, leading dolls to radiate a strong sense of presence within an overall calm. Hayashi was designated a Living National Treasure in 2002, for his 'doll with *tōso* over a wooden core' (*tōso ningyō*) technique. (Cat. no. 106)

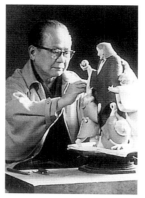

Hirata Gōyō II (1903–81)

Hirata was born in Tokyo. He first studied the techniques of the 'lifelike doll' (*iki ningyō*) tradition of Yasumoto Kamehachi I (1825–1900), under his father Gōyō I. His earliest works were very detailed and realistic. A member of Hakutakukai society, he contributed to the development of the 'Creative Doll' (*Sōsaku ningyō*) movement. He reflected long and hard on the forms and expressive content of dolls and finally, through his excellent technique, was able to achieve a unique style. After the war his works became more abstract, but his sure grasp of human anatomy meant that even when the dolls were abbreviated or deformed they still maintained a harmonious beauty. Gōyō II was designated a Living National Treasure in 1955, for his 'costume doll' (*ishō ningyō*) technique. (Cat. no. 102)

Hori Ryūjo (1897–1984)

Hori was born in Tokyo. She taught herself doll-making and later joined the Dontakusha and Kōjitsukai societies, becoming the central figure in the 'Creative Doll' (*Sōsaku ningyō*) movement. When dolls were first included in the Teiten exhibition in 1936, her's was one of the six exhibited. Her earliest works tended to be lyrical and expressive, but she went on to focus on the inner emotions conveyed by dolls that were self-contained in their postures, a style uniquely her own. A particular fondness for textiles is seen in her dolls, with subtle details such as placing gauze over carefully combined costume patterns to give them extra depth. Hori was designated a Living National Treasure in 1955 for her 'costume doll' (*ishō ningyō*) technique. (Cat. no. 104)

Kagoshima Juzō (1898–1982)

Kagoshima was born in Fukuoka. From the age of fifteen he studied with Arioka Yonejirō, a maker of Hakata dolls. After becoming independent, he first began to make dolls using terracotta. Later, however, he turned to traditional paper doll-making techniques, developing a kind of *shiso* paste that was crack resistant and had good colour retention. He specialized in full-bodied figures that exploited the special qualities of *washi* paper, applying to them colourful dyed papers built up into soft patterns, and his works are ample and rich in poetic sentiment. Known also as a poet of the Araragi school, he sometimes derived themes for his works from the ancient *Manyōshū* poetry anthology of the AD 700s. A member of the Kōjitsukai society, he contributed to the development of the 'Creative Doll' (*Sōsaku ningyō*) movement. Kagoshima was designated a Living National Treasure in 1961 for his '*shiso* paste doll' (*shiso ningyō*) technique. (Cat. no. 103)

Serikawa Eiko (b. 1928)

Serikawa was born in Tokyo. She graduated from the literature department of Japan Women's University. From 1954 she studied with Hirata Gōyō II (q.v.) and learned a realistic style of doll-making, using wood-carving techniques. She has a strong interest in history, literature and the stage arts and manages to imbue the taught lines of the bodies she carves with a lyrical mood derived from these sources. With delicate feminine sensibility she captures charming expressions of the moment. She painstakingly adds the costumes using the *kimekomi* technique and has also developed a method called 'colour carving' (*saichō*), which she uses to express detailed patterns. Each doll is thereby imbued with its own specific character. (Cat. no. 107)

Cut metal foil

Eri Sayoko (b. 1945)

Eri was born in Kyoto. She began the study of traditional Japanese-style painting (*Nihonga*) from her high-school years, then textile dyeing when she was at college. Later, she married into a family of Buddhist sculpture makers and began to take interest in the 'cut metal foil' (*kirikane*) technique used to apply ornamental decoration to the sculptures. She learned traditional cut metal foil techniques from Kitamura Kishō. Since 1983 she has displayed her work regularly at the Japan Traditional Art Crafts Exhibition and held many one-woman shows, establishing her own independent style. She is known for her original forms and fulsome colouring, in such works as a delicate ornamental box with stand and an incense container in the shape of an embroidered decorative ball (*mari*). Eri was designated a Living National Treasure in 2002 for her 'cut metal foil' (*kirikane*) technique. (Cat. no. 109)

Saida Baitei (1900–81)

Saida was born in Kyoto, the fifth son of a family that specialized in Buddhist paintings with cut metal foil (*kirikane*) at Nishi-Honganji temple. He graduated in design from Kyoto City University of Arts and learned the cut metal-foil technique from his elder brother, Tokisaburō V, going on to inherit the family trade following this brother's death. Together with other local Kyoto craftsmen, he formed the Sekkōkai society dedicated to the preservation of the cut metal-foil technique. Furthermore, he worked to extend the use of the technique beyond Buddhist painting, applying it to other crafts, and his work was accepted at the Bunten exhibition. After the war he pursued a long and active career, showing at the Nitten and Japan Traditional Art Crafts Exhibition. He specialized in ornamenting pale wood surfaces, such as paulownia and mulberry, with exquisitely executed geometric patterns full of classical elegance. Saida was designated a Living National Treasure in 1981 for his 'cut metal foil' (*kirikane*) technique. (Cat. no. 108)

Glass

Aono Takeichi (b. 1921)

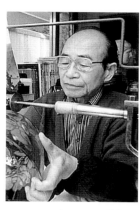

Aono was born in Hyōgo prefecture. He graduated in craft design from Himeji Technical High School in 1939. He specializes in mould-blown lidded wares, with highly pictorial relief work executed in coloured overlay glass. His favourite motifs are typical East Asian flowers and plants such as camellia, which he delicately expresses using complex combinations of techniques such as engraving, sandblasting and *kiriko* cutting. He has mainly shown his works at the Nitten since 1949 and the Japan Traditional Art Crafts Exhibition since 1976. The combination of traditional Japanese beauty of form with the particular medium of glass gives Aono's work a unique and powerful presence. (Cat. no. 111)

Ishida Wataru (b. 1938)

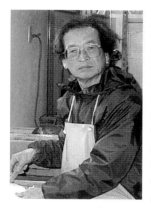

Ishida was born in Osaka. He first aspired to a career in textile design and apprenticed with Kanō Toyohiro, later establishing his independence as a designer. In 1985 he began to study *pate-de-verre* glass, and his work in this technique was first accepted at the Japan Traditional Art Crafts Exhibition in 1995. In 2000 he won an Encouragement Award at the exhibition. He exploits the semi-transparent qualities of *pate-de-verre* to create works that are delicate and lyrical. The uniform designs that cover the full exterior of his works are carefully executed with precise skill, creating pleasing rhythms within a calm form. (Cat. no. 112)

Shirahata Akira (b. 1946)

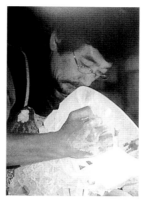

Shirahata was born on the island of Izu Ōshima, Tokyo. From 1965 he worked at the Hoya Corporation, studying the cut-glass (*kiriko*) technique. In 1992 he established his independence. Cut-glass technique is normally used just for surface decoration, but he has boldly expanded it to help create the actual forms of his dynamic vessels, in a range of shapes that are much admired. He has shown his work since 1974 at the Japan Traditional Art Crafts Exhibition, where in 1992 he won an Outstanding Award. Shirahata's vessels with deeply carved grooves around the rim or base are then finished with delicate and exquisite cut-glass patterns that enhance with many different effects the clear, uncoloured beauty of the crystal glass. (Cat. no. 110)

Description of Works

Ceramics

1

Covered jar with geometric pattern, 1953
Tomimoto Kenkichi (1886–1963)
Porcelain with overglaze enamels, gold and silver
H: 18.0, D: 24.0 cm
The National Museum of Modern Art, Kyoto

2

Large dish with cross design, 1955
Hamada Shōji (1894–1978)
Stoneware with slip and glaze
H: 13.9, D: 51.0 cm
The National Museum of Modern Art, Kyoto

3

Large dish, 1957
Kaneshige Tōyō (1896–1967)
Stoneware, Bizen style
H: 10.0, D: 45.5 cm
The National Museum of Modern Art, Tokyo

4

Jar with bird design, 1958
Ishiguro Munemaro (1893–1968)
Stoneware with black and brown iron-oxide glazes
H: 23.5, D: 18.5 cm
The National Museum of Modern Art, Tokyo

5

Lidded round container, 1958
Katō Hajime (1900–68)
Porcelain with yellow-green glaze and gold enamel
H: 10.2, D: 21.5 cm
The National Museum of Modern Art, Tokyo

6

Water jar for tea gatherings, 1958
Miwa Kyūwa (1895–1981)
Stoneware, Hagi style
H: 16.8, W: 21.0, D: 13.7 cm
The National Museum of Modern Art, Tokyo

7

Teabowl, 1960
Arakawa Toyozō (1894–1985)
Stoneware with glaze, Shino style
H: 9.5, D: 12.5 cm
The National Museum of Modern Art, Tokyo

8

Large bowl, 1962
Okabe Mineo (1919–90)
Stoneware with copper-green glaze, Oribe style
H: 26.0, D: 48.5 cm
The National Museum of Modern Art, Kyoto

9

Cylindrical vase, 1963
Fujiwara Kei (1899–1983)
Stoneware, Bizen style
H: 26.5, D: 11.8 cm
The National Museum of Modern Art, Kyoto

10

Jar with grapevine trellis design, 1964
Kondō Yūzō (1902–85)
Porcelain with underglaze cobalt blue
H: 32.0, D: 39.0 cm
The National Museum of Modern Art, Kyoto

11

Large dish with iris design, 1965
Tamura Kōichi (1918–1987)
Stoneware with iron-oxide glaze

H: 9.8, D: 50.0 cm
The National Museum of Modern Art, Kyoto

12

Large bowl with celadon glaze, 1973
Shimizu Uichi (1926–2004)
Stoneware with glaze
H: 15.5, D: 42.0 cm
The National Museum of Modern Art, Tokyo

13

Large bowl with celadon glaze, 1976
Miura Koheiji (1933–2006)
Stoneware with glaze
H: 16.0, D: 30.0 cm
The National Museum of Modern Art, Tokyo

14

Bowl with floral design, 1978
Imaizumi Imaemon XIII (1926–2001)
Porcelain with underglaze uranium oxide (*fukizumi*) and overglaze enamels, Nabeshima style
H: 14.0, D: 46.0 cm
The National Museum of Modern Art, Tokyo

15

Large vase with decorative fissures, 1979
Matsui Kōsei (1927–2003)
Stoneware with three-layered clay
H: 40.5, D: 44.0 cm
The National Museum of Modern Art, Kyoto

16

Lidded container with design of silk trees and sparrows, 1982
Fujimoto Yoshimichi (1919–92)
Porcelain with overglaze enamels

and silver
H: 6.2, W: 32.0, D: 32.0 cm
The National Museum of Modern
Art, Kyoto

17
Large dish, 1983
Tsukamoto Kaiji (1912–90)
Porcelain with underglaze cobalt
blue
H: 6.5, D: 51.5 cm
The National Museum of Modern
Art, Kyoto

18
Vase, 'Blue Vessel' (Sōyō), 1984
Katō Takuo (1917–2005)
Stoneware with three-colour glaze
(sansai)
H: 18.5, D: 37.0 cm
The National Museum of Modern
Art, Tokyo

19
Bowl with striped design, 1985
Itō Sekisui V (b. 1941)
Stoneware with marbled clay,
Mumyōi ware
H: 18.5, D: 50.0 cm
The National Museum of Modern
Art, Tokyo

20
Bowl with azalea design, 1986
Sakaida Kakiemon XIV (b. 1934)
Milk-white (nigoshi-de) porcelain
body with overglaze enamels
H: 20.0, D: 52.3 cm
The National Museum of Modern
Art, Tokyo

21
Teabowl, 1989
Miwa Jusetsu (b. 1910)
Stoneware, 'rugged Hagi' (onihagi)
style
H: 11.6, D: 14.6 cm

The National Museum of Modern
Art, Tokyo

22
Bowl, 'Genesis' (Sōsei), 1991
Tokuda Yasokichi III (b. 1933)
Porcelain with vivid coloured glazes
(yōsai)
H: 8.0, D: 54.5 cm
The National Museum of Modern
Art, Tokyo

23
Bowl with clematis design, 1992
Yoshita Minori (b. 1932)
Porcelain with underglaze gold
H: 11.0, D: 55.0 cm
Agency for Cultural Affairs

24
Flower-shaped bowl, 1996
Inoue Manji (b. 1929)
White porcelain
H: 17.0, D: 47.0 cm
The National Museum of Modern
Art, Tokyo

25
Jar with faceted body, 1996
Maeta Akihiro (b. 1954)
White porcelain
H: 43.0, D: 31.5 cm
The National Museum of Modern
Art, Tokyo

26
Teabowl, 2001
Katō Kōzō (b. 1935)
Stoneware with glaze, black Seto
style
H: 10.2, D: 12.4 cm
Private collection

27
Large jar with bird and flower
design, 2005
Hara Kiyoshi (b. 1936)

Stoneware with iron-oxide glaze
H: 37.5, D: 37.0 cm
Agency for Cultural Affairs

28
Rectangular plate, 2005
Isezaki Jun (b. 1936)
Stoneware, black Bizen style
H: 9.5, W: 43.5, D: 43.5 cm
The National Museum of Modern
Art, Tokyo

29
Large bowl with celadon glaze and
incised design, 2005
Nakashima Hiroshi (b. 1941)
Stoneware with glaze
H:13.0, D:44.5 cm
Private collection

30
Teabowl, 2006
Suzuki Osamu (b. 1934)
Stoneware with glaze, Shino style
H: 9.5, D: 13.0 cm
Private collection

Textiles

31
Kimono with design of wild plants,
bamboo grass and chequered
pattern (hitta), 1955
Inagaki Toshijirō (1902–63)
Stencil dyeing on cotton
H: 159.0, W: 134.0 cm
National Museum of Modern Art,
Kyoto

32
Door curtain (noren) inscribed 'This
mountain path… (Kono yama
michi…)', 1959
Serizawa Keisuke (1895–1984)
Stencil dyeing on cotton
H: 181, W: 74.0 cm

National Museum of Modern Art, Tokyo

33
Kimono with chrysanthemum-petal design, 1960
Moriguchi Kakō (b. 1909)
Yūzen dyeing on white pongee (*jōdai tsumugi*) silk
H: 161.0, W: 125.0 cm
National Museum of Modern Art, Tokyo

34
Kimono, 'Star Festival' (*Tanabata*), 1960
Shimura Fukumi (b. 1924)
Pongee (*tsumugi*) silk
H: 165.0, W: 130.8 cm
National Museum of Modern Art, Kyoto

35
Kimono, 'Rippled Shadow' (*Yōei*), 1960
Tajima Hiroshi (b. 1922)
Yūzen dyeing on crêpe silk
H: 160,0, W: 124.0 cm
National Museum of Modern Art, Tokyo

36
Kimono, 'On the Water' (*Fuyū*), 1961
Hata Tokio (b. 1911)
Yūzen dyeing on crêpe silk
H: 162.6, W: 132.0 cm
National Museum of Modern Art, Kyoto

37
Kimono, 'Refreshing Hill' (*Sōkyū*), 1966
Yamada Mitsugi (1912-2002)
Yūzen dyeing on crêpe silk
H: 160.0, W: 124.0 cm
National Museum of Modern Art, Tokyo

38
Kimono, 'Melody' (*Senritsu*), 1968
Matsubara Yoshichi (b. 1937)
Indigo stencil dyeing on silk
H: 160.0, W: 132.0 cm
National Museum of Modern Art, Tokyo

39
Two-fold screen, design of Japanese syllabic characters in six columns, 1973
Serizawa Keisuke (1895–1984)
Stencil dyeing on cotton
H: 168.0, W: 182.0 cm
National Museum of Modern Art, Tokyo

40
Kimono with fine repeating pattern (*Edo komon*) known as 'sliced pear', 1976
Komiya Yasutaka (b. 1925)
Stencil dyeing on crêpe silk
H: 163.0, W: 124.0 cm
National Museum of Modern Art, Tokyo

41
Sash (*obi*), 'Early Spring' (*Haru niou*), 1978
Koga Fumi (b. 1927)
Saga-brocade (*Saga nishiki*) type weave
W: 31.5, L: 356.0 cm
National Museum of Modern Art, Tokyo

42
Kimono, 'Dancing Fragrance' (*Sankun*), 1978
Ogura Kensuke (1897-1982)
Tie-dyeing on silk
H: 160.0, W: 130.0 cm
National Museum of Modern Art, Kyoto

43
Kimono with flower pattern, 1979
Suzuta Teruji (1916–81)
Woodblock dyeing on silk
H: 168.0, W: 130.0 cm
National Museum of Modern Art, Tokyo

44
Kimono, 'Perpetual Recurrence' (*Seisei kyorai*), 1980
Fukuda Kijū (b. 1932)
Embroidered silk
H: 167.5, 130.0 cm
National Museum of Modern Art, Tokyo

45
Kimono, 'Sand Flow' (*Ryūsa*), 1984
Moriguchi Kunihiko (b. 1941)
Yūzen dyeing on silk
H: 162.0, W: 138.0 cm
Private collection

46
Kimono with striped and circular patterns, 1984
Munehiro Rikizō (1914–89)
Pongee (*tsumugi*) silk
H: 165.0, W: 132.0 cm
National Museum of Modern Art, Tokyo

47
Kimono, 'Sapphire Blue' (*Safaiya buruu*), 1986
Moriyama Torao II (b. 1933)
Woven silk with *Kurume-gasuri* style pattern
H: 204.6, W: 136.0 cm
Agency for Cultural Affairs

48
Kimono, 'Straw Mounds' (*Warazuka*), 1986
Suzuta Shigeto (b. 1954)
Woodblock and stencil dyeing on silk

H: 166.3, W: 131.8 cm
National Museum of Modern Art,
Tokyo

49
Kimono, 'Caper' (*Fūchōsō*), *c*.1987
Kamaga Toshiko (b. 1938)
Stencil dyeing on silk
H: 166.3, W: 133.2 cm
National Museum of Modern Art,
Tokyo

50
Kimono, 'Path Leading into the
Woods' (*Mori ni kakaru michi*), 1989
Murakami Ryōko (b. 1949)
Woven pongee (*tsumugi*) silk
H: 169.0, W: 133.0 cm
Private collection

51
Kimono, 'Plants and Flowers'
(*Sōka*), 1991
Tamanaha Yūkō (b. 1936)
Double-sided *bingata* stencil dyeing
on ramie silk
H: 174.0, W: 138.0 cm
National Museum of Modern Art,
Tokyo

52
Kimono, 'Southern Sea' (*Minami no
umi*), 1993
Miyahira Hatsuko (b. 1922)
Woven silk in *hanakura-ori* style
H: 168.0, W: 137.0 cm
Private collection

53
Pale blue textile with transparent
pattern, 1996
Kitamura Takeshi (b. 1935)
Woven silk fine gauze (*ra*)
H: 72.0, W: 460.0 cm
National Museum of Modern Art,
Tokyo

54
Sash (*obi*), 'Early Summer Breeze'
(*Kunpū*), 2000
Hosomi Kagaku (b. 1922)
Figured brocade weave
W: 31.0 cm
Private collection

55
Dark blue textile with bird, flower
and boat pattern, 2001
Taira Toshiko (b. 1921)
Woven banana tree-fibre
W: 37.2 cm
Agency for Cultural Affairs

56
Kimono, 'Fragrance of the Breeze'
(*Kaze no kaori*), 2005
Sasaki Sonoko (b. 1939)
Woven pongee (*tsumugi*) silk with
kasuri pattern
H: 174.5, W: 132.0 cm
Private collection

Lacquer

57
Tray, 1957
Masumura Mashiki (1910–96)
Lacquer on wood using *kanshitsu*
technique
H: 7.5, W: 38.0, D: 38.0 cm
National Museum of Modern Art,
Tokyo

58
Ornamental box in a flowing
design, *c*.1957
Kuroda Tatsuaki (1904–82)
Red lacquer on wood (*sekishitsu*)
H: 18.5, W: 31.2, D: 16.0 cm
National Museum of Modern Art,
Tokyo

59
Bowl with circle design, 1961
Akaji Yūsai (1906–84)
Lacquer on wood using *magewa*
(hoop-built) technique with
coloured lacquer
H: 10.0, D: 42.1 cm
National Museum of Modern Art,
Tokyo

60
Ornamental box, solar eclipse
design, 1963
Taguchi Yoshikuni (1923–98)
Lacquer on wood with sprinkled
gold (*maki-e*)
H: 17.1, W: 19.1, D: 19.1 cm
National Museum of Modern Art,
Tokyo

61
Incense tray with wave design,
1966
Isoi Masami (b. 1926)
Lacquer on wood with *kinma*
technique
H: 3.0, W: 45.5, D: 25.5 cm
National Museum of Modern Art,
Kyoto

62
Water jar for tea gatherings in
trillium flower design, 1966
Otomaru Kōdō (1898–1997)
Lacquer on wood using layered
lacquer carving (*chōshitsu*)
H: 15.0, D: 16.0 cm
National Museum of Modern Art,
Kyoto

63
Box, 'Dragonfly' (*Akatombo*), 1969
Matsuda Gonroku (1896–1986)
Lacquer on wood, with mother-of-
pearl inlay and sprinkled gold
(*maki-e*)
H: 11.3, W: 15.5, D: 27.5 cm

National Museum of Modern Art, Kyoto

64
Letter box with crane design, 1973
Ōba Shōgyo (b. 1916)
Lacquer on wood with gold and silver using *hyōmon* technique
H: 14.5, W: 16.0, D: 26.7 cm
National Museum of Modern Art, Tokyo

65
Water jar for tea gatherings, 'Spring' (*Haru*), 1976
Terai Naoji (1912–98)
Lacquer on metal with sprinkled gold (*maki-e*)
H: 16.6, D: 18.8 cm
National Museum of Modern Art, Tokyo

66
Incense case with lid, 1977
Shioda Keishirō (b. 1926–2006)
Lacquer on wood using *kanshitsu* technique
H: 11.0, W: 24.0, D: 25.0 cm
National Museum of Modern Art, Tokyo

67
Tray with handle, 1979
Masumura Kiichirō (b. 1941)
Cinnabar lacquer on wood using *kanshitsu* technique
H: 26.0, W: 43.0, D: 31.0 cm
National Museum of Modern Art, Tokyo

68
Tanzaku (poetry slip) box, 'Morning Oze' (*Oze no asa*), 1982
Sasaki Ei (1934–84)
Lacquer on wood with sprinkled gold (*maki-e*) and coloured-shell inlay

H: 9.0, W: 44.0, D: 10.0 cm
National Museum of Modern Art, Tokyo

69
Letter box, 'Butterfly' (*Chō*), 1986
Ōta Hitoshi (b. 1931)
Woven bamboo base (*rantai*) with *kinma* technique
H: 6.5, W: 26.0, D: 28.0 cm
National Museum of Modern Art, Tokyo

70
Small chest with squirrel design, 1987
Nakano Kōichi (b. 1947)
Lacquer on wood with sprinkled gold (*maki-e*)
H: 17.4, W: 14.0, D: 24.5 cm
Agency for Cultural Affairs

71
Writing-paper box, 'Morning Mist' (*Asagiri*), 1998
Mae Fumio (b. 1940)
Lacquer on wood with gold inlay (*chinkin*)
H: 6.0, W: 28.0, D: 31.0 cm
National Museum of Modern Art, Tokyo

72
Box, 'Impressions of Ancient Tomb' (*Koryōsō*), 1999
Yamaguchi Matsuta (b. 1940)
Lacquer on wood with coloured lacquer appliqué using *kanshitsu* technique
H: 16.0, W: 27.5, D: 15.0 cm
Agency for Cultural Affairs

73
Ornamental box, 'Coloured Lights' (*Saikō*), 2000
Murose Kazumi (b. 1950)
Lacquer on wood with sprinkled

gold (*maki-e*) and mother-of-pearl inlay
H: 9.2, D: 25.2 cm
Agency for Cultural Affairs

74
Round tray in hoop-built (*magewa*) technique, 2000
Ōnishi Isao (b. 1944)
Black translucent lacquer (*tamenuri*) on wood
H: 5.4, D: 53.0 cm
Agency for Cultural Affairs

75
Box with butterfly and peony design, 2002
Kitamura Shōsai (b. 1938)
Lacquer on wood
H: 11.3, W: 16.0, D: 24.0 cm
Private collection

76
Round tray, 'Dawn', 2002
Komori Kunie (b. 1945)
Woven bamboo base (*rantai*) with hoop-built (*magewa*) technique
H: 3.8, D: 44.5 cm
Agency for Cultural Affairs

Metal

77
Kettle for tea gatherings in the shape of a toy top, 1961
Kakutani Ikkei (1904–99)
Iron
H: 15.9, D: 27.5 cm
National Museum of Modern Art, Tokyo

78
Oblong box with incised line pattern, 1962
Naitō Shirō (1907–88)
Brass

H: 8.6, W: 10.1, D: 18.1 cm
National Museum of Modern Art,
Tokyo

79
Vase with square sides and
diamond motif, 1963
Katori Masahiko (1899–1988)
Bronze
H: 30.5, W: 15.6, D: 11.5 cm
National Museum of Modern Art,
Tokyo

80
Kettle for tea gatherings with
triangular wave pattern and jewel-
shaped knob, 1965
Nagano Tesshi I (1900–77)
Iron
H: 19.0, D: 26.0 cm
National Museum of Modern Art,
Kyoto

81
Vase with horizontal stripes, 1965
Takamura Toyochika (1890-1972)
Bronze
H: 20.2, D: 26.0 cm
National Museum of Modern Art,
Tokyo

82
Letter box with snipe design, 1967
Masuda Mitsuo (b. 1909)
Wrought iron with silver inlay
H: 10.0, W: 17.0, D: 9.0 cm
National Museum of Modern Art,
Kyoto

83
Water jar for tea gatherings with
dayflower design, 1977
Kashima Ikkoku (1898–1996)
Silver, and copper and silver alloy
(*rōgin*) with textile-imprint inlay
(*nunome zōgan*)
H: 11.0, D: 20.7 cm

National Museum of Modern Art,
Tokyo

84
Vase, 'Sea Breeze' (*Shiokaze),* 1986
Ōsumi Yukie (b. 1945)
Hammered silver
H: 20.3, D: 18.0
Agency for Cultural Affairs

85
Vase with stripe design, 1988
Nakagawa Mamoru (b. 1947)
Caste copper inlaid with copper
and silver alloy (*rōgin*)
H: 21.0, W: 24.5, D: 24.5 cm
Agency for Cultural Affairs

86
Flower vase, 1992
Saitō Akira (b. 1920)
Copper and silver alloy (*rōgin*),
lost-wax technique
H: 22.0, D: 22.0 cm
National Museum of Modern Art,
Tokyo

87
Bowl, 1997
Okuyama Hōseki (b. 1937)
Copper and silver alloy (*rōgin*)
H: 13.5, D: 24.5 cm
National Museum of Modern Art,
Tokyo

88
Water jar for tea gatherings with
horizontal line design, 1998
Uozumi Iraku III (b. 1937)
Copper and tin alloy (*sahari*)
H: 9.5, D: 24.0 cm
Agency for Cultural Affairs

89
Water jar for tea gatherings, 1999
Tanaka Masayuki (1947–2005)
Welded silver and copper and gold

alloy (*shakudō*)
H: 10.0, D: 17.0 x 9.0 cm
Agency for Cultural Affairs

Wood and Bamboo

90
Box for utensils for tea gatherings,
1964
Himi Kōdō (1906–75)
Japanese larch, sand-polished
H: 13.0, W: 14.5, D: 21.5 cm
National Museum of Modern Art,
Tokyo

91
Large bowl, 1964
Kawagita Ryōzō (b. 1934)
Zelkova wood with clear lacquer
H: 9.4, D: 48.0 cm
National Museum of Modern Art,
Tokyo

92
Flower basket, 'Fence' (*Magaki*),
1968
Shōno Shōunsai (1904–74)
Bamboo, double-wall weave
(*musō ami*)
H: 32.0, W: 44.0, D: 31.0 cm
National Museum of Modern Art,
Tokyo

93
Flower basket with leaf pattern in
the weave, 1972
Maeda Chikubōsai II (1917–2003)
Bamboo
H: 29.0, D: 25.2 cm
National Museum of Modern Art,
Tokyo

94
Seal box with inlaid flower circle
design, 1981
Akiyama Issei (1901–88)

Striped ebony wood
H: 12.5, W: 12.5, D: 18.5 cm
National Museum of Modern Art,
Tokyo

95
Flower-shaped bowl, 1981
Nakadai Zuishin (1912–1981)
Paulownia wood
H: 5.7, D: 34.7 cm
National Museum of Modern Art,
Tokyo

96
Small box, 1993
Ōno Shōwasai (1912–96)
Mulberry and mottled persimmon
wood
H: 13.6, W: 9.3, D: 18.3 cm
National Museum of Modern Art,
Tokyo

97
Basket, 'Shallow Stream' (Seseragi)
with narrow wave design, 1997
Katsushiro Sōhō (b. 1934)
Split bamboo technique (masawari)
H: 8.5, W: 68.5, D: 28.5 cm
Agency for Cultural Affairs

98
Tray with line design, 2000
Murayama Akira (b. 1944)
Zelkova wood with clear lacquer
H: 6.2, W: 42.7, D: 42.7 cm
National Museum of Modern Art,
Kyoto

99
Hexagonal flower basket with
herringbone design, 2001
Hayakawa Shōkosai V (b. 1932)
Bamboo
H: 34.0, W: 23.0, D: 21.0 cm
Agency for Cultural Affairs

100
Flower basket, 'Open-mouthed
Dragon' (Donryū), 2002
Iizuka Shōkansai (1919–2004)
Bleached bamboo (shirasabi)
H: 48.0, W: 67.0 cm
Agency for Cultural Affairs

101
Shikishi box with wood mosaic
pattern, 2002
Nakagawa Kiyotsugu (b. 1942)
Aged cedar wood
H: 10.8, W: 21.8, D: 29.8 cm
Agency for Cultural Affairs

Other Crafts

Dolls

102
Doll, 'In Leisure' (Nodoka), 1958
Hirata Gōyō II (1903–81)
Paulownia wood, paulownia wood
sawdust past (tōso), cloth,
powdered shell (gofun)
H: 35.0 cm
National Museum of Modern Art,
Tokyo

103
Doll, 'Ōmori gift' (Ōmori miyage),
1958
Kagoshima Juzō (1898–1982)
Papier mâché
H: 23.0 cm
National Museum of Modern Art,
Tokyo

104
Doll, 'Old Mirror' (Kokyō), 1963
Hori Ryūjo (1897–1984)
Paulownia wood, paulownia wood
sawdust paste (tōso), cloth,
powdered shell (gofun)
H: 30.0 cm

National Museum of Modern Art,
Tokyo

105
Doll, 'Naming a Child' (Meimei),
1980
Akiyama Nobuko (b. 1928)
Paulownia wood sawdust paste
(tōso)
H: 25.0 cm
National Museum of Modern Art,
Tokyo

106
Doll, 'Eguchi', 1984
Hayashi Komao (b. 1936)
Paulownia wood, paulownia wood
sawdust paste (tōso), cloth,
powdered shell (gofun)
H: 30.0 cm
National Museum of Modern Art,
Tokyo

107
Doll, 'Turning Autumnal'
(Aki meku), 1995
Serikawa Eiko (b. 1928)
Paulownia wood, cloth
H: 35.0 cm
National Museum of Modern Art,
Tokyo

Cut metal foil

108
Small box with rape-flower design,
1963
Saida Baitei (1900–81)
Wood with cut metal-foil
decoration (kirikane)
H: 9.6, W: 12.3, D: 12.3 cm
National Museum of Modern Art,
Tokyo

109
Ornamental box, 1991

Eri Sayoko (b. 1945)
Wood with cut metal-foil
decoration (*kirikane*)
H: 23.0, W: 16.0, D: 16.0 cm
Agency for Cultural Affairs

Glass

110
Vase with three points, 1988
Shirahata Akira (b. 1946)
Crystal glass
H: 27.0, D: 15.5 cm
Private collection

111
Covered container with camellia
design, 1993
Aono Takeichi (b. 1921)
Red cut overlay glass
H: 15.5, D: 23.0 cm
National Museum of Modern Art,
Tokyo

112
Covered container, 'White Age
(Age 99)', 2000
Ishida Wataru (b. 1938)
Glass, *pate de verre*
H: 14.5, D: 26.3 cm
Private collection

Craft Heritage

113
Flower vase, 1580–1620
Stoneware with natural ash glaze,
Iga ware
H: 27.0, D: 15.5 cm
Loaned by the Urasenke
Foundation, Kyoto

114
Dish with bull's-eye motif, early
1800s

Stoneware with slip and glaze, Seto
ware
H: 5.0 cm, D: 26.5 cm
The British Museum, JA 1947.12-
17.42

115
Lobed dish with design of birds
and flowers, late 1600s
Porcelain with overglaze enamels,
Hizen ware, Ko-Kutani style
Given by Sir A W Franks
D: 21.3 cm
The British Museum, JA F1704

116
Dish with design of maple leaves
and rushing stream, about 1700-20
Porcelain with underglaze cobalt
and overglaze enamels, Nabeshima
ware
Given by Sir A W Franks
D: 20.5 cm
The British Museum, JA F1283+

117
Vase with shell design, *c.*1900
Seifū Yohei III (1851–1914)
Porcelain with glaze
Given by David Hyatt King
H: 14.8 cm, D: 19.0 cm
The British Museum, JA 1979.10-
13.2

118
Rital tray (*suebako*), about 1400s
Wood, gilt-bronze, lacquer, silk
L: 33.8, W: 29.5
The British Museum, JA 1968.2-
12.1

119
Mirror with birds and butterflies,
1400s–1500s
Bronze
Given by H. Yamakawa
D: 12.2 cm

The British Museum, JA 1927.10-
14.8

120
Katana blade, 1963
Miyairi Akihira (1913–77)
Steel
L: 88.2 cm
Loaned by Mrs Geoffrey Hamilton

121
Saké pourer, 1400s
Wood, lacquer, Negoro style
H: 33.5, D: 24.5 cm
The British Museum, JA 1978.4-
21.1

122
Tiered picnic box with design of
poppies, late 1600s
Wood, lacquer, shell-inlay
H: 38.0, W: 27.3, D: 27.3 cm
Bequeathed by Oscar Raphael
The British Museum, JA 1945.10-
17.487

123
Emperor and empress dolls,
c. early 1800s
Wood, powdered shell (*gofun*),
textile
Emperor H: 29.5, W: 32.5, D: 20.0
cm; empress H: 31.0, W: 32.5,
D: 26.0 cm
The British Museum, JA 2001.11-
29.1,2

Bibliography

Agency for Cultural Affairs 2001. *Bunkazai hogohō gojūnen shi* (*Fifty Years of the Law for the Protection of Cultural Properties*), Tokyo, Gyōsei, 2001

Aoki 1989. Aoki Hiroshi, 'Iizuka Rōkansai to sono kindaisei' (*Iizuka Rōkansai and his Modernity*), *Iizuka Rōkansai ten* (*Iizuka Rōkansai: Master of Modern Bamboo Crafts*) (exhibition catalogue), Utsunomiya, Tochigi Prefectural Museum of Art, 1989: pp. 14–22

Asahi Newspaper 1984. Asahi Newspaper Western Japan Head Office Planning Departmen (eds), *Dentō kōgei sanjūnen no ayumi* (*30 Years of Traditional Crafts*) (exhibition catalogue), Fukuoka, Asahi Shimbunsha, 1984

Asahi Newspaper 2003. *Nihon dentō kōgeiten 50-nen kinen – Waza no bi* (*Japan's Traditional Art Crafts – A 50-Year Retrospective*)(exhibition catalogue), Tokyo, Asahi Shimbunsha, 2003

Asahi Newspaper 2006. *Shūkan Asahi hyakka: Shūkan ningen kokuhō* (*Asahi Weekly Encyclopedia: Living National Treasures*), 70 vols, Tokyo, Asahi Shimbunsha, 2006-

Baekeland 1993. Baekeland, Frederick et al., *Modern Japanese Ceramics in American Collections* (exhibition catalogue), New York, Japan Society, 1993

Best 1991. Best, Susan-Marie, 'The Yūzen Kimono of Moriguchi Kunihiko', *Eastern Art Report* vol. III, no. 2, July/August 1991: pp. 18–20

Brown and Mitchell 2004. Brown, Sandy and Maya Kumar Mitchell (eds), *The Beauty of Craft, a resurgence anthology*, Dartington, Totnes, Devon, Green Books, 2004

Cort 1979. Cort, Louise, *Shigaraki: Potters' Valley*, Tokyo, New York and San Francisco, Kōdansha International, 1979
Cort 1992. Cort, Louise, *Japanese*

Collections in the Freer Gallery of Art: Seto and Mino Ceramics*, Washington D.C., Smithsonian Institution, 1992

Dalby 1993. Dalby, Liza, *Kimono: Fashioning Culture*, New Haven and London, Yale University Press, 1993

Dusenbury 1993. Dusenbury, Mary, 'Kasuri', in Rathbun 1993: p. 57 ff.

Düsseldorf Kunstmuseum 1993. Ricke, Helmut (ed.), *Neues Glas in Japan* (*New Glass in Japan*)(exhibition catalogue), Düsseldorf, Kunstmuseum, 1993

Earle 1986. Earle, Joe et al., *Japanese Art and Design*, London, Victoria & Albert Museum, 1986

Earle 2005. Earle, Joe, *Contemporary Clay: Japanese Ceramics for the New Century*, Boston, Museum of Fine Arts Publications, 2005

Enomoto 1989. Enomoto Tōru et al., *Gendai no Nihon tōgei* (*Contemporary Japanese Ceramics*), 10 vols, Kyoto, Tankōsha, 1989

Faulkner 1995. Faulkner, Rupert, *Japanese Studio Crafts: Tradition and the Avant-Garde*, London, Laurence King and the Victoria & Albert Museum, 1995

Faulkner and Impey 1981. Faulkner, Rupert and Oliver Impey, *Shino and Oribe Kiln Sites: A Loan Exhibition of Mino Shards from Toki City* (exhibition catalogue), London, Robert G. Sawers Publishing and Ashmolean Museum, Oxford, 1981

Graham 1985. Graham, Patricia J., 'Sencha (Steeped Tea) and its Contribution to the Spread of Chinese Literati Culture in Edo Period Japan', *Oriental Art* vol. XXXI, no. 2, Summer 1985: pp. 186–95

Gunma Prefectural Museum of Modern Art 1980. *Some to ori: gendai no dōkō* (*Dyeing and Weaving: Contemporary Trends*)(exhibition catalogue), Takasaki, Gunma Prefectural Museum of Modern Art, 1980

Gunma Prefectural Museum of Modern Art 1982. *Shimura Fukumi ten* (*Shimura Fukumi Exhibition*)(exhibition catalogue), Takasaki, Gunma Prefectural Museum of Modern Art, 1982

Gunma Prefectural Museum of Modern Art 1991. *Some to ori: gendai no dōkō II* (*Dyeing and Weaving: Contemporary Trends II*)(exhibition catalogue), Takasaki, Gunma Prefectural Museum of Modern Art, 1991

Guth 1993. Guth, Christine M. E., *Art, Tea, Industry: Masuda Takashi and the Mitsui Circle*, Princeton, Princeton University Press, 1993

Harada 1983. Harada Hiroshi et al., *Living National Treasures of Japan* (exhibition catalogue), Boston, Museum of Fine Arts, 1983

Hasebe 1981. Hasebe Mitsuhiko, 'Ishiguro Munemaro no tōgei' (The Ceramic Art of Munemaro Ishiguro), in Tokyo National Museum of Modern Art, (eds), *Ishiguro Munemaro ten: tōgei no kokoro to waza* (*Ishiguro Munemaro Exhibition: The Creative Spirit of his Ceramic Art*)(exhibition catalogue), Tokyo, Mainichi Newspaper, 1981

Hasebe 1991. Hasebe Mitsuhiko, *Tōgei: dentō kōgei* (Traditional Ceramic Art), *Nihon no bijutsu* no. 306 (Japanese Art Series), Tokyo, Shibundō, 1991

Hayashiya 1983. Hayashiya Seizō et al., *Japanese Ceramics Today: Masterworks from the Kikuchi Collection* (exhibition catalogue), Tokyo, Hakuhōdō, 1983

Hida 2004. Hida Toyojirō, *Kōgeika: dentō no seisansha* (*Craftspeople: Makers of Tradition*), Tokyo, Bigaku Shuppan, 2004

Hirayama 2003. Hirayama Ikuo and Inui Yoshiaki, *Ningen kokuhō no waza to bi: tōgei meihin shūsei* (*The Techniques and Aesthetics of Living National Treasures: Ceramic Masterpiece Collection*), 3 vols, Tokyo, Kōdansha, 2003

Hokkaidō Asahikawa Museum of Art 1986. *Ki no bi: dentō no Nihon* (*The Beauty of Wood: Tradition in Japan*)(exhibition catalogue), Asahikawa, Hokkaidō Asahikawa Museum of Art, 1986

Hokkaidō Museum of Modern Art 1986. *Nihon no garasu zōkei: Shōwa (Japanese Glass in the Shōwa Era)*(exhibition catalogue), Tokyo, Asahi Shimbunsha, 1986

Hori 1956. Hori Ryūjo, *Ningyō ni kokoro ga ari (Dolls have Hearts)*, Tokyo, Bungei Shunjū Shinsha, 1956

Imai 2003. Imai Yōko, 'The Doll: Vessels of Pathos', in Kaneko Kenji and Imai Yōko (eds), *Contemporary Dolls: Formative Art of Human Sentiment*, Tokyo National Museum of Modern Art, 2003: pp. 8–16

Imaizumi 1975–7. Imaizumi Atsuo et al., *Gendai no tōgei (Contemporary Ceramics)*, 17 vols, Tokyo, Kōdansha, 1975–7

Impey 1991. Impey, Oliver, *The Yūzen Kimono of Moriguchi Kunihiko* (exhibition catalogue), Oxford, Ashmolean Museum, 1991

Inui 1979. Inui Yoshiaki (ed.), *Genshoku gendai Nihon no bijutsu: tōgei 2 (Arts of Modern Japan in Colour: Ceramics 2)*, 16 vols, Tokyo, Shōgakukan, 1979

International Research Center 2005. International Research Center for Japanese Studies (eds), *International Japanese Arts and Crafts in the 21st Century (27th International Symposium)*, Kyoto, International Research Center for Japanese Studies, 2005

Ishikawa Prefectural Art Museum 2006. Ishikawa Prefectural Art Museum et al., *Ningen Kokuhō: Matsuda Gonroku no sekai (Living National Treasure: Matsuda Gonroku Exhibition)*(exhibition catalogue), Tokyo, Mainichi Shinbunsha, 2006

Ishimura 1988. Ishimura Hayao et al., *Robes of Elegance: Japanese Kimonos of the 16th–20th Centuries* (exhibition catalogue), Raleigh, North Carolina Museum of Art, 1988

Itō 1980. Itō Seizō, *Nihon no urushi (Japanese Lacquer)*, Tokyo, Tokyo Bunko, 1979

Japan Folk Crafts Museum 1995. The Japan Folk Crafts Museum (eds), *Mingei: Two Centuries of Japanese Folk Art*, Tokyo, The Japan Folk Crafts Museum, 1995

Kaneko 1987. Kaneko Kenji, '*Modaan Aato Kyōkai no seikatsu bijutsu*' ('Craft Art of the Modern Art Association'), in Tokyo National Museum of Modern Art, 1987: pp. 18–30

Kaneko 2001. Kaneko Kenji, *Gendai tōgei no zōkei shikō (Rethinking Contemporary Art Ceramics)*, Tokyo, Abe Shuppan, 2001

Kaneko 2002. Kaneko Kenji, 'Studio Craft and Craftical Formation', in Paul Greenhalgh (ed.), *The Persistence of Craft*, London, A & C Black, 2002: pp. 28–36.

Katō 1972. Katō Tōkurō, *Genshoku tōki daijiten (Complete Colour Dictionary of Ceramics)*, Kyoto, Tankōsha, 1972

Katori 1983. Katori Kazuo, *Bijutsu imono no shūhō (Techniques of Art Metal Casting)*, Tokyo, Agne, 1983

Kawakita 1991. Kawakita Michiaki et al. (eds), *Kōgei (Crafts)* vols I-III, *Shōwa no bunka isan (Cultural Heritage of the Shōwa Era)* vols 6-8, Tokyo, Gyōsei, 1990–91

Kikuchi 2004. Kikuchi, Yuko. *Japanese Modernisation and Mingei Theory*, London, Routledge Curzon, 2004

Kitamura 1991. Kitamura Tetsurō, *Senshoku: dentō kōgei (Traditional Dyeing and Weaving)*, *Nihon no bijutsu* no. 307 (Japanese Arts series), Tokyo, Shibundō, 1991

Kitamura 1993. Kitamura Takeshi, *Gendai ni ikiru ori: Kitamura Takeshi (Traditional Fabric Design and Techniques Given Life by an Artist, Takeshi Kitamura)*, Kyoto, Kitamura Takeshi, 1993

Komatsu City Museum 2006. *Shodai Tokuda Yasokichi (Tokuda Yasokichi I)* (exhibition catalogue), Komatsu City Museum, Ishikawa, 2006

Kyoto National National Museum of Modern Art 1998. *Kyoto no kōgei, 1910–1940: dentō to henkaku no hazama ni (Crafts in Kyoto, 1910–1940: A Struggle between Tradition and Revolution)* (exhibition catalogue). Kyoto, National Museum of Modern Art, 1998

Kyoto National Museum of Modern Art 2001. *Kyoto no kōgei, 1945–2000 (Crafts in Kyoto, 1945-2000)* (exhibition catalogue), Kyoto, National Museum of Modern Art, 2001

Mainichi Newspaper 1967. Mainichi Shinbun Ningen Kokuhō Henshū Iinkai (eds), *Ningen kokuhō: jūyō mukei bunkazai o hōji suru hitobito (Living National Treasures: People Who Preserve Important Intangible Cultural Assets)*, Tokyo, Mainichi Shinbunsha, 1967

Maruyama 1988. Maruyama Nobuhiko, '*Yūzen* Dyeing', in Ishimura 1988: pp. 23–30

Matsumoto 1984. Matsumoto Kaneo, *Shōsōin-gire to Asuka Tempyō no senshoku (Jōdai-gire : 7th and 8th Century Textiles in Japan from the Shōsōin and Horyūji)*, Kyoto, Shikōsha, 1984

Mellott 1993. Mellott, Richard, '*Katazome, Tsutsugaki, and Yūzenzome*', in Rathbun 1993: pp. 51–6

Minami 2004. Minami Kunio et al., *Ningen kokuhō jiten: kōgei gijutsu hen (Dictionary of Living National Treasures: Crafting Techniques)*, Tokyo, Unsōdō, 2004

Mizuta 1993. Mizuta Yoriko, 'Historical Development of Modern Glass in Japan', in Düsseldorf Kunstmuseum 1993: pp. 16–22

Moeran 1982a. Moeran, Brian, 'A Survey of Modern Japanese Pottery, Part 1: From Craft to Art', *Ceramics Monthly* vol. 30, no. 8, October 1982: pp. 30–2

Moeran 1982b. Moeran, Brian, 'A Survey of Modern Japanese Pottery, Part 2: In Search of Tradition', *Ceramics Monthly* vol. 30, no. 9, November 1982: pp. 44–6

Moeran 1982c. Moeran, Brian, 'A Survey of Modern Japanese Pottery, Part 3: Exhibitions', *Ceramics Monthly* vol. 30, no. 10, December 1982: pp. 32–4

Moeran 1983. Moeran, Brian, 'A Survey of Modern Japanese Pottery, Part 4: The Business of Pottery', *Ceramics Monthly* vol. 31, no. 1, January 1983: pp. 54–7

Moeran 1984. Moeran, Brian, *Lost Innocence: Folk Craft Potters of Onta, Japan*, Berkeley, Los Angeles and London, University of California Press, 1984

Morse 1998. Morse, Samuel C. (ed.), *Shaped with a Passion, The Carl A Weyerhaeuser Collection of Japanese Ceramics from the 1970s*, Duxbury, Massachusetts, Art Complex Museum, 1998

Moroyama 1999. Moroyama Masanori, 'The Development of Bamboo Crafts in Modern and Contemporary Japan', in *Japanese Bamboo Baskets: Masterworks of Form & Texture*, Los Angeles, Cotsen Occasional Press, 1999

Murayama 1991. Murayama Akira, '*Murayama Akira: mokkō*' (Murayama Akira: Woodwork), *NHK kōbō tanbō: tsukuru* (NHK Workshop Visits: Craft Makers) vol. 9, Tokyo, Japan Broadcasting Association, 1991

Museum of Ceramic Art 2006. The Museum of Ceramic Art, Hyōgo (eds), *Tōgei no genzai, soshite mirai e* (*Ceramic Now +*), Sasayama City, Hyōgo, The Museum of Ceramic Art, 2006

Nakanodō 1987. Nakanodō Kazunobu, '*Kamoda Shōji no tōgei*' (*The Ceramic Work of Kamoda Shōji*), in Tokyo National Museum of Modern Art 1987b: pp. 9–37

Nakanodō 1993. Nakanodō Kazunobu, 'Japanese Public Collections of Modern Ceramics and their Direction: From a

Museum Curator's Viewpoint', in Baekeland 1993: pp. 61–7

Newcastle Region Art Gallery 1987. *Four Aspects of Contemporary Japanese Ceramics* (exhibition catalogue), Newcastle (Australia), Newcastle Region Art Gallery, 1987

Nichigai Associates 1990. *Gendai meikō shokunin jinmei jiten* (*Skilled Craftsmen and Artisans in Japan: A Biographical Dictionary*), Tokyo, Nichigai Associates, 1990

Nihon Dentō Kōgeiten-shi Hensan Iinkai 1993. Nihon Dentō Kōgeiten-shi Hensan Iinkai (eds), *Nihon dentō kōgeiten no ayumi* (*Development of the Japan Traditional Art Crafts Exhibition*), Tokyo, Nihon Kōgeikai, 1993

Nihon Kōgeikai 1973. Nihon Kōgeikai (eds), *Gendai no dentō kōgei* (*Traditional Crafts in the Present*), Tokyo, Kōdansha, 1973

Nihon Kōgeikai 1983. Nihon Kōgeikai, eds., *Gendai no dentō kōgei* (Traditional Crafts in the Present), Tokyo, Kōdansha, 1983

Nihon Kōgeikai 2006. Nihon Kōgeikai (eds), *Nihon dentō kōgei: Kanshō no tebiki* (*Handbook for Appreciation: Japanese Traditional Crafts*), Tokyo, Unsōdō, 2006

Nishida 1977. Nishida Hiroko, *Nihon tōji zenshū* vol. 24: *Kakiemon* (A Pageant of Japanese Ceramics: Kakiemon), Tokyo, Chūō Kōronsha, 1977

Okada 1977–9. Okada Yuzuru (ed.), *Ningen kokuhō series* (*Living National Treasure series*), 43 vols, Tokyo, Kōdansha, 1977–9

Ōme Municipal Museum of Art 1988. *Fujimoto Yoshimichi ten* (*Fujimoto Yoshimichi Exhibition*) (exhibition catalogue), Tokyo, Ōme Municipal Museum of Art, 1988

Ōtaki 1991. Ōtaki Mikio, '*Kinkō: dentō kōgei*' (*Traditional Metalwork Crafts*),

Nihon no bijutsu no. 305 (Japanese Art series), Tokyo, Shibundō, 1991

Paris, Mitsukoshi Étoile 1999. *Nihon no kōgei 'ima' 100-sen ten* (exhibition catalogue), Paris Mitsukoshi Étoile 1999

Pitelka 2005. Pitelka, Morgan, *Handmade Culture, Raku Potters, Patrons, and Tea Practioners in Japan*, Honolulu, University of Hawaii Press, 2005

Rathbun 1993. Rathbun, William (ed.), *Beyond the Tanabata Bridge: Traditional Japanese Textiles* (exhibition catalogue), Seattle, Thames & Hudson in association with Seattle Art Museum, 1993

Ricke 1993. Ricke, Helmut, 'An Attempt at Rapprochement: Japan's Glass art from the European Perspective', in Düsseldorf Kunstmuseum 1993: pp. 36–40

Rosenfield 1992. Rosenfield, John M (ed.), *Competition and Collaboration: Hereditary Schools in Japanese Culture*, Boston, Isabella Stewart Gardner Museum, 1992

Seibu Department Store 1988. *Otomaru Kōdō kaiko ten* (*Retrospective Exhibition of Otomaru Kōdō*) (exhibition catalogue), Tokyo, Seibu Department Store, 1988

Shiga Prefectural Contemporary Ceramics Museum 1990. *Tsuchi no hakken: gendai tōgei to genshi doki* (*Primitivism in the Contemporary Ceramics*) (exhibition catalogue), Shigaraki, World Ceramics Festival Organizing Committee, 1990

Shimasaki 2006. Shimasaki Susumu, 'The World of Gonroku Matsuda', in Ishikawa Prefectural Museum of Art 2006: pp. 10–24

Shiraishi 1991. Shiraishi Masami, *Mokuchiku kōgei: dentō kōgei* (*Traditional Woodwork and Bamboo Crafts*), *Nihon no bijutsu* no. 303 (Japanese Arts series), Tokyo, Shibundō, 1991

Simpson 1979. Simpson, Penny et al., *The Japanese Pottery Handbook*, Tokyo, New York and San Francisco, Kōdansha International, 1979

Stinchecum 1993. Stinchecum, Amanda, 'Textiles of Okinawa', in Rathbun 1993: pp. 75–90

Sugaya 1990. Sugaya Tomio, '*Momoyama tōgei no saihakken*' (The Rediscovery of Momoyama Ceramics), in Kawakita 1991, vol. 6: pp. 126–9

Sugimura 1967. Sugimura Tsune (photos) and Ogawa Masataka (text), *Ningen kokuhō: dentō kōgei* (*Living National Treasures: Traditional Crafts*), Tokyo, Bijutsu Shuppansha, 1967

Suzuki 1978. Suzuki Kenji (ed.), *Genshoku gendai Nihon no bijutsu: kōgei* (*Japanese Modern Art in Colour: Crafts*), 15 vols, Tokyo, Shōgakukan, 1978

Suzuki 1980. Suzuki Kenji, ed., *Genshoku gendai Nihon no bijutsu: tōgei I* (Japanese Modern Art in Colour: Ceramics I), 14 vols., Tokyo, Shōgakukan, 1980

Taguchi 1991. Taguchi Yoshikuni et al., *Maki-e: Taguchi Yoshikuni* (*The Maki-e Art of Taguchi Yoshikuni*), Tokyo, Arrow Artworks, 1991

Tanaka 1996. Tanaka Aiko (ed.), *Miwa-gama* (*The Miwa Kiln*), Nagoya, Matsuzakaya Art Museum, 1996

Tochigi Prefectural Museum of Art 1986. *Kamoda Shōji ten* (*Retrospective Kamoda Shōji*)(exhibition catalogue), Utsunomiya, Tochigi Prefectural Museum of Art, 1986

Tokuda 1995. Tokuda Yasokichi, *Yōsai – Tokuda Yasokichi sakuhin shū* (*The Works of Yasokichi Tokuda*), Tokyo, Kôdansha, 1995

Tokyo National Museum of Modern Art 1978. *Matsuda Gonroku-ten* (*Matsuda Gonroku Exhibition*)(exhibition catalogue), Tokyo, Nihon Keizai Shinbunsha, 1978

Tokyo National Museum of Modern Art 1982. Tokyo National Museum of Modern Art (eds), *Japanese Lacquer Art: Modern Masterpieces*, New York, Tokyo and Kyoto, Weatherhill/Tankōsha, 1982

Tokyo National Museum of Modern Art 1983a. *Kuroda Tatsuaki* (*Kuroda Tatsuaki: Master Wood Craftsman*) (exhibition catalogue), Tokyo National Museum of Modern Art, 1983

Tokyo National Museum of Modern Art 1983b. *Modaanisumu to kōgeika-tachi: kinkō o chūshin ni shite* (*Modernism and Craftsmen: The 1920s to the 1930s*) (exhibition catalogue), Tokyo National Museum of Modern Art, 1983

Tokyo National Museum of Modern Art 1985a. *Take no kōgei: kindai ni okeru tenkai* (*Modern Bamboo Craft*) (exhibition catalogue), Tokyo National Museum of Modern Art, 1985

Tokyo National Museum of Modern Art 1985b. *Gendai senshoku no bi: Moriguchi Kakō, Munehiro Rikizō, Shimura Fukumi* (*Kimono as Art: Modern Textile Works by Kakō Moriguchi, Rikizō Munehiro, and Fukumi Shimura*) (exhibition catalogue), Tokyo, Nihon Keizai Shinbunsha, 1985

Tokyo National Museum of Modern Art 1987a. *Gendai tōgei no bi: Kamoda Shōji ten* (*Kamoda Shōji: A Prominent Figure in Contemporary Ceramics*) (exhibition catalogue), Tokyo, Nihon Keizai Shinbunsha, 1987

Tokyo National Museum of Modern Art 1987b. *Mokukōgi: Meiji kara gendai made* (*Modern Woodcraft*) (exhibition catalogue), Tokyo National Museum of Modern Art, 1987

Tokyo National Museum of Modern Art 1990. *Japan's Traditional Crafts: Spirit and Technique* (exhibition catalogue: Finland, Norway, Sweden and Denmark), Tokyo, Asahi Shimbunsha, 1990

Tokyo National Museum of Modern Art 1993. *Nuri no keifu* (*Nuances in Lacquer: 70 Years of Innovation*) (exhibition catalogue), Tokyo National Museum of Modern Art, 1993

Tokyo National Museum of Modern Art 1994. *Gendai no katazome: kurikaesu pataanu* (*Contemporary Stencil Dyeing and Printing: The Repetition of Patterns*) (exhibition catalogue), Tokyo National Museum of Modern Art, 1994

Tokyo National Museum of Modern Art 1999. *Katō Hajime ten: kindai tōgei no seika* (*Katō Hajime Exhibition: Flowering of Modern Ceramics*) (exhibition catalogue), Tokyo National Museum of Modern Art, 1999

Tokyo National Museum of Modern Art 2007. *Mineo Okabe: A Retrospective*, Tokyo National Museum of Modern Art, 2007

Tokyo National Museum of Modern Art 2002. *Shōwa no Momoyama fukkō: tōgei kindaika no tenkanten* (*Modern Revival of Momoyama Ceramics: Turning Point Toward Modernization of Ceramics*) (exhibition catalogue), Tokyo National Museum of Modern Art, 2002

Tokyo National Museum of Modern Art 2003. *Kyō no ningyō geijutsu: sōnen no zōkei* (*Contemporary Dolls*) (exhibition catalogue), Tokyo, TBS, 2003

Tokyo National Museum of Modern Art 2005. *Kindai kōgei annai* (*Modern Craft Art Japan*), Tokyo National Museum of Modern Art, 2005

Tokyo National Museum of Modern Art 2006. Tokyo National Museum of Modern Art (eds), *Miwa Jusetsu no sekai: Hagiyaki no zōkeibi* (*Jusetsu Miwa: A Retrospective*) (exhibition catalogue), Tokyo, Asahi Shinbunsha, 2006

Tomita 1982. Tomita Jun and Tomita Noriko, *Japanese Ikat Weaving*, London, Boston, Melbourne and Henley, Routledge & Kegan Paul, 1982

Tsuchiya 1987. Tsuchiya Yoshio, *Nihon no garasu* (*Glass of Japan*), Kyoto, Shikōsha, 1987

Tsukada 2007. Tsukada Kyōko, 'We have Nurtured Trees since Time Immemorial to Get the Precious Drops', *Kateigahō International*, Winter Edition, 2007: p. 39

Uchiyama 2006. Uchiyama Takeo et al., *Tanjō 120 nen Tomimoto Kenkichi ten (Tomimoto Kenkichi Exhibition, Commemorating 120 years since his birth)* (exhibition catalogue), Tokyo, Asahi Shimbunsha, 2006

Wada, Rice and Barton 1983. Wada Yoshiko, Mary Rice and Jane Barton, *Shibori: The Inventive Art of Japanese Shaped Resist Dyeing*, Tokyo, New York and San Francisco, Kōdansha International, 1983

Wajima Museum of Lacquer Art 1991. *Gendai shitsugei no ishō-tachi (Masters of Contemporary Lacquer Art)* (exhibition catalogue), Wajima Museum of Lacquer Art, 1991

Yabe 2002. Yabe Yoshiaki et al. (eds), *Kadokawa Nihon tōji daitjiten*, Tokyo, Kadowkawa Shoten, 2002

Yanagi 1972. Yanagi Sōetsu (adapted by Bernard Leach), *The Unknown Craftsman*, Tokyo, New York and San Francisco, Kōdansha International, 1972

Yagihashi 1991. Yagihashi Shin, '*Shitsugei: dentō kōgei*' (*Lacquer: Traditional Crafts*), *Nihon no bijutsu* no. 304 (Japanese Art series), Tokyo, Shibundō, 1991

Yomiuri Newspaper 1994. *Dentō to sōsei – yūzen no bi: Moriguchi Kakō-Kunihiko ten (Tradition and Creativity – The Beauty of Yūzen: An Exhibition of Moriguchi Kakō and Moriguchi Kunihiko)* (exhibition catalogue), Osaka, Yomiuri Shinbunsha Osaka Head Office, 1994

Acknowledgements

The Editor would particularly like to thank the following persons who have assisted in the preparation of this catalogue:

Tim Clark (BM), Rupert Faulkner (V&A), Higashi Mariko (The Asahi Shimbum), Hirano Akira (SISJAC), Ishizaki Yasuyuki (Hagi Uragami Museum), Anna Jackson (V&A), Kaneko Kenji (MOMAT), Simon Kaner (SISJAC), Kida Takuya (MOMAT), Matsubara Ryūichi (MOMAK), Akiko of Mikasa (BM), Miyazaki Shinya (BM), Miwa Kazuhiko, Moriguchi Kunihiko (Japan Art Crafts Association), Moroyama Masanori (MOMAT), Murose Kazumi (Japan Art Crafts Association), Morohashi Kazuko (SISJAC), Keiko Newton (SISJAC), Ōguchi Masami, Ōhori Kazuhiko, Saitō Masamitsu, Shirota Yutaka, Suzuta Yukio (Kyushu Ceramic Museum), Uchida Hiromi (SISJAC), Uchiyama Takeo (MOMAK), Tokuda Yasokichi III (Japan Art Crafts Association) and Yamada Kyōko (The Asahi Shimbun).

Photographic acknowledgements

The Asahi Shimbun Company: cat. nos 70, 99, 110

Portraits of the artists courtesy of The Asahi Shimbun Company except the photographs listed (1)–(3) below

Japan Art Crafts Association: cat. nos 29, 47, 50, 72, 89, 111, 112

The National Museum of Modern Art, Tokyo: cat nos 3, 4, 5, 6, 7, 12, 13, 14, 18, 19, 20, 21, 22, 24, 25, 28, 32, 33, 35, 37, 38, 39, 40, 41, 43, 44, 46, 48, 49, 53, 57, 58, 59, 60, 64, 65, 66, 68, 69, 71, 77, 78, 81, 83, 86, 90, 91, 92, 93, 94, 95, 96, 102, 103, 104, 105, 107

The National Museum of Modern Art, Kyoto: cat nos 1, 2, 8, 9, 10, 11, 15, 16, 17, 31, 34, 36, 42, 61, 62, 63, 80, 82, 98

New Color Photographic Printing: cat. no. 56

Agency for Cultural Affairs: cat nos 23, 27, 55, 73, 74, 76, 87, 88, 97, 100, 101, 109

Moriguchi Kunihiko: cat no. 45

Nakagawa Mamoru: cat. no. 85

Unsōdō: cat. nos 26, 51, 54, 75, 84

Arrow Art Works: cat. nos 30, 52, 67, 79, 106, 108

(1) Ōhori Kazuhiko: portraits of Serizawa Keisuke, Saitō Akira, Nakadai Zuishin

(2) Takamura Tadashi: portrait of Takamura Toyochika

(3) Tarumi Kengo: portrait of Miyahira Hatsuko